PUEBLO BEAD JEWELRY

Living Design

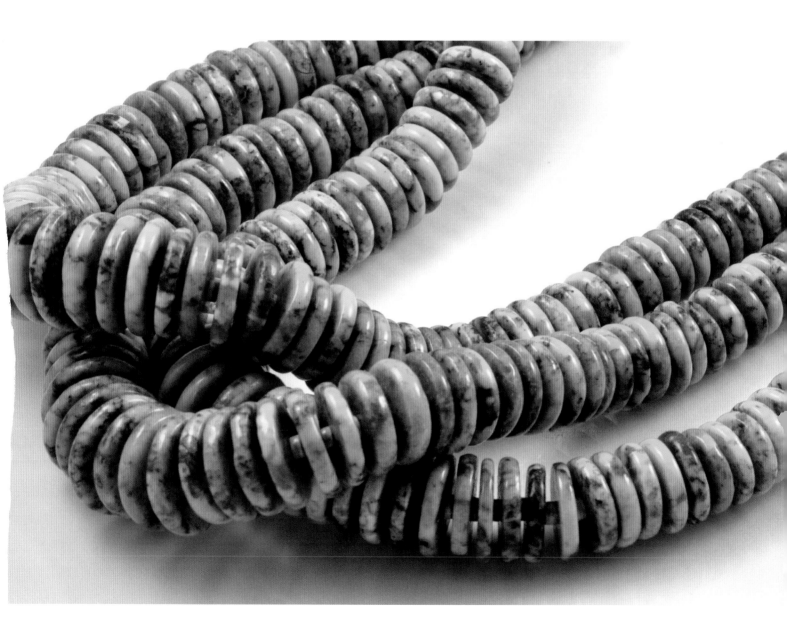

Paula A. Baxter | Photography by Barry Katzen

Schiffer Publishing Ltd

4880 Lower Valley Road • Atglen, PA 19310

Other Schiffer Books by the Author:

Southwestern Indian Bracelets: The Essential Cuff, ISBN 978-0-7643-4868-6
Southwestern Indian Rings, ISBN 978-0-7643-3875-5

Other Schiffer Books on Related Subjects:

Turquoise Mines, Minerals, and Wearable Art, 2nd Ed., Mark P. Block, ISBN 978-0-7643-5364-2
Pueblo Dancing, Nancy Hunter Warren & Jill Drayson Sweet, ISBN 978-0-7643-3860-1
Reassessing Hallmarks of Native Southwest Jewelry: Artists, Traders, Guilds, and the Government, Pat Messier and Kim Messier, ISBN 978-0-7643-4670-5

Library of Congress Control Number: 2018934134

Designed by RoS
Cover design by RoS
Front jacket image: Two spiny oyster shell dance necklaces, 1960s–1970s. Private collection. Back jacket images: *Top:* Heishi beads surround a pin pendant of a Pueblo maiden by Gomeo Bobelu (Zuni), 2014. Author's collection. *Bottom:* Masses of Pueblo beads. Private collection.
Type set in Alegreya Sans

ISBN: 978-0-7643-5585-1
Printed in China

Published by Schiffer Publishing, Ltd.
4880 Lower Valley Road
Atglen, PA 19310
Phone: (610) 593-1777; Fax: (610) 593-2002
E-mail: Info@schifferbooks.com
Web: www.schifferbooks.com

For our complete selection of fine books on this and related subjects, please visit our website at www.schifferbooks.com. You may also write for a free catalog.

Schiffer Publishing's titles are available at special discounts for bulk purchases for sales promotions or premiums. Special editions, including personalized covers, corporate imprints, and excerpts, can be created in large quantities for special needs. For more information, contact the publisher.

We are always looking for people to write books on new and related subjects. If you have an idea for a book, please contact us at proposals@schifferbooks.com.

Title page:
Heavy triple-strand turquoise *heishi* beads by Lester Abeyta (Santo Domingo), 2015. Private collection.

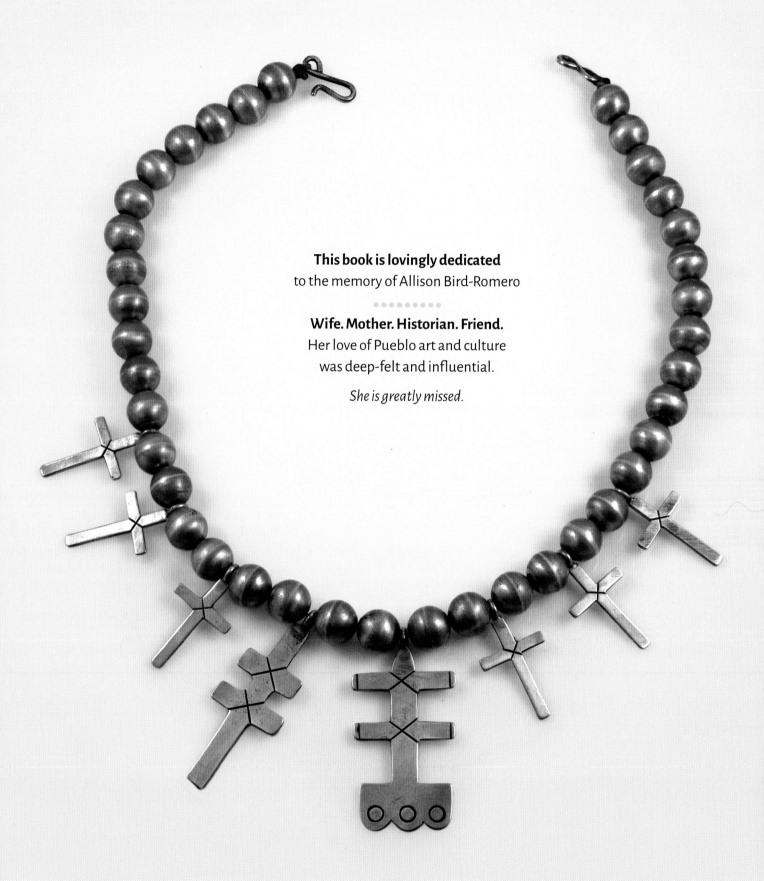

This book is lovingly dedicated
to the memory of Allison Bird-Romero

· · · · · · · · · ·

Wife. Mother. Historian. Friend.
Her love of Pueblo art and culture
was deep-felt and influential.

She is greatly missed.

Mike Bird-Romero's contemporary
tribute to the Pueblo old-style cross
necklace, ca. 2010.

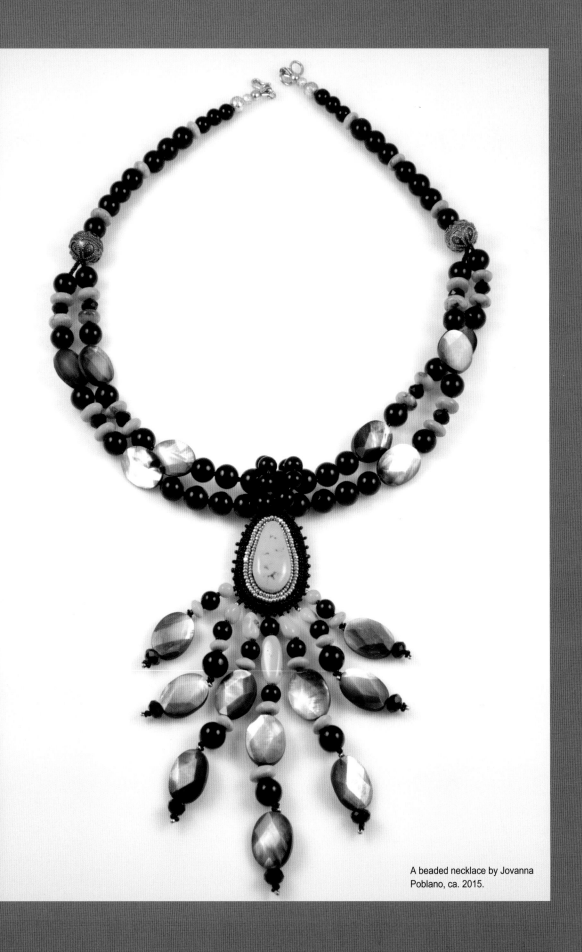

A beaded necklace by Jovanna
Poblano, ca. 2015.

Contents

Acknowledgments

A book such as this has many debts owed to individuals, institutions, and the world of ideas. It was born from the abiding love I possess for Southwestern Native American bead jewelry, especially Pueblo adornment. This love also transmitted itself to the makers and other people who share my passion. There has never been enough literature on the subject, and I've frequently been frustrated by how many writers relegate Pueblo jewelry making and makers to second-place status. Get ready for some revisionism, now.

First, I'd like to acknowledge those who contributed images to this work. The economics of creating a book such as this do not allow the luxury of purchasing numerous museum images and reproduction rights. Since we are dealing with a living art form, the contributions of artists, dealers, and collectors are essential. Therefore, my heartfelt thanks go to Laura Anderson, Steve and Mary Delzio, Eason Eige, Bill Faust, Abby Kent Flythe, John C. Hill and Linda Sheppard, Robert Mac Eustace Jones, Suzette Jones, Yasutomo Kodera, Bill and Minnie Malone, Andrew Munana, Alston and Deborah Neal, Paul and Valerie Piazza, Dr. Elizabeth Simpson, and Karen Sires. I'd also like to thank the two East Coast collectors who have elected to remain private contributors: you know who you are!

Special thanks go to Mark Bahti, Bob Bauver, Kamella and Mike Bird-Romero, Ernie Bulow, Laura Cardinal, Dexter Cirillo, Lois Dubin, Dennis and Joyce June, Mario Nick Klimiades, Henrietta Lidchi, Ann Marshall, and Diana Pardue. I received help from staffs at the Indian Pueblo Culture Center, the Santo Domingo Trading Post, and the Utility Shack, all three in Albuquerque, New Mexico. Thanks to the Santa Fe museums that provided exhibitions on Lloyd Kiva New: the Museum of New Mexico, the Museum of Indian Arts and Cultures, and the Museum of the Institute of American Indian Arts (IAIA). My appreciation also to the Collections Photo Archives at the National Museum of the American Indian, Washington, DC. Much library research needed to be done: at the incomparable Billie Jane Baguley Library and Archives of the Heard Museum; the electronic library holdings of Berkeley College, New York and New Jersey; and materials viewed through the New York Public Library, the Scottsdale (Arizona) Public Library, and the Westchester (New York) Library System (WLS).

Unfortunately, this book has also been accompanied by personal loss. To lose one dear friend and guide is bad enough, to lose two felt unbearable, and then after the years of work began, there would be more bereavements: Tony Eriacho and Myron Panteah of Zuni; Orville Tsinnie; Jay Evetts; and Laura Anderson.

Back east, my appreciation to Sandra Carpenter, Dan Fermon, Warren Fischbach, Terry Kirshner, Judith Kornberg, Dr. Mark Kupersmith, Daniel Starr, Drs. Ralph Peters and Roseann Torciello, and all my students at Berkeley College. Wholehearted thanks to Peter Schiffer and the Schiffer staff! Barry Katzen, my partner in this work, receives all my love, as do the rescue rabbits that run our home.

—Paula A. Baxter

The major Pueblos and reservations of the American Southwest.

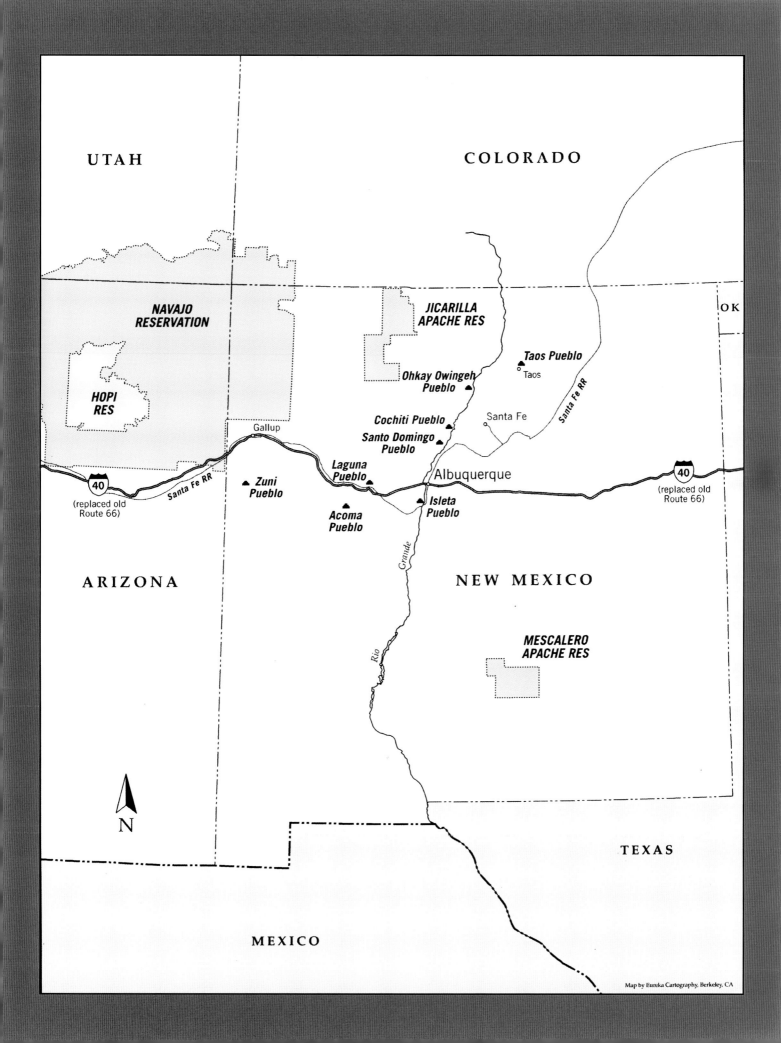

UTAH

COLORADO

OK

NAVAJO
RESERVATION

JICARILLA
APACHE RES

HOPI
RES

Taos Pueblo

Taos

Ohkay Owingeh
Pueblo

Santa Fe

Santa Fe RR

Gallup

Cochiti Pueblo

Santo Domingo
Pueblo

Laguna
Pueblo

Albuquerque

40

Santa Fe RR

Zuni
Pueblo

Isleta
Pueblo

(replaced old
Route 66)

40

(replaced old
Route 66)

Acoma
Pueblo

Santa Fe RR

Rio

ARIZONA

NEW MEXICO

MESCALERO
APACHE RES

Grande

N

Rio

TEXAS

MEXICO

Map by Eureka Cartography, Berkeley, CA

" The good thing about working in Native American art history today is there is so much flawed, incorrect information out there that it's a lot of fun to go back and correct the misrepresentations. "

—**Robert Mac Eustace Jones** (2016)[1]

■ **THERE ARE MANY BRANCHES** into the main stream of Native American design, but one of the strongest and most active tributaries is that of the design of the Pueblo peoples of the American Southwest. Since Pueblo jewelry making is both an ancient and live ongoing art, an investigation of its design legacy requires several areas of study. And when we begin this examination, we encounter some established "facts" that are questionable.

To begin, Navajo and Pueblo Indian jewelry history has become a shared story, dominated most often by Navajo-centric accounts. While it is true that these two peoples' silversmiths and jewelers interacted closely over the years, the nature of their design contributions needs reappraisal. How did the concept of Navajo jewelry design supremacy come about, especially when the acknowledged most famous maker was a Pueblo Indian? Why does Pueblo jewelry often take second place in older ethnographic and collector literature? And why have Pueblo jewelry makers traditionally received credit for their lapidary abilities at the expense of their silverwork?

This work intends to separate emotional "truth" from fact by scrutinizing an area of Pueblo jewelry making that has been underappreciated in the literature. Pueblo skill in hand carving, shaping, and stringing beads, which we will call by the Keres word *heishi*, is second to none. Such mastery of the bead form also applies to lapidary cutting and inlay, and later to the construction of fine silver beads. At all times, we see highly innovative work produced by Pueblo jewelers that illustrates the historical power of their cultural design. Their innovation through beadwork has deeply influenced Native and non-Native jewelry creation and continues to do so.

The bead resembles an endless circle or loop, mirroring Pueblo aesthetics and beliefs, and it can be a design element, motif, or pattern. This book asks you to take a look at the images that accompany the text, and then to look again more closely. You will see an integral human design legacy that has been passed down over the centuries to the present, one that will live on into the future.

Now, we need to look again at certain key assumptions that were made by non-Native observers during the twentieth century. These became embedded in our understanding about Pueblo shell, stone, and silver jewelry making. We should reexamine these assumptions to better understand why they don't reflect an accurate portrayal of Pueblo living design:

"Notwithstanding the greater disadvantage under which the latter (Navajo) labors, the ornaments made by his hand are generally conceded to be equal or even superior to those made by the Pueblo Indian." (1934)[2]

"The Pueblo smiths who made silver of aesthetic importance did their finest work during the nineteenth century. Today these smiths are either dead, or so old that they no longer practice the craft." (1944)[3]

The Importance of Pueblo Beads

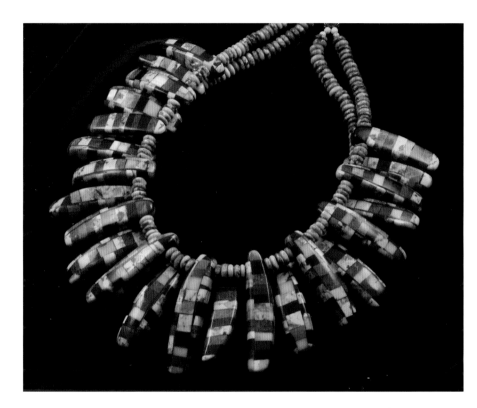

Two-tier mosaic tab collar necklace by Jolene Bird (Santo Domingo), ca. 2009. Private collection.

"The Zuñis were, and remain, essentially lapidaries, not silversmiths." (1950)[4]

"All the pueblos say they used to have silver workers—a surprise to those who think of this craft as a Navaho specialty." (1953)[5]

"For a long time the silversmiths of Santo Domingo patterned their jewelry after that of the Navajos, whose ornaments they continued to wear." (1973)[6]

". . . Pueblo jewelry, made in enormous quantities for outsiders, has artistic validity that appears to be irrelevant to its artists." (1979)[7]

Well-made coral *heishi* flows like silk and has the texture of snake skin, 1950s. Private collection.

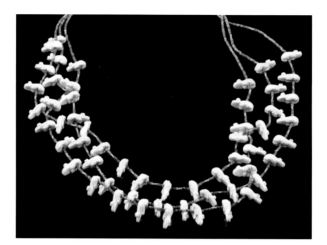

Three-strand white bear fetish necklace by Peter and Dinah Gaspar (Zuni), 1980s. Courtesy of Paul and Valerie Piazza.

There are a number of reasons these notions developed, and this book hopes to examine them and assist the reader in understanding Pueblo jewelry design in a more genuine context. These reasons range from historical to consumer misunderstanding, emphasis on silverwork at the expense of other modes, and non-Native confusion in the pursuit of knowledge. After all, we have entered the century where Native discourse will soon supplant non-Native evaluation. What better timing than now to correct such errors for the future of Native American design history?

Why does design history work better than other scholarly methodologies? Most of our ideas about Navajo and Pueblo jewelry were originated by anthropologists doing fieldwork with informants, and scholars pursuing laboratory research with selected objects. Anthropological investigation works well for cultural analysis and perspective. When faced with an ongoing, functioning ethnic art market for Native jewelry creation, however, anthropologists became torn between labeling this activity either as an artificial cultural construct or a cultural diversion. Today, tracing the impulses of a living art created largely for those outside their makers' culture calls for different weights and measures.

The discipline of art history was created to assess the artistic impulses and production of Western civilization. When applied to non-Western cultures, there has had to be a certain amount of reinvention. Many of the investigated cultures had rather different concepts of artistic production. A new dynamic for art-historical appraisal of Native American art arose in the 1980s.[8] Most often,

however, when it touches on material culture, this evaluation serves best for patronage issues—which are not the whole story.

Design history, on the other hand, can be used to investigate how objects from material culture have meaning, purpose, and functionality. Over time and general human application, the definitions of what types of objects we investigate become blurred or indistinct. Terms applied to peoples and things can become incorrect or inaccurate labels. In order to appreciate the real living creativity of a specific people's jewelry making, we need to go back to redefine those terms involved and explain how assumptions have arisen that helped make those terms confused and incomplete.

A larger shadow looms over Pueblo jewelry design and meaning, one that we must recognize and respect. The Pueblo peoples have had a long struggle to retain their cultural values and beliefs. We can say that they are excellent examples of people who have used *survivance* to do so.[9] Many prized jewelry designs and visual patterns originated from a ceremonial function that is not the purpose of this book to investigate. Those who visit and interact with Pueblo peoples today understand that their communities retain conservative values; it is not the business of those outside their culture to press for meanings the Puebloans wish to keep private. Instead, we all need to study and appreciate what jewelry design is offered in the marketplace and focus our attention on its rich visual vocabulary and context.

The rewards for such attention are deeply pleasing. This book centers on the universal bead, that item of adornment venerated

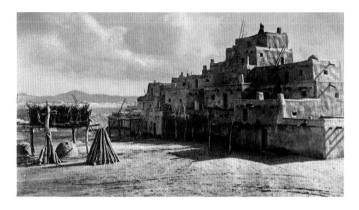

Historical postcard of the Panama-California Exposition, 1915–1916, where many people were introduced to Pueblo crafts and dancing. Private collection.

over history and across cultures around our global planet. During our exploration we will see how this bead helped transform Southwestern Native lapidary creation and silverwork and continues to inspire Pueblo design in general.

Pueblo jewelry has often trailed behind Navajo jewelry in scholarly and collector discussion for various reasons. The fact that early Navajo and Pueblo stone and metal jewelry created in the first decades of metalworking often couldn't be told apart, and the reality that the first Indian jewelry experts possessed a sometimes unconscious bias toward Navajo design, didn't help. Scholars such as John Adair, Harry Mera, and Arthur Woodward dominated the growth of literature on Southwestern Native jewelry and shaped dealer and collector opinion. Anglo Indian trader C. G. Wallace created a narrative for Zuni jewelry making that became virtually de facto. Later writers such as Clara Lee Tanner and Margery Bedinger followed their lead. At the Santa Fe institutions that gathered collections of Native arts, their publications focused more on the development of pottery or metal adornment than on the legacy of beadwork.

Pueblo architecture inspired Rapp and Rapp's 1917 Museum of New Mexico, Santa Fe, New Mexico.

Navajo anthropological informants spoke of jewelry production from a "hard goods" point of view. Puebloans, however, were not as inclined to discuss their jewelry making, since so much of it possessed or touched on private sacred associations. Even when a commercial market was established, such Pueblo reticence went a long way toward allowing Navajo description to dominate. To make up for their Pueblo smiths' lack of storytelling, non-Native curio store owners and middlemen invented whole lists of Indian "symbols" for eager tourists.

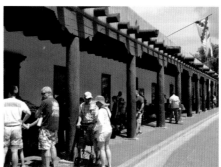

Indian art vendors under the portal of the Palace of the Governors, Santa Fe.

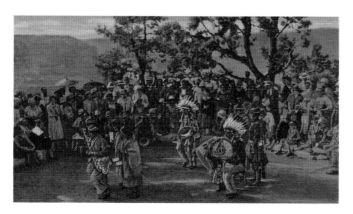

Historical postcard of tourists viewing Hopi dancing at the Grand Canyon, 1910s. Private collection.

The problem for non-Native writers was that they often failed to understand that they were dealing with a living art, not one frozen in a traditional time warp. These individuals' misrepresentations were based on one great fear: that, thanks to the commercial market, Indians such as the Puebloans would cease making genuine, authentic designs that reflected their true indigenous nature, and thus lack cultural relevance. The reasons for this false assumption are naive at the least, and racist at the worst. Adding to these writers' dilemma was the fact that, during this same period of time, other non-Native arts educators and design scholars were eager to adopt Pueblo designs as part of a truly "American" national design movement.

Let's look at four sets of clarifying definitions for this book. These explanations will help the reader understand just what elements in Pueblo bead jewelry render it meaningful, influential, and ongoing. Pueblo beadwork also enhanced silver jewelry by endowing the metalworking process with viable shapes and forms, or elements, motifs, textures, and an aesthetic sense that is both tangibly organic and conceptually brilliant.

Who Are the Pueblo Indians?

The Pueblo Indians have deep roots. A number of indigenous peoples occupied the ancient Southwest before the coming of the first Europeans. They formed cultural groups whose settlement expanded along various waterways, from secondary rivers and streams to the mighty Rio Grande itself; these peoples established networks of barter and exchange, practiced warfare, and defended themselves against incoming nomadic tribes such as the Navajos and Apaches.

By the time the Spanish invaders arrived, many of these groups had vanished, but some remained in occupied settled habitations, or villages, that the Spaniards dubbed *pueblos*. These explorers and conquerors brought colonists in their wake. Too often, the Puebloans have been the victims of a Fred Harvey–style "peaceful Indian" one-dimensional reputation. In fact, Pueblo warriors have a long tradition of being strong and effectively routing invaders. It was PoPay of San Juan Pueblo (now Ohkay Owingeh) who led the only successful Indian revolt against European incomers in 1680. The Spanish returned later, however, and the Pueblo peoples became enslaved and subjugated to colonial settlers and Catholic missionaries bent on converting them to the Christian faith.

The spirit of determination that made Pueblo peoples take their religious beliefs underground is part of their conservative lifeways today. They practice a survivance that informs their artistry; their subsequent private worldview and internal belief systems color Pueblo design. Past and present have deep meaning. The Pueblos are divided into several language cultural groups: the Tewa, Towa, Tiwa, Keresan, Zunian, and Hopi (Uto-Aztecan). Sacred stories,

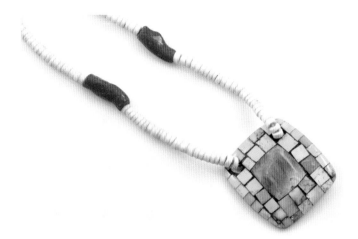

Pendant with mosaic turquoise and orange spiny oyster shell on white shell with coral beads, first half of the 20th century, originally owned by Mrs. Fowler McCormick. Courtesy of John C. Hill and Linda Sheppard.

emergence legends, and *katsinam* gods and helpers vary among these groups, but the Puebloans share a fierce belief in privately maintaining their rituals. Some ceremonies and social dances can be viewed by outsiders, but a common desire to protect and preserve their religious heritage runs through every group. At the same time, every pueblo has a mission church, and many Puebloans have become Catholics or joined another Christian denomination. Hispanic Catholic practices have edged into Pueblo design in an intriguing manner as a result. These can range from annual *Matachines* dances to rosaries with dragonfly-shaped crosses that possess ambiguous meaning.

The nineteen surviving, occupied pueblos are tribal nations, each with their own government structure. Geographically, they are divided between those that occupy the Rio Grande valley and the western Pueblos (see map on page 7). Fifteen follow the bends of the Rio Grande from Taos in the north to Isleta, thirty miles south of Albuquerque. Laguna and Acoma lie to the west, and Zuni is situated close to the western border of New Mexico. The Hopi live on scattered mesa-top settlements in northeastern Arizona.

In terms of jewelry making, certain pueblos have become generally associated with specific forms of adornment. Isleta is known for its fine silver cross necklaces, while Santo Domingo jewelers are good traders and particularly known for their *heishi* work, which ranges from museum quality to costume jewelry category. Zuni lapidary work has been celebrated since the early to mid-twentieth century, while post–World War II Hopi overlay and richly shaped stonework are well recognized.

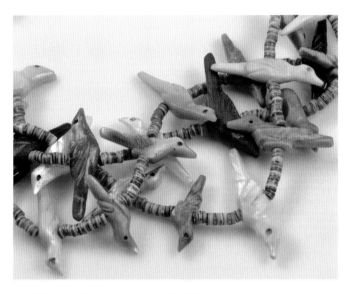

Detail of birds on three-strand olive shell *heishi* by David Tsikewa (Zuni), 1940s–1950s. Courtesy of Paul and Valerie Piazza.

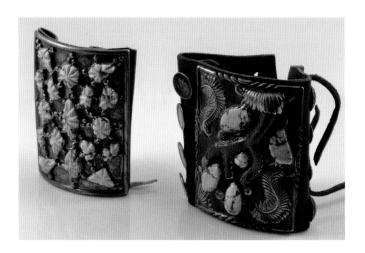

Two early bowguards with organic designs, Zuni, ca. 1920s–1930s. Courtesy of Bill and Minnie Malone.

Defining the Word "Bead"

Beads are "universal" in that they are found throughout the history of mankind and were made by peoples on every continent. Prehistoric beads were carved and shaped from bone, antler, wood, shell, and local stone. Although most people visualize beads as being round or ovoid, they come in a variety of shapes. The best definition for a bead is that it is "a little ball of any suitable material intended to be strung with others."[10] Lois Dubin observes that beads are among the "first durable ornaments" of human choice and are notable for being portable, varietal, and valuable to their owners, making them visually dynamic adornment.[11]

In a primal sense, a bead has special connotations through the fact that while most often (but not always) round, it has a central passageway that must be pierced, or perforated, for stringing. A bead becomes a "center place" when made of sacred materials, and such adornment can also become a sacrament. Beads are meaningful according to the use made of them, and archaeological investigation shows that early peoples of the Southwest created extensive trade networks beyond their region to obtain prized materials for bead making.

Beads retain a sacred sense in Pueblo life, especially when bead necklaces are worn for ceremonial dancing. Yet, beads can be employed in a fully secular sense as adornment for sale to non-Native consumers. Pueblo jewelers have been successfully creative in using the bead form for a variety of wearable art creations. One example is the development of "cornrow" beads for use on bracelets and rings. Beads inspire variations on jewelry forms, from "corn" kernels on the ends of *jaclas* to tab pendant earrings.

How Should We Define *Heishi*?

Heishi is the Keres word for "shell." The ancient residents of the American Southwest fashioned the first shell necklaces; archaeological evidence shows that these people engaged in extensive trade as far as the California coast and the west coast of Mexico to obtain these shells. Shell *heishi* possessed sacred meaning, and the handmade creation of a shell necklace or pendant was a skilled, laborious process. Sometimes, bits of natural stone would be added to the necklace's string.

By the historical era of the Southwest, Pueblo people created *heishi* (also known as *heishe* or *hishi*) that incorporated other natural materials such as turquoise, jet, coral, and pipestone into its design. When a marketplace developed for sale to non-Natives, Pueblo jewelry makers permitted the term *heishi* to apply to any handmade necklace using these traditional materials.

The operative word here is "handmade." *Heishi* has become a label for handmade Native American beads in general. Some dealers and collectors point to the rich sound of the word: it connotes exotic and painstakingly detailed work. Southwestern-made beadwork is strikingly different from the wampum-stringing traditions of the East and the fine lazy-stitch beading done by Oklahoma and Plains tribes; yet, all these forms of beads share the same eye for design and physical coordination for construction. Trade has continued through the centuries between the different cultures relating to beading materials and finished products. Talented Native bead makers not from Southwestern cultures, such as Marcus Ammerman and Teri Greeves, have found the region to be a profitable marketplace and continue to do so at today's Indian arts shows.

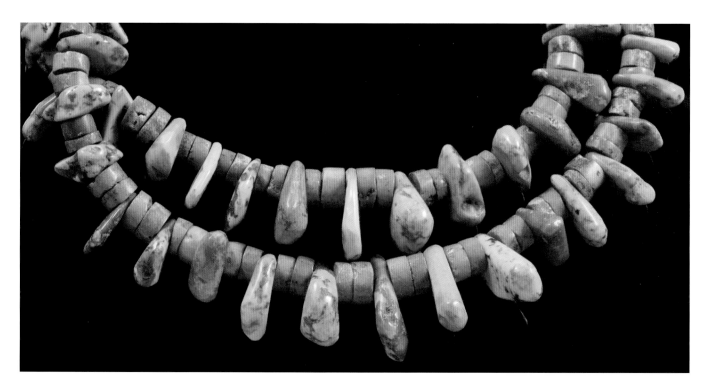

Close-up of two-strand green-and-blue turquoise
tab *heishi* choker, mid-20th century.
Courtesy of Suzette Jones.

Full view of choker.

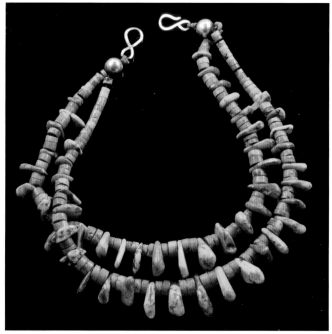

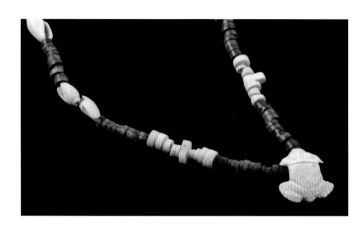

Early historic-era white shell frog pendant with dark and light shell beads. Courtesy of Andrew Munana Collection.

By the mid-twentieth century, however, the low end of the Indian jewelry marketplace adapted the term *heishi* as a shorthand for any bead necklace put together by an Indian. This use of the term allowed sellers to throw a blanket of authority over necklaces strung with cheap manufactured materials that bore no resemblance to the authentic item, which was now a form of ideal. Some makers went along with this sloppiness because the term furthered the object's salability. Unfortunately, buyers in ignorance of the truth found themselves applying this term to mass-produced necklaces sold by Indians at roadside rest stops.

As a consequence, the term *heishi* has become falsely applied to goods in today's marketplace, not unlike the label "old pawn." Sellers of Indian jewelry, and many Natives themselves, will call a beaded necklace *heishi* simply because the beads were put together by an Indian and the product resembles the genuine article in a general way. Those collectors who seek out real *heishi* should be aware that they will pay more for the better-quality materials and the Native artistic skill and patience employed in making the necklace by hand.

This means that an honest appraisal of *heishi* making should take in both the finely made artistic version and the lower-end "wannabe" adornment. A genuine evaluation of *heishi* must reflect this reality. In fact, the lower-end jewelry has real value as costume jewelry, and a historical means whereby Natives made affordable items for the market that they greatly appreciated as much-needed income. When we remember that this market is about wearable art, the discrepancies become simply matters of degree.

Defining Design in Pueblo Adornment

Pueblo motifs were appropriated in the early to mid-twentieth century to build a new, vigorous American design canon. This movement coincided with educators' desire to identify American modernist design that incorporated indigenous and New World imagery both for artistic and patriotic purposes.[12] Consequently, our examination of Pueblo jewelry design using shell, stone, and, later, metal requires a look at the intense non-Native study of Pueblo pottery. These pottery motifs were extracted to characterize American Indian design in general, and such generalizations found their way into the Southwestern (and beyond) education system.[13]

When twentieth-century master jewelers such as Michael Kabotie, Charles Loloma, Lewis Lomay, and Julian Lovato discussed the artistic features of their creations, they neatly demonstrated how adornment once meant for sacred ritual purposes could be transformed into secular wearable art. Their relatively spare words also underscored how Pueblo jewelry makers could safely operate in two modes: one stream of production would continue to create adornment with ceremonial and religious purpose, while a second and larger stream went for sale to outsiders. Sometimes when a necklace outlived its ritual purpose, it could even go into the market because it had lost its original associations.

This brings us to the underlying issue that is responsible for much of the meaning behind the misassumptions quoted at the start of this chapter. The early- to mid-twentieth-century non-Native patrons and writers were grounded in anthropological and ethnographic outlook; when Indian jewelry became part of a huge

Classic eight-strand coral *heishi* with turquoise and white shell beads, strung with two turquoise *jaclas*, 1890s. Courtesy of Territorial Indian Arts.

commercial marketplace, one that allowed Native incomes and careers to be sustained, non-Native disappointment figures in their subsequent commentary. They felt that Indian jewelry and its design were purest when made only for traditional Indian consumption. They believed that the Fred Harvey Company, manufacturers, and curio stores represented forces that would harm or pollute Native design.

This viewpoint was, of course, inevitably doomed to be short-sighted. The rapid shifts in technology that mark our modern era were driving American Indians, along with everybody else, to new ways of seeing. Late-twentieth-century (post-1980) Natives considered themselves artists and created jewelry with design that melded legacy and avant-garde purpose. There was still room for those Indians who were more comfortable as craft practitioners, making old-style designs for grateful consumers. The truth lies in the fact that *Native jewelry makers have always been in control of their design*. In many respects, too, this applied to those Indians who worked in shops turning out non-Native-directed motifs—many of them with roots in Pueblo design.

Two pendants by Mary Tafoya (Santo Domingo), 10" each: (l.) square with serpentine backing, 2011; (r.) insect, 2014. Courtesy of Suzette Jones.

· · · · · · · · · · · · · · · · · · · ·

Now that we have defined our subjects of interest, we can move ahead to the rest of this book. Chapter 1 will examine the Pueblo worldview as it relates to our knowledge of jewelry design. The motifs, colors, shapes, and other viable patterns that go into forming bead jewelry have their origins in nature, and an excellent shorthand definition for much Pueblo design is "organic." However, nat-

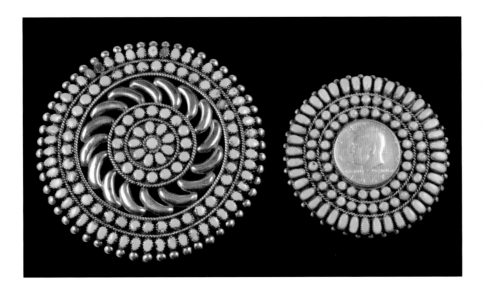

Two large Zuni cluster pins: (l.) 6" 1960s; (r.) JFK half-dollar coin, 1967. Courtesy of Bill and Minnie Malone.

ural phenomena we would call nonorganic are also represented in design. Happily, we can "read" these designs in a manner that allows us to respect Pueblo cultural aesthetics without intruding into matters that are not meant for outsiders.

In chapter 2, we begin with the true stuff of *heishi*: white clamshell, and look at its ancient origins. Chapter 3 focuses on the addition of other highly valued materials, including turquoise and local stones. The grinding and shaping of such materials entailed different approaches, often leaving loose pieces, and became fodder for mosaic and other forms of inlay.

In chapter 4, we see how the mechanics of stone carving, shaping, and decoration gave Pueblo makers an edge in the production of lapidary work. Gifted artists taught others how to work with these natural materials. The bead form could be the genesis of fine stonework set on various materials, and increasingly in silver. The various abstract and material images created from lapidary work are the subject of chapter 5. In chapter 6 we see how the cross-cultural artistic currents of the early twentieth century influenced Pueblo design. Pueblo silverwork, as seen in chapter 7, reflects its makers' lapidary heritage but is not diminished by it. And finally, in chapter 8, we see that Pueblo jewelers retain an edge in contemporary design, wedding tradition, and exploration.

One final word. Since the jewelry work of the Pueblo peoples, past and present, is a living art, this book's survey must take in all the levels of quality produced for the marketplace. While many readers may prefer to view only museum-quality or high-end Pueblo creations, this would not be telling the whole story. One of

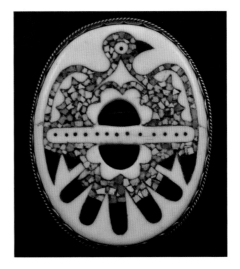

Pueblo inlay scarf slide, set in silver by Frank Patania Sr., who trained many Pueblo smiths, 1950s. Courtesy of Karen Sires.

the greatest pleasures of Native-made jewelry is how such work can be accessed in a variety of price ranges. The genius of Pueblo jewelry design also lies in its democracy of production; to this day, consumers may be able to purchase and enjoy fine adornment that is both unique and affordable. For those with deep pockets, truly dazzling creations can also be obtained, and a specific collector market exists for these works. After we examine the history of modern Pueblo jewelry-making ingenuity and enterprise, we can agree that this is truly "American" wearable art.

Birds on fetish necklace strung with commercial materials, ca. 2000. Private collection.

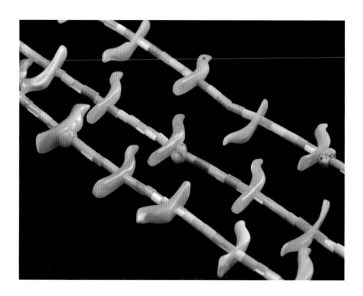

Two popular Pueblo earring styles: (l.) Hopi overlay with cab "beads"; (r.) herringbone mosaic circles, 1960s–1970s. Courtesy of Elizabeth Simpson.

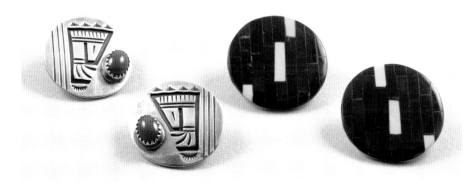

Two multistrand *heishi* necklaces by Joe Caté (Santo Domingo): brown baby olive shell, late 1990s; white clamshell, 2000. Courtesy of Eason Eige Collection.

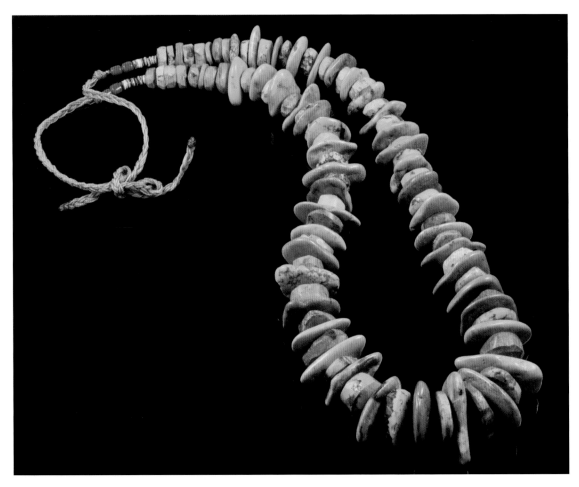

This turquoise chunk dance necklace was hand shaped and polished by Robert Rosetta (Santo Domingo), ca. 2005. Courtesy of Eason Eige Collection.

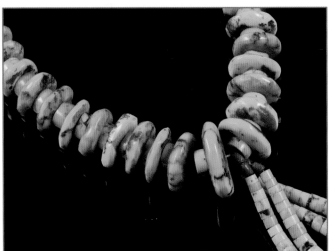

Pueblo artists are adept in fashioning beads from nontraditional materials: two gaspeite necklaces, ca. 1990s–2000. Private collection.

Turquoise dance necklace, ca. 2000.
Courtesy of Eason Eige Collection.

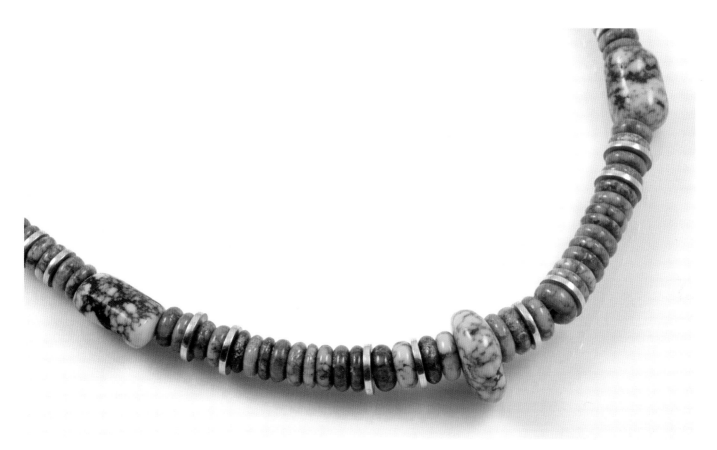

High-grade Lone
Mountain turquoise and
golds mark this artful
creation by Charles
Supplee (Hopi), 1980s.
Courtesy of Abby Kent
Flythe.

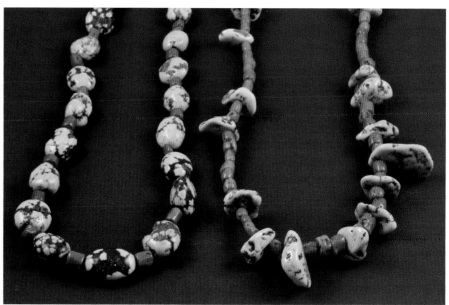

Turquoise and coral
compose a "traditional"
pairing of materials,
mid-20th century.
Author's collection.

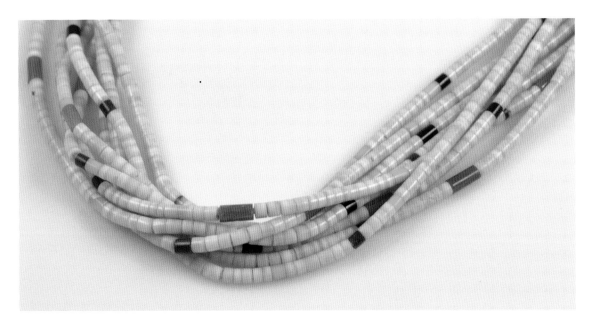

Eight-strand melon shell and green turquoise choker, 1950s–1960s. Courtesy of Paul and Valerie Piazza.

Notes

1. Personal communication, August 4, 2016. Jones is a McNair Scholar studying Native American art history at the University of New Mexico and is going on to graduate work. Of Zuni and Cochiti descent, he represents the future of discourse on Native arts.

2. Farnham, Emily. "Decorative Design in Indian Jewelry." *Design* 35 (March 1934), pp. 23–24.

3. Adair, John. *The Navajo and Pueblo Silversmiths.* Norman: University of Oklahoma Press, 1944, p. 172.

4. Neumann, David. "Modern Development in Indian Jewelry." *El Palacio* 57 (June 1950), p. 173.

5. Underhill, Ruth. *Pueblo Crafts.* Lawrence, KS: Haskell Institute; Bureau of Indian Affairs, 1953, p. 123.

6. Bedinger, Margery. *Indian Silver: Navajo and Pueblo Jewelers.* Albuquerque: University of New Mexico Press, 1973, pp. 172–173.

7. Ortiz, Alfonso, ed. *Handbook of North American Indians.* Vol. 9. Washington, DC: Smithsonian Institution Press, 1979, p. 603. J. J. Brody is the author of this quote.

8. Art-historical methodology has been successfully applied to Native American artistic and cultural production by art historians Janet Berlo and Ruth B. Phillips, among others, in the last quarter of the twentieth century. There is an understanding that since Native values are non-Western in origin, other signifiers must to be used to develop art-historical examination, which has often been focused on patronage and how Native artists deal with Western-based art establishments (e.g., museums, art schools).

9. The term "survivance" is the creation of Native scholar and social critic Gerald Vizenor. The best definition of this term occurs in *Survivance: Narratives of Native Presence,* edited by Vizenor (Lincoln: University of Nebraska Press, 2008). It is a merger of the terms "survival" and "resistance." The word demonstrates a process of ongoing change that pertains to design as well as words. When applied to Indian jewelry design, its creators move into the future by transforming the past—a "restorative return" that invests Native artists with collective creative strength.

10. Orchard, William C. *Beads and Beadwork of the American Indians.* 2nd ed. New York: Museum of the American Indian, Heye Foundation, 1975, p. 15.

11. Dubin, Lois Sherr. *The History of Beads: From 30,000 B.C. to the Present.* Rev. and expanded ed. New York: Abrams, 2009, pp. 9–10. Dubin explains how beads are compelling to handle and sort, and typical of items found in ancient graves around the world.

12. The story of a search for a national design mode was prompted by the same currents that brought Art Deco to America, whereby the style was transformed into something uniquely American, as in the case of New York's skyscrapers. The same mood helped Pueblo Deco become a new architectural and interior decoration choice. Various factors were in play, including America's cut-off from European art during World War I, and a desire for new patriotic visual roots.

13. The identification of strong indigenous American design matched the desire to create a national design curriculum for education of American students in the arts. The roots for educational use of Pueblo design arose after significant national expositions and world fairs, and from the production of various books of illustrated American Indian design, many compiled by ethnographers.

Full view of early-20th-century green turquoise mosaic necklace with found materials and unusual *naja*. Courtesy of Karen Sires.

Close-up of *naja* and tabs.

Santo Domingo Depression-era-style bird pendant on gypsum beads, ca. 1940s–1950s. Courtesy of Karen Sires.

"I picked and chose what I wanted to use, keeping in mind who I was, where I came from, and my culture. I didn't want to uproot myself."

— **Raymond Sequaptewa** (2007)[1]

THE PUEBLO VIEW OF THE WORLD is rich, complicated, and relevant only to those born into that culture. Those outside their ethnicity rely on what visual and design aesthetics the Pueblo peoples choose to share. Fortunately, their vision touches us deeply. This may be because two of the strongest creative elements that mark the Pueblo worldview are respect and observation. The physical world—nature—is their source for design, not unlike that of other cultures. We all share a bond with the planet we occupy.

The term "design" is both a noun and a verb. We speak of things having a design, whether natural or manmade, and we also talk of designing things. Design also implies organization. The Pueblo worldview is deeply organized on many levels. Ideas and social concepts vary among the Pueblo groups, but they share similar feelings for materials and their purposes.

A word that often occurs in outsiders writing about Pueblo design is "fluidity." This reflects a Pueblo tendency toward the circle, spiral, or curved line, as opposed to the firm geometrical lines espoused by early Navajo jewelry designers. Certainly, design principles have become shared over the years. The first non-Native writers on Southwestern Native jewelry design frequently termed Pueblo design as being "organic." Fluid design employs curved lines of a sinuous nature, lines that seem to possess an effortless flow as seen on pottery. But the word "fluid" can also mean adaptable: Pueblo design possesses an inherent flexibility in its re-creation of the natural, or organic, world.

Ironically, this fluidity in vision does not account for the Pueblo social structure, which is fixed and communal, not individual based. A Pueblo child is born into a society where his or her frames of reference are dictated by custom and practice. Anthropologists have labored long to describe and make systematic the Puebloan worldview; these descriptions are not always successful, since there are subtle complexities and differences depending on which Pueblo culture group is studied. Nor have non-Native investigations been generally approved or appreciated by the Puebloans themselves.[2]

That very disapproval also underscores a significant point about the Puebloans. They are a conservative, private people who have been very badly treated by the various dominant European American cultures that took over their region. Spanish conquerors enslaved them, Spanish missionaries sought to rip away their religion, and each successive government has done little to prevent Pueblo mistrust. Along the way, Pueblo artistic achievements have proved to be a bridge or common ground between differing cultures. Nevertheless, non-Natives, who wrote about and professed to champion Pueblo arts from the late nineteenth century to the mid- to late twentieth century, still often managed to get their facts wrong.

In April 2016, the Indian Pueblo Cultural Center (IPCC) in Albuquerque, New Mexico, celebrated its fortieth anniversary by renovating its permanent museum exhibit, devoting time and attention to a narrative that would satisfy non-Native curiosity about their culture without violating any of that culture's principles. The exhibition, called "We Are of This Place: The Pueblo Story," covers the nineteen pueblos of New Mexico, since the Hopi of Arizona have their own cultural center. A review of this exhibition and

Design and the Pueblo Worldview

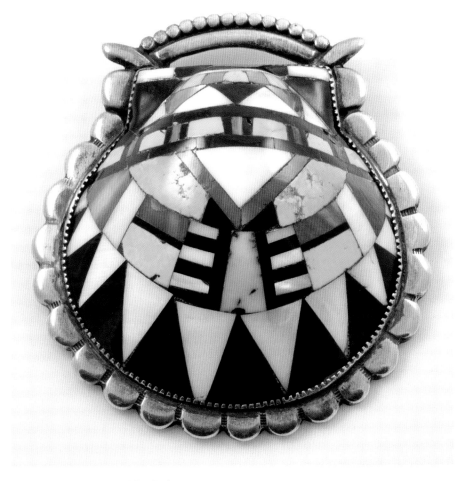

Shell set with abstract pattern inlay, Zuni,
1940s–1950s. Courtesy of Karen Sires.

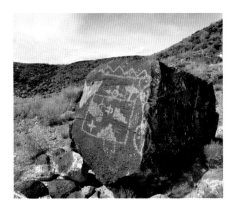

Petroglyph "symbols"
are sources for design.

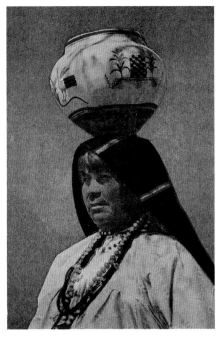

Postcard showing how
Pueblo women wore
beads for all occasions,
1910s. Private
collection.

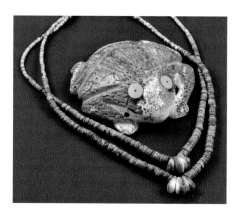

Two elongated *jaclas* converted into a choker, tipped with shell "corn," 1930s. Private collection.

its printed guide offers us an authentic opportunity, frank and candid, to learn about the forces that shape Pueblo values.

What we also discover is that this presentation tallies with the author's design history theory of the universal bead as a means of explaining the cyclical Pueblo worldview. Pueblo belief is circular or rounded, like a bead, with perforations that allow expression to go in and come out. Seasons are anchored by a calendar of activities, practical and ceremonial. The Pueblos all share an origin story about a place, often a sacred lake, where the people emerged into the Middle World. A Pueblo child also emerges from the womb to begin a journey that continues even after death, with the spirit now a protective guide for the living.

The bead can also symbolize the self-contained sacred spirit of the Earth. Respect for and observation of the land leads to an obligation to care for the Earth and its life-giving gifts. Non-Indians have long praised Native Americans for possessing an ecological awareness of conserving natural resources and animals; Pueblo culture is concerned with ensuring a balance that includes not just the Earth, but the universe, too. In 2016, during the writing of this book, many Pueblo individuals traveled to South Dakota to support the stand against the Dakota Pipeline routing that threatened Native and local water supplies.

One of the ways respect and observation are shown is in the seasonal dances. These vary according to need: for example, the butterfly and harvest dances occur in the spring and summer, while the buffalo and deer dances take place in winter.[3] What the dancers wear is important, so the choices of adornment are meaningful.

Pueblo dancing has often been responsible for the creation of large-scale jewelry pieces that stand out nicely, enhancing the wearer and his or her prayers.

Other aspects of the Pueblo worldview that have relevance to jewelry design are shared storytelling to direct actions and belief, and social respect for family and community. Especially at Santo Domingo and Zuni, twentieth-century families have shared and adopted specific designs and techniques created by older relatives. This has proved maddening to non-Native collectors who want the exact makers' names, but Puebloan design ownership is more flexible than in other Native cultures.

Pueblo peoples also have long memories. Their suffering at the hands of Spanish, Mexican, and American overlords has tested their resilience. Anthropologists of the past have demonstrated cultural insensitivity and intrusiveness in the name of being helpful. At the IPCC, Pueblo "perseverance" is particularly praised, along with a tactful acknowledgment of Pueblo-Catholic practice in present-day communities (made visible by the church usually built on pueblo grounds).

Other factors mentioned at the IPCC include the ongoing challenges of tribal sovereignty, maintaining water resources and rights, tribal tourism, Native wellness, and endangered Pueblo languages. It's interesting to note that the exhibition's points about tourism relate to revenue from casino gaming, resorts, and recreational opportunities, while the profitable ethnic Indian arts market is not mentioned. This is probably because the Pueblo concept of "art"—as non-Natives know it—doesn't exist.[4]

Installations tell the story at the Indian Pueblo Culture Center, Albuquerque, New Mexico.

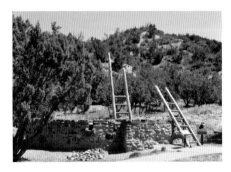

Gisewa Pueblo, 14th century CE, with remains of a reconstructed kiva and its ladders to the right, Jemez National Monument, New Mexico.

In recent years, the author personally has known a number of Puebloan individuals who have put their jewelry-making careers on hold when asked to perform duties for their pueblo's governors. This sense of obligation and responsibility is a very firm aspect of their worldview. In terms of artistry, also, such an attitude promotes respect and observation for everything essential. Their worldview acknowledges that personal expression is made stronger by the deep sense of responsibility individuals possess for their culture, which their rituals help keep in order. When Anglo-run juried art shows began in the 1920s, persons singled out for awards faced disapproval at home; over the last forty years, however, Pueblo societies have developed a more accommodating outlook toward the role of the artist.

Nevertheless, Puebloans remain on guard constantly, as the peoples strive to keep specific religious and communal activities private. At this point, it's wise to remind readers that this privacy is very important—outsiders do not have a place in these rituals, and unlike other Native cultural worldviews where sharing is permitted, it is essential for the well-being of the Pueblos and their sacred duties that an impenetrable curtain remains in place. This need has influenced the use of certain designs and motifs in all the arts, with jewelry making no exception. The march of time, however, has softened some previously firm prohibitions. The increased depiction of *katsina*-like figures began gradually in the 1960s and 1970s and is always accompanied by special care not to approximate authentic reproductions.

Early on, non-Native observers such as Bertha Dutton recognized that the representations of supernatural beings in dances

North-central New Mexico. Puebloans have a strong sense of "place."

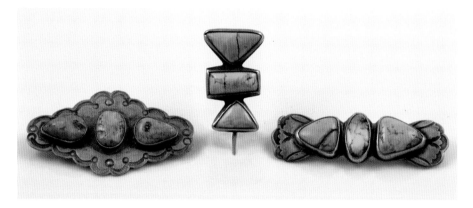

Three pins: the two horizontal are manta pins, probably Acoma-made adornment, ca. 1910s. Courtesy of John C. Hill and Linda Sheppard.

and ceremonies were impersonations.[5] The imitators were aided by costumes, paint, and masks that could be altered to shield the genuine immortal. In the same vein, dancers acted as mediators for the sacred spirits they impersonated. When the commercial and tourist ethnic art markets became more firmly established in the early to mid-twentieth century, traders and curio store owners pressed Pueblo jewelry makers for depictions of these spirits, seeing them as colorful and highly salable.

Careful compromises were achieved. Canny jewelers appropriated petroglyph-like figures, corn and *olla* maidens, popular dancers including those wearing *tablitas*, and secular male and female forms. Pueblo jewelry makers also seized upon Hopi girls with their hair in traditional whorls, and even non-Pueblo figures such as Apache *Gan* dancers, with their striking lattice-like headdresses. Zuni jewelers were under particular pressure to come up with eye-catching figures; they chose two minor deities, the Knifewing (*Achiyalatopa*) and Rainbow Man, which quickly became classic designs. Decades later, Zuni inlayers had fun making comic characters from television and cartoons (before the heavy hand of the Disney Company descended on the pueblo).

Military service, television, and increased college attendance broadened the experiences of Pueblo youth in the latter half of the twentieth century. Popular culture, with its own cult of celebrity, became a stronger influence on Native young people. In many ways, Pueblo youngsters had an advantage; they learned to balance their emergent individuality with respect for their all-encompassing Native upbringing. When discussing the remarkable creativity

of Pueblo jewelers in the last few decades, the author feels that their sense of belonging in the world around them has paid off in a mainstream-dominant society where so many people struggle to find their own identity. However, this does not mean that I am romanticizing Pueblo society. They have not been immune to the dark forces that attack their people along with mainstream America: they suffer from alcoholism and other diseases such as diabetes, drugs and gang activity, the PTSD that accompanies military veterans home from active duty in America's wars, lack of economic opportunities, and other maladies.

When addressing design and Pueblo worldview, it's also essential to discuss the role of color. The seasons have their own colors, and so do Tewa (and other) moiety societies. Red and white are associated with winter, and Tewa individuals are even permitted to wear a large amount of silver during that season, but not in the summer months.[6] Warm materials linked with summertime colors include yellow shell, green stone, and black (jet and other black stone) beads.[7] Color meaning is diversified throughout the pueblos, and artists employ favored hues and tones in their works according to tradition. One very popular combination is white, black, red, and blue (or abalone, jet, coral, and turquoise): these colors can be seen in the highly popular sun face design motif.

Above all others, shell is a symbol of life and existence (see chapter 2 for a more in-depth discussion). Other meaningful design elements and motifs derive from Puebloan tributes to sacred landscapes, food, water, and jewels from the earth (jet) and sky (turquoise). These are the primary design sources, along with

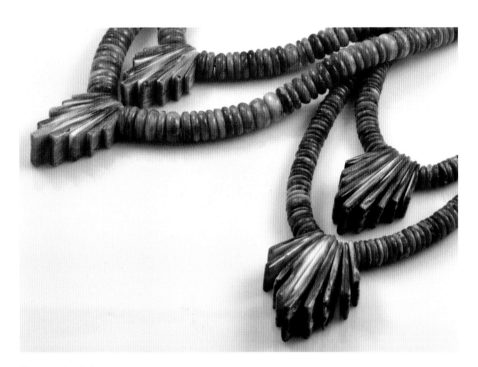

Close-up of central
pendants on two spiny
oyster shell dance
necklaces,
1960s–1970s. Private
collection.

Full view of necklaces.

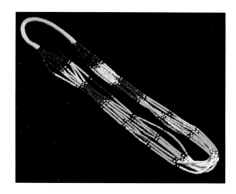

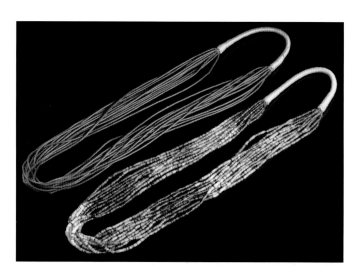

Modern "*heishi*" found in many Southwestern gift shops, 2015. Author's collection.

These necklaces were found at an I-40 tourist shop near Laguna; purple *heishi* is Navajo made, 2016. Author's collection.

animals associated with rain and water (frogs, lizards, sacred serpents) and animals whose flesh sustains Pueblo life (rabbits, deer, bears). Design, especially in jewelry, shows how all these symbols of the peoples' survival are significant to their culture.

Design elements used in adornment tend to make shorthand illustrations of the natural forces they represent. Pueblo elements combine the straight line and the more fluid round curves, or hooks, for repetitive border design. The bead, in the form of a circle, often appears rather like punctuation. The results, when mixed, are stately rather than unassuming. An uncanny affinity with mainstream Modernist motifs exists in work between 1920 and the 1940s and will be discussed in chapter 6. It's important to remember that in a physical world populated with the spiritual, some elements such as clouds can represent the spirits of the dead, while others, such as cornstalks, embody life-giving energies. Unsurprisingly, jewelry makers choose symbols that combine nature, society, and self.

The Navajo, later entrants into the American Southwest, adopted and adapted many aspects of Pueblo culture to suit their own purposes. One aspect of culture they shared was the belief in adornment—especially from fine materials—as "jewels." This term, found both in Pueblo and Navajo songs and stories, refers to turquoise and other valued stones. Later on, Navajos included silverwork both as jewels and "hard goods." This had to do with their system of credit and pawn developed from trading with non-Native-owned trading posts. The pueblos had fewer close relationships with traders since trading posts were usually established on or

close to the sprawling Navajo reservation, with the exception of Zuni, where traders managed to gain a presence in the pueblo.

As mentioned previously, this book is not about treating Pueblo jewelry made for private religious and ceremonial purposes; that has never been my story to tell.[8] This may disappoint some collectors, but the truth is that most jewelry made today by Southwestern Natives, including the Pueblos, is intended for public consumption as true artistry. That changes the nature of design intentions. Since the individuals who make this jewelry are artists, the designs they choose to create are secular in purpose even if they refer to aspects of sacred meaning. For Pueblo artists, who live a life endowed with strong sanctified associations based on their unique worldview, this means they share what is revered and sincere—a gift to the wearer.

In fact, if we borrow the Southwestern Native concept of "jewels," we purchase Pueblo adornment that is self-enhancing and also a display of materials with spiritual value. If we embrace the Puebloan conception of the world as being "timeless," unfolding according to a pattern that is preordained and reinforced by their rituals, then we are partaking of their essential blessings to keep our planet in balance—of conserving our world and its living creatures.[9]

Puebloan artisans serve as ambassadors of sorts to those who view their arts sold under the portals of the Albuquerque and Santa Fe plazas. They are licensed in those cities to sell their wares in these locations where tourists congregate. The variety and quality of such goods is remarkable; jewelry, in its best and worst guises, is on

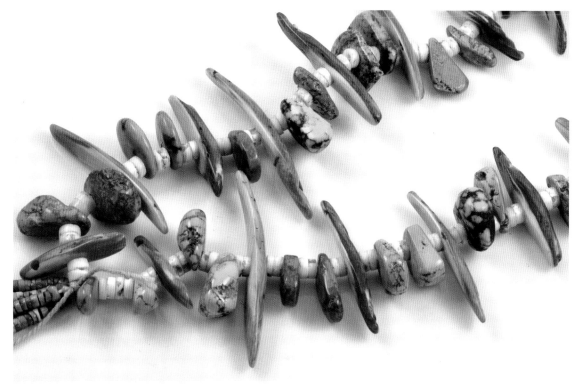

Single-strand necklace
from Santo Domingo,
1900: long-cut shell
slivers were popular
1800s wear. Courtesy of
Suzette Jones.

Fine-art interpretations
of *heishi*: (top) Veronica
Poblano, (bottom)
Marian Denipah, ca.
2010. Private collection.

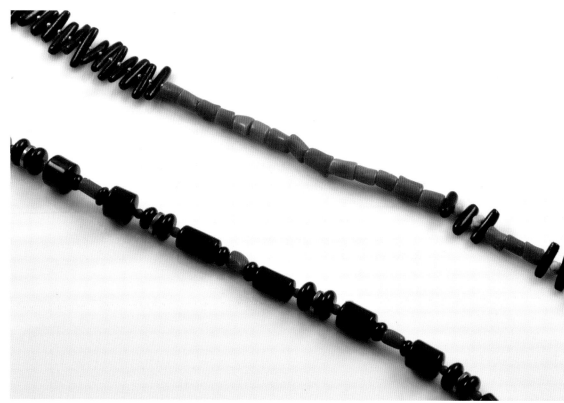

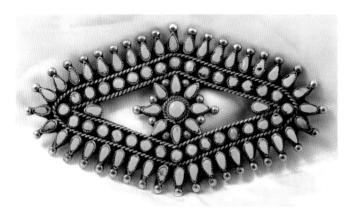

Diamond-shaped Zuni pin, 4" wide, shows beads as cabochon designs, 1940s. Courtesy of Suzette Jones.

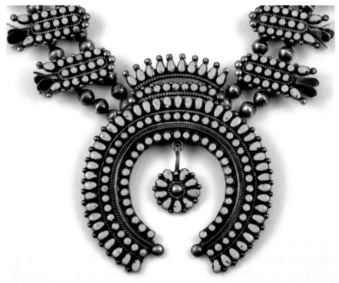

Small-stone Zuni snake eye and petit point squash blossom necklace, 1935–1945. Courtesy of Eason Eige Collection.

display to interested consumers. For many newcomers, this is their first look at *bona fide* Indian arts. In this respect, they are following a tradition that began a century ago when visitors began arriving in the Land of Enchantment.[10]

To look at the allure of Pueblo worldview, let's go back to the early twentieth century. Unlike their Navajo and Apache neighbors, the Pueblos had remained peaceful and unthreatening during the last decades of the nineteenth century. They were favorites with the first era of tourist providers (such as the Fred Harvey Company) and with the non-Native artists drawn to New Mexico, many of them Social Realists from the East. These artists painted romanticizing views of the Southwest's Native peoples, and a number of their models were Puebloans, posed in solitary splendor such as Maynard Dixon's *Earth Knower* (1933) or in a group performing ceremonial dancing as in Ernest Blumenshein's *Dance at Taos* (1923).[11]

Therefore, the Puebloans were well positioned to be the subjects of non-Native admiration for the apparent beauties of their rituals and spirituality. This meant, of course, that Pueblo theology was ripe for misrepresentation because of its unworldliness and otherworldliness. Pueblo adornment, in particular, caught non-Native attention precisely because of the mix of materials, colors, and design motifs that betokened hidden spiritual meaning. In the early 1990s, the author was attending the SWAIA Annual Indian Market in Santa Fe and was afforded a glimpse of what Pueblo artists have long had to contend with. A Hopi jeweler at his booth was subjected to a protracted, insistent interrogation by a young Anglo woman who wanted to know just what exactly his designs meant spiritually in his culture. The artist managed to be kind and patient, but the woman's neediness was clearly wearing him down.

We, in the twenty-first century, must move past such demands. Native art *is* art and therefore is subject to the same respect as all other forms of art and design. The misuse of "Indian spirituality" needs to become a thing of the past. Those who live and work in the Pueblo worldview have much to offer, and those who receive their creations should employ the same level of respect and observation in accepting them.

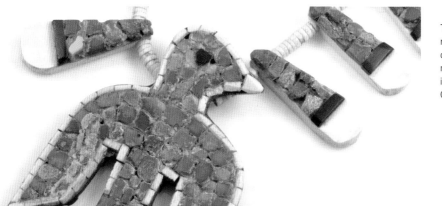

The thunderbird has many guises in Pueblo culture: bone with mosaic and black-plastic inlay, 1920s–1930s. Courtesy of Karen Sires.

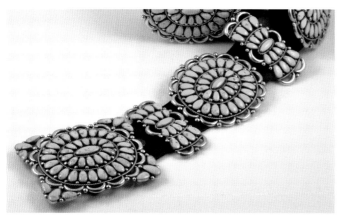

Concha belt with fine turquoise cluster work by Alice Quam (Zuni), 1970s. Courtesy of Bill and Minnie Malone.

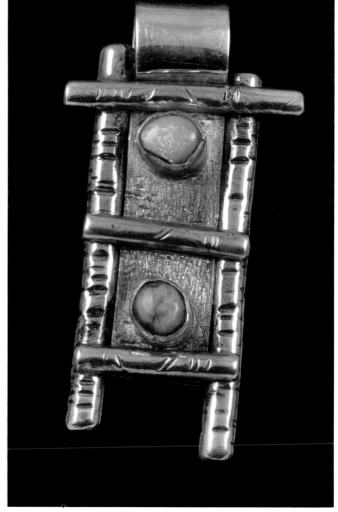

Kiva ladder pendant by Roy Tenorio (San Felipe), 2016. Private collection.

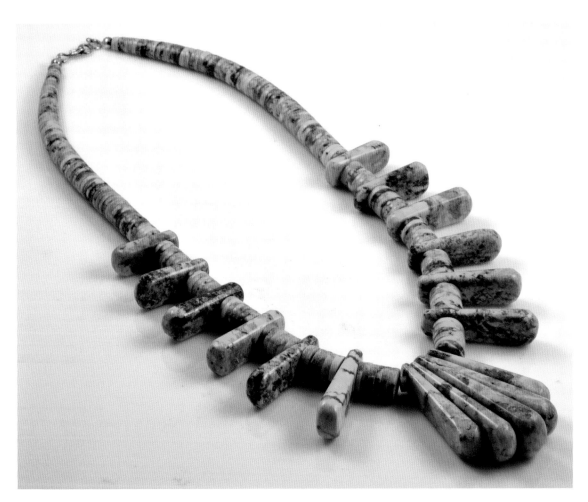

Turquoise dance necklace in classic design by Lupe
Lovato, mid-20th century. Author's collection.

Detail of 1980s Zuni
fetish necklace, showing
carved birds. Courtesy
of Steve and Mary
Delzio.

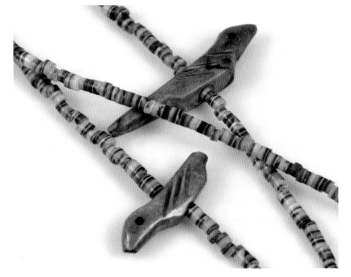

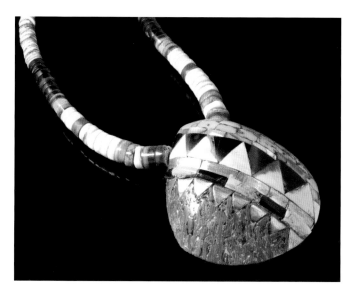

Large 4" mosaic and inlaid shell with handmade disc beads, 1930s. Courtesy of Steve and Mary Delzio.

A fine two-strand showing Native taste: trade beads and turquoise tabs, *jaclas* tied at bottom, 1910s. Courtesy of Andrew Munana Collection.

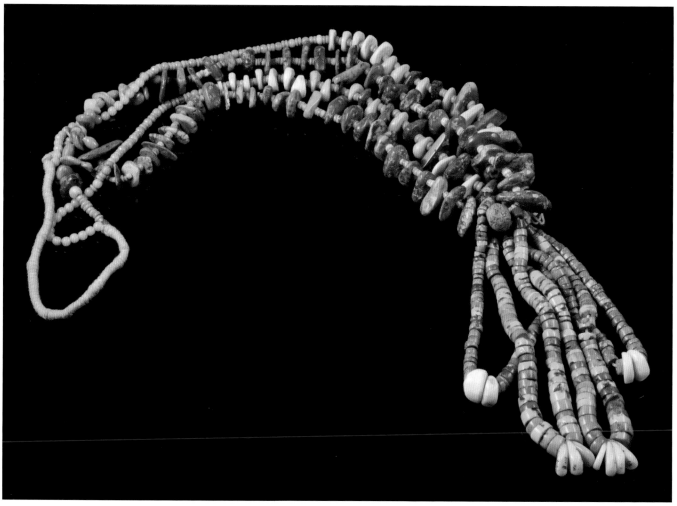

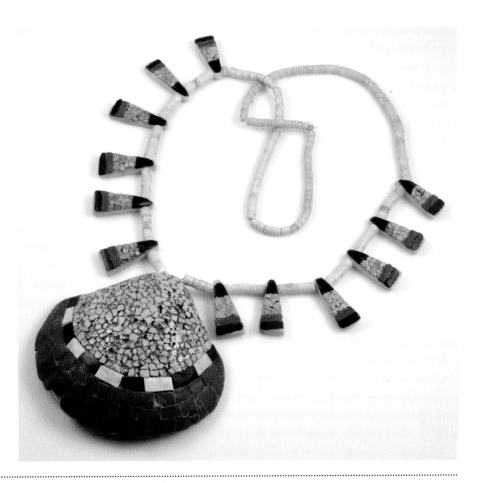

Inlaid large shell pendant, 1950. Courtesy of Karen Sires.

Notes

1. Bahti, Mark. *Silver + Stone: Profiles of American Indian Jewelers*. Tucson, AZ: Rio Nuevo, 2007, p. 161.

2. Pueblo informants have always been fewer in number than Navajos and other tribes. The author became aware during the years of research needed for this book that there was a great gulf between the works of non-Native anthropologists and the few scholars in this area of Pueblo birth. While their styles vary from lyrical (Alfonso Ortiz) to matter of fact (Joe Sando) to practical (Edward Dozier), these men write in a manner that is less burdened with preconceived assumptions, and more redolent of the truth, than their non-Native colleagues.

3. *We Are of This Place: The Pueblo Story*. Exhibition guide. [Albuquerque, NM]: Indian Pueblo Cultural Center, 2016, [p. 6].

4. In fact, the IPCC exhibition touches on the fact that Pueblo culture classifies art with utilitarian function, as in the making of pottery.

5. Dutton, pp. 42–43. The appearance of these *katsinas* had to do with functions ranging from upholding nature to providing social discipline.

6. Ortiz, p. 34.

7. Ortiz, p. 105.

8. Since I began researching and writing on the topic of Native American jewelry in the late 1980s, I have always adhered to the belief that ceremonial jewelry with private religious meaning was off-limits to investigation. America's Indians have had enough of their privacy violated over the last two hundred years and more; it's to their credit that Southwestern Natives devised artful jewelry for an ethnic art market, and that they have built and maintained a strong economic foothold through this wearable art.

9. Eggan, Fred. "The Pueblos: An Introduction." In *Handbook of North American Indians*, p. 234. This great purpose is the animating factor in Pueblo cultural conservatism. While its leaders do accept social change, such change comes slowly, and always with restraint and many tests. What makes things so interesting, now in the twenty-first century, is how well Pueblo youth have adapted to modern technology and creative flair while still accepting their culture's traditional function to keep the world in balance.

10. Hoerig, Karl A. *Under the Palace Portal: Native American Artists in Santa Fe*. Albuquerque: University of New Mexico Press, 2003. This interesting study shows that Native artists hold more power as vendors than tourists might expect.

11. These paintings romanticized the Pueblo Indians and also acted as a draw for tourists. They contributed to the non-Native idea of the Puebloans as "peaceful Indians," in comparison to other tribes who had been subdued late in the nineteenth century.

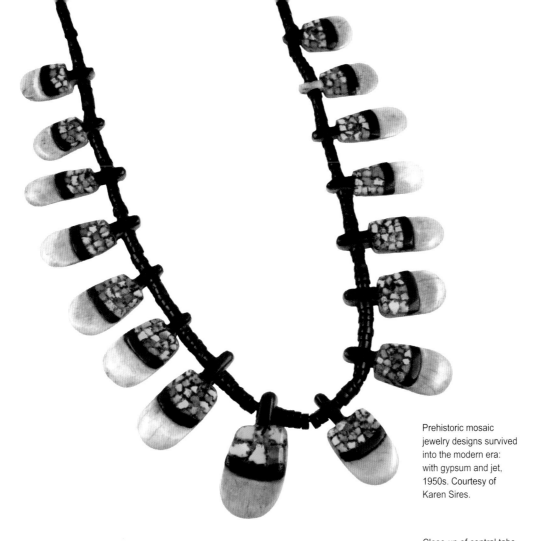

Prehistoric mosaic
jewelry designs survived
into the modern era:
with gypsum and jet,
1950s. Courtesy of
Karen Sires.

Close-up of central tabs.

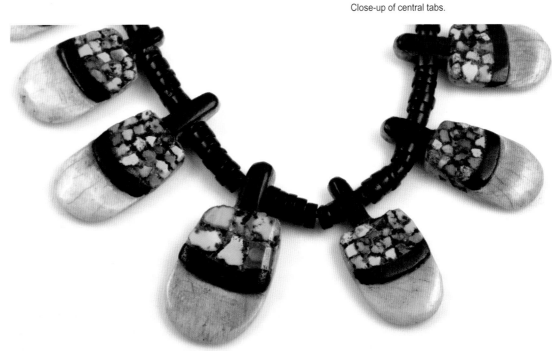

> *"There is a design in living things; their shapes, forms, the ability to live, all have meaning . . .*
> *Our values are indwelling and dependent on time and space unmeasured. This in itself is beauty."*
>
> —**Popovi Da** (1971, 1976)[1]

THE EXAMINATION OF EARLY PUEBLOAN shell and stone beads was often left to perfunctory documentation by archaeologists, who found a profusion of these materials at settlement sites throughout the Southwest. Linking evidence of this ancient craft to present-day lapidary work was not a priority. Since the first non-Native scholars did not wholly connect early peoples with the current Pueblo population, the heritage of bead making remained neglected. By the time that the Ancestral Puebloans (formerly known as the "mysterious" Anasazi) were established in the population's mind, metalwork jewelry dominated both the marketplace and books on the subject.

Yet, a closer study of beads made by the Pueblo peoples, past and present, shows us that this process significantly affected the creation of skilled lapidary work *and* metalwork. The carved and shaped bead inserted itself into the design psyche of Pueblo jewelers and influenced Navajo work as well. With stone and silver being the predominant jewelry materials in demand, researchers interested in documenting this living art tended to overlook or bypass Pueblo bead making as worthy in its own right. Native artists, however, never lost sight of the bead's effectiveness, nor did they forget the sanctified properties of shell as well as turquoise.

There is universal agreement on one point: Natives and non-Natives alike understand that shell is a deeply meaningful material to the Pueblo peoples, past and present. Its presence in ancient settlement and burial sites throughout the American Southwest confirms this point. However, shell could not be found naturally in such a landlocked region. Native peoples traveled long distances, to the California Baja and even to the Gulf of Mexico, or traded with those who traveled there and returned with varied types of shells for barter and usage.

The prehistoric Southwest was home to Paleo-Indian peoples as far back as 9000 BCE. Sometime around 300 CE, groups of Native peoples settled in various areas of the region. The three largest of these cultures were the Hohokam, the Mogollon, and the Ancestral Puebloans. The latter also occupied the largest range of land: from central New Mexico through the Four Corners region.

All three culture groups wore shell adornment. From a single scallop shell tied around the neck with yucca string to multiple strands of minute beads shaped and strung with painstaking care, shell bead pendants and necklaces were ornaments of choice. The prevalence of these objects in local ruins signals their importance as life-giving symbols of water.[2]

This association of white shell with ruins can spin us into a fantasyland of speculation about why an object of water could be so dear to the hearts of those in a harsh desert environment. The shells themselves are housing or carapaces of an absent organism, but it is the power of their color that is suggestive too. Our more romantic imaginings see these objects as dreamlike connections to a long-lost Atlantis, where the white-capped waves of the sea echoed the snow-topped crest of great mountains. They also resemble the bleached white bones of those who have passed into spirit form. This whiteness leaves behind a sense of wonder, which is recollected into ornament most blessed.

Heishi: Sacred White Shell

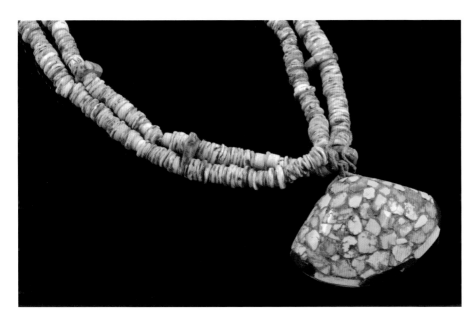

Prehistoric-era two-strand 13" necklace with mosaic inlaid on white clamshell. Courtesy of Suzette Jones.

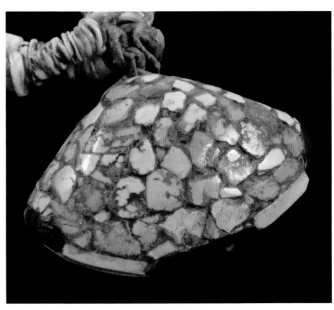

Close-up of inlaid clamshell; jet and pink stone added later.

Prehistoric-era clamshell on handmade beads with small white shell tabs. Courtesy of Andrew Munana Collection.

As early as 8800 BCE the early Archaic residents of the Southwest were wearing necklaces strung with olivella shells and small animal bones.[3] The most-popular necklace forms were either beads wrapped choker-like around the neck or suspended in a string down to the breastbone.[4] Round olivella or tubular dentalium shells predominated. This form of adornment was well fitted to people occupying a semiarid land; shell's durable, portable, and aesthetic qualities tied to religious values ensured its survival into the historic era.

Archaeological sites yielded impressive physical evidence. At Chaco Canyon Cultural Center, spiny oyster shell pendants unearthed at Pueblo Bonito date to ca. 1000–1200 CE. Nearby Chetro Ketl held ten caches of black-and-white necklaces; four of these caches possessed necklaces with 1,588, 1,940, 1,724, and 1,797 tiny beads.[5] Splendid carved beads emerged from Hawikuh Ruin, visually absorbed by Zunis working at the excavation site during 1917–1923. Shell carving could also be quite sophisticated: two human figurines made by Hohokam artisans for trade were found in 1932 at the Swarts Ruin Mogollon culture site.[6]

Shell bead forms varied widely in shape and color. White clamshell was the dominant color, and its popularity survived into the historic era. The abundant olivella shells lent themselves to round disc shaping. Prehistoric disc beads contain a rectangular drill hole considered "characteristic" of the Southwestern region; each very tiny bead, even those no more than three-quarters of an inch in diameter, required individual drilling.[7]

Bead shapes, however, extended beyond the disc form. Prehistoric-era beads could be barrel-like, cylindrical, figure eight (from bilobed shells), globular, and irregular shaped. Laevicardium, Gylcymeric, and Spondylus shells were usually cut and shaped into discs. Two popular bead shells from the Gulf of California were the Nassarius (univalve with shoulder ridges) and the more smoothly shaped Columbella or Dove shell.[8]

Another enduring shape was the tabular bead, worked not just in shell but also in stone and turquoise. The tab could be cut and shaped as an oval, or trapezoidal, or even a triangular form with its edges rounded. Tab beads were most often strung at intervals along a necklace with differently shaped beads.

The colors of these shells run into light and dark spectrums. Various shades of white, from bright white to cream color, move into tones of grays and browns. The latter can range from pale tan to almost opaque dark brown. Pink hues, from light to dark, can even be confused with coral. Bead makers take care in choosing shell colors. Olivella shell can either be dark or light in tone. Other preferences move from white clamshell and iridescent mother of pearl to melon shell. Spiny oyster shell runs from yellow, orange, and pink hues to red and purple.

The Ancestral Puebloans exhibited strong abilities in carving and decorating shell. Marine shells in particular lent their forms to such embellishment. Early surface decorating involved etching shells with the acidic vinegar of the saguaro fruit.[9] Incised shell surfaces could also be filled in with black pigment. In addition, the Ancestral Puebloans employed a form of mosaic inlay that would

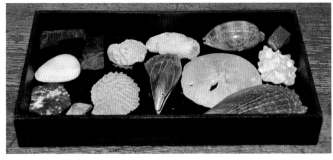

Box containing ancient shell and stone. Courtesy of Utility Shack, Albuquerque, New Mexico.

A variety of shells in the rough. Courtesy of Utility Shack, Albuquerque, New Mexico.

survive and be revived by their descendants. Fragments of shell and stone, usually turquoise, would be placed together on a backing to form a pattern. A fine example of such mosaic work was recovered from the Aztec Ruins site in the Four Corners region; one whole shell was inlaid with a striking chevron motif.[10]

Shell beads were created from clever carving work. Such adroit carving and shaping are directly related to the same skills used for inlay—and set the stage for the inherited versatility that Puebloans demonstrate today. In fact, bead making was the genesis activity that led to the historic-period Pueblo peoples' subsequent reputation for brilliant lapidary work in shell and stone.

The bead maker sliced shell into strips and then used a hand tool to cut these strips into small squares. Both prehistoric and early historic-era individuals used a flat stone—commonly sandstone—to roll, rub, and shape the squares, which have been strung together. When these materials are being rolled over the stone, water and grit are added to abrade the rough edges.[11]

Nowadays, the sandstone slab has been replaced by a turning stone wheel. Whether old or new, this shaping process leads to more than half of the original material being lost. The skilled bead maker controls the size and fineness of the bead shape by his or her hands, allowing for some beads to chip, crack, and spin off the wheel.

Bead perforations in shell tend to be bigger than those made in stone. Prehistoric-era shell beads were drilled with a desert cactus spine needle. Early bead necklaces could be strung on a variety of natural fibers, from wild cotton to yucca plant. Rounded beads had central holes drilled but tab beads could be pierced at the top or

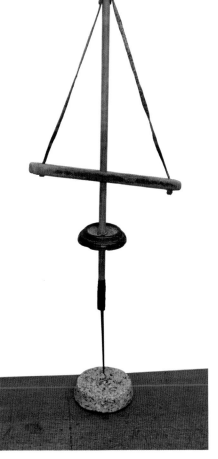

Pump drill used for drilling holes in beads. Courtesy of Utility Shack, Albuquerque, New Mexico.

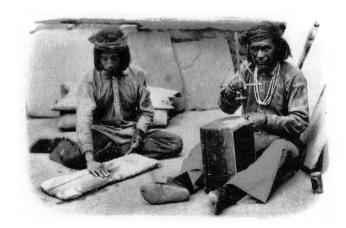

Postcard of Zuni Indians drilling shell beads, ca. 1910s. Private collection.

narrowest center, as were pendants meant to hang vertically. If the pendant was meant to serve as horizontal adornment, then perforations were made at each end.[12]

People fascinated by beads of the early historic era were particularly intrigued by the Puebloan usage of the pump drill. This device survived into the late nineteenth century, despite its inherent awkwardness, and has been revived for limited present-day usage.[13] Constructed from two wooden shafts crossed at the center, it operated as a drill by revolving the bottom piece for piercing, while adding water to the action. When used to drill holes in beads, the crosspiece was pulled downward, allowing a long leather thong on the shank to spin until the thong twisted in the other direction. The vertical shaft was tipped with a stone point, a nail point, or a piece of steel file. With fingers placed on the wooden crossbar, which resembled a bow, the drill end is pumped up and down with the help of a stone (often a piece of pottery) that keeps the device in motion. Pushing in a smooth, steady manner, the drill will create precise holes for stringing beads.[14]

Shell occupies all of the human five senses. Sacred shell, intended only for ceremonials, could strengthen wearers who revered its qualities. Pueblo priests made use of shell fetishes, drank from white-shell medicine bowls, and blew on conch shells.[15] Shells rattle as they hang from prayer sticks, and conus shells tinkle on a dancer's garments. Ropes of shell beads, along with strings of scallop shell, flash in the sun while adorning ceremonial dancers and spectators alike. Wet shell smells like rain, or the sea. Shells can also be cool or warm to the touch.

When the Pueblo people see, hear, smell, touch, or taste this sanctified material, they appreciate that shell beads are the jewels of their origin stories. Its pure glow suffused the trappings of Big Shell Chieftain and Hard Substance Woman—known at Zuni as White Shell Woman.[16] Finely shaped and carved shell is one of the primary legacies of Puebloan aesthetic design vision. Their bead makers have generously shared shell's properties with all of mankind, especially when they allowed *heishi* to be sold commercially. Shell rightly means *heishi*, and, as we will see, its beauty defines adornment of the finest quality.

Elsie Parsons, in her famous study of Pueblo religion, understood the primary role shell played in adornment for ritual purpose. At one point, she names the materials of most demand for those taking part in dancing. This list has not varied over the years: "In dances there is always a great display of necklaces consisting of white shell, turquoise, coral, abalone shells, silver, or blue yarn."[17]

Shell also takes us back to the Ancestral Puebloan era, to the earliest creations of those people. Pride in the past, in Native heritage, still motivates today's artists. They may make more use of brightly colored yellow, orange, or purple spiny oyster shells or red coral shell from ocean beds, but the purity of white shell remains the ideal. When we look at the future of shell adornment, whether it is a carved bird for a necklace or a strand of hand-rolled *heishi* beads, one element in particular stands out. E. W. Jernigan wrote about this element, pointing out how early artistry would take hold in the "reduction of natural form to stylistic form."[18] Such artistic invention would prove timeless.

Postcard of Pueblo woman wearing white shell beads for everyday chores, ca. 1910s. Private collection.

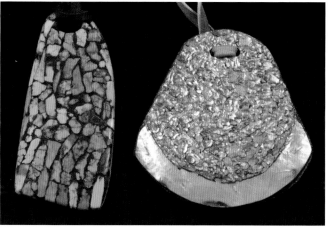

Ancient mosaic work, including abalone inlay on white clamshell. Courtesy of Eason Eige Collection.

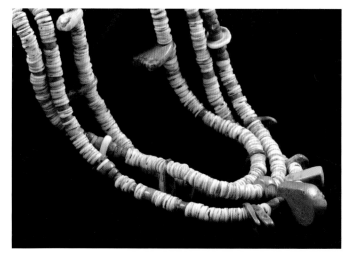

Nineteenth-century hand-pump-drilled tabs on three-strand white clamshell *heishi*.
Courtesy of Suzette Jones.

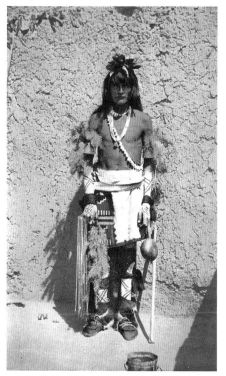

Postcard of Santo Domingo man dressed for the Corn Dance, wearing white shell adornment, ca. 1908. Private collection.

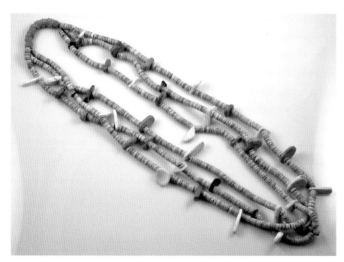

Nineteenth-century three-strand shell necklace with clamshell and natural turquoise tabs. Courtesy of John C. Hill and Linda Sheppard.

Close-up of beads and tabs.

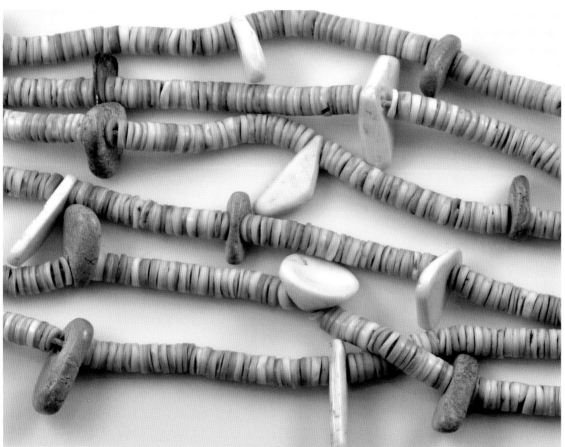

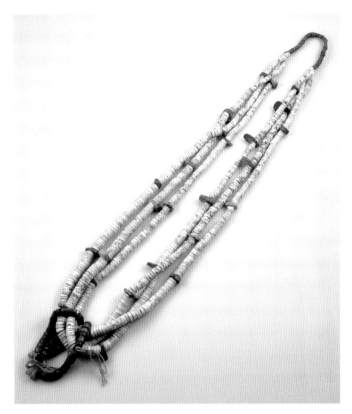

Close-up of two white shell necklaces. Courtesy of John C. Hill and Linda Sheppard.

Another 19th-century three-strand bow-drilled white shell and natural turquoise tabs necklace, 15" with two green stone *jaclas* and white shell "corn." Courtesy of John C. Hill and Linda Sheppard.

Mid-20th-century Zuni necklace is the twin of a necklace collected at the pueblo in 1900 by a University of Pennsylvania expedition. Private collection.

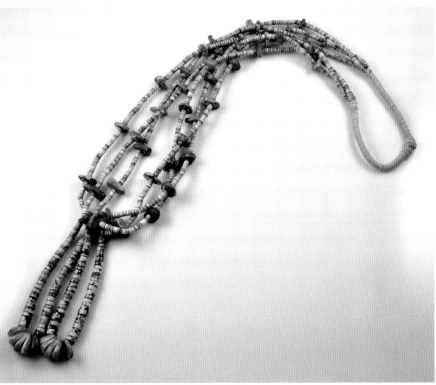

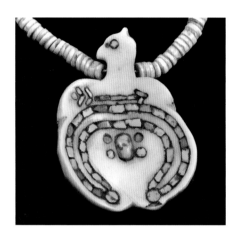

Early Zuni bird pendant (note the *naja*-style body) made from inlay on shell, ca. 1910. Courtesy of Karen Sires.

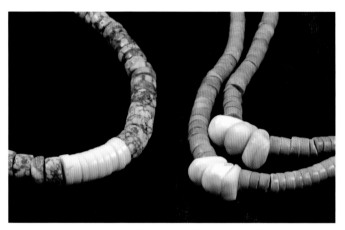

Two turquoise *heishi* necklaces showing white shell: (l.) at center bottom and (r.) as "corn" kernels, early 20th century. Courtesy of Laura Anderson.

Santo Domingo necklace with turquoise chip mosaic, gypsum and jet beads, and unusual square pendant, mid-20th century. Courtesy of Karen Sires.

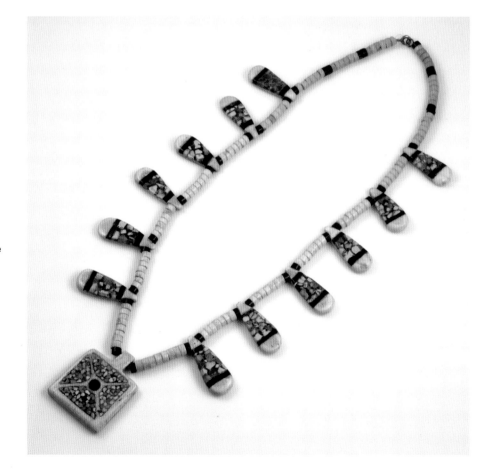

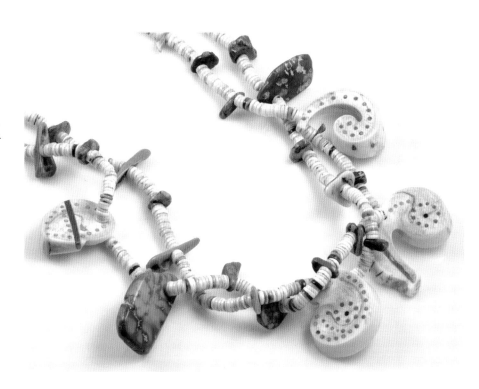

Two-strand Santo Domingo white shell necklace with Cerrillos turquoise and cross-section cut snail shells, first half of 20th century. Courtesy of Karen Sires.

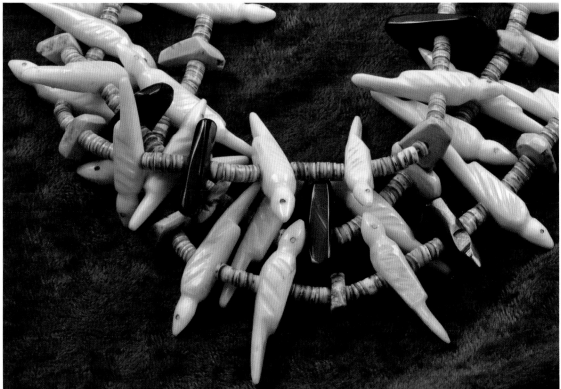

Three-strand bird fetish necklace from Santo Domingo with olive shell *heishi* and birds carved in white shell and jet. Courtesy of Suzette Jones.

Close-up of white shell strand with mosaic turquoise tabs, mid-20th century. Courtesy of Karen Sires.

Fossil white branch coral bead choker, mid-20th century. Private collection.

Playful carved-bone steer heads and bone *naja* pendant, ca. 1930s. Courtesy of Karen Sires.

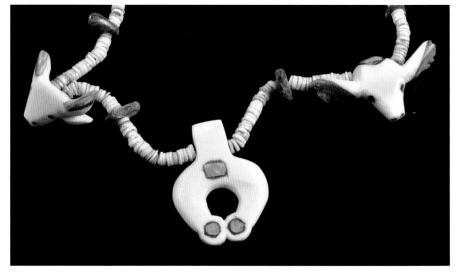

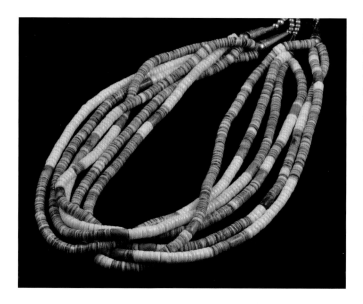

"Traditional" six-strand choker with white olivella shell and green turquoise beads strung in interval patterns, 1970s–1980s. Private collection.

This five-strand white clamshell necklace by Sharon Abeyta (Santo Domingo), ca. 2012, even glows in the dark! Author's collection.

Jolene Bird's thirteen-strand olivella shell choker with turquoise drum-shaped beads set at intervals pays tribute to older styles, 2016. Private collection.

Notes

1. Sando, Joe S. *The Pueblo Indians*. San Francisco: Indian Historian Press, 1976, pp. 182–183. Popovi Da was the son of famed potters Maria and Julian Martinez of San Ildefonso. Da painted, created pottery, and fashioned silver jewelry; he was a keen advocate of Indian artists using traditional modes.

2. Orchard, William C. *Beads and Beadwork of the American Indians*. New York: Museum of the American Indian, Heye Foundation, 1975, p. 19. The author notes that Puebloans use shell beads found in local ruins of their ancestors.

3. Dubin, Lois. *North American Indian Jewelry and Adornment: From Prehistory to the Present*. New York: Abrams, 1999, p. 466.

4. Jernigan, E. W. *Jewelry of the Prehistoric Southwest*. Santa Fe, NM: School of American Research, 1978, pp. 20, 38. Intriguingly, today many Pueblo jewelers make attractive multiple-strand chokers, using beads and silver, that are little different from ancestral designs.

5. Fox, Nancy. "Southwestern Indian Jewelry." In *I Am Here: Two Thousand Years of Southwest Indian Arts and Culture*. Santa Fe: Museum of New Mexico, 1989, pp. 68–69.

6. Jernigan, p. 115.

7. Jernigan, p. 33.

8. Jernigan, p. 43.

9. Ezell, Paul. "Shell Work of the Prehistoric Southwest." *The Kiva* 3.3 (December 1937), pp. 9–12. Many non-Native anthropologists made notes about Pueblo facility with inlay, including Cushing at Zuni.

10. Jernigan, p. 190.

11. Orchard, p. 32.

12. Fox, p. 63

13. Underhill, Ruth. *Pueblo Crafts*. Lawrence, KS: Haskell Institute; Bureau of Indian Affairs, 1953, p. 121. She provides one of the best descriptions of this tool, which quickly faded from common use by the 1920s. The pump drill clearly requires a lot of stamina and muscle to keep making repetitive motions.

14. Ibid.

15. Tyler, Hamilton A. *Pueblo Gods and Myths*. Norman: University of Oklahoma Press, 1964, p. 178.

16. Parsons, Elsie Clews. *Pueblo Indian Religion*. 2 vol. Lincoln: University of Nebraska Press, 1939 (reprinted in 1966), vol. 1, pp. 168, 177–179. Shell appears in many Southwestern Native cosmologies, often as adornment on deities and sacred spirits.

17. Parsons, p. 401.

18. Jernigan, p. 234.

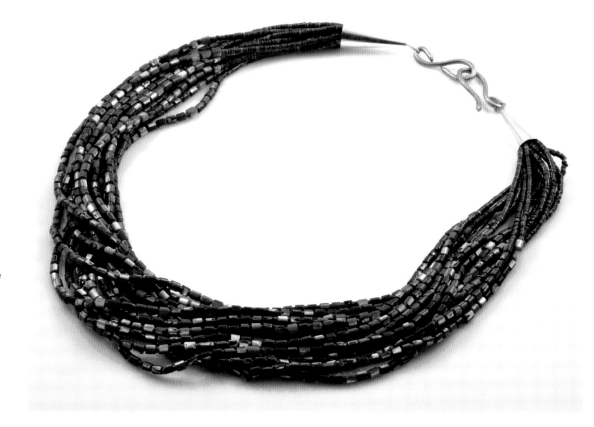

Green baby olivella shell choker by Janice Tenorio (Santo Domingo), 2016. Private collection.

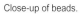

Close-up of beads.

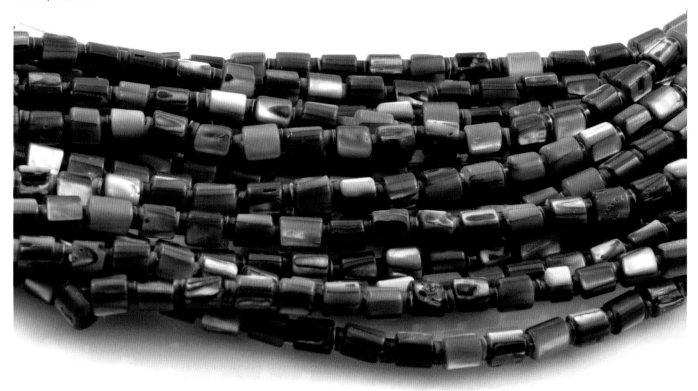

CHAPTER 3

*"I like to challenge myself. After buying turquoise
I have to think what I can do with it. The material tells you what it can be."*

—**Ray Lovato Sr.** (2007)[1]

OF COURSE, SHELL WAS NOT ALONE as a sacred material. Turquoise, jet, pipestone, and hematite, among others, can be included in the Pueblo repertoire of minerals with spiritual properties. Objects made from these stones also appear in prehistoric-era sites. Pueblo stories don't speak of turquoise as the Sky Stone, but as an object related to the Earth. These stones, along with white shell, reflect colors of the Six Directions.

Scores of books and exhibitions have been devoted to the various hues of turquoise, from a deep rich green (an early preference) to a light vivid blue. Even the matrix elements in the stones have value. Untreated natural turquoise ages the stone's color becomingly. While not faceted, the beauty of turquoise made it as lustrous as any fine jewel.

Originally, *heishi* referred exclusively to beads made of shell. However, turquoise and jet were also prime bead materials. When stones became integrated into bead and jewelry making, they gradually became referred to as *heishi* as well. These stones, semiprecious or not, proved much harder to work than shell.

Turquoise soon became as beloved as shell, since the Pueblo people believed it made wearers more attractive and desirable.[2] An ancient center for mining was located in the north-central Cerrillos, New Mexico, area at Mt. Chalchihuital and Turquoise Hill. Turquoise was a popular trade good too. Excavators found 50,000 pieces of turquoise alone stored in Pueblo Bonito, in the Chaco system, along with a beautifully shaped turquoise necklace and a basket of inlaid mosaic work.[3]

Other local stones were utilized for adornment. Chief was black jet, a form of lignite or cannel coal. Jet and brown pipestone were softer to work than shell or turquoise. The ancient cultures of the Southwest also worked argillite, hematite, serpentine, and steatite; a popular prehistoric necklace style was one constructed from black and dark-gray beads with red accents of hematite.[4] A spectacularly complex necklace made by Ancestral Puebloans between 1225 and 1300 CE, now in the collection of Arizona State Museum, contains 15,000 tiny hand-drilled disc beads made from argillite, steatite, and turquoise.[5]

By the historic era, Pueblo bead making was a widely acknowledged expertise. The compact unity of smoothly shaped beads strung with a pleasing sense of contrast between pale or colored shell and stone made the acquisition of such necklaces highly desired. Ancestral Puebloan mosaic inlay, incorporating turquoise and jet, would survive into, and be revived in, modern times. Most important of all, the Pueblo genius for fine lapidary work was firmly inborn; Pueblo jewelry design was widely admired throughout the region—and beyond.

Fashioning beads from turquoise, however, took longer than carving shell beads. Turquoise is a harder material and requires more time to drill, grind, and polish. Both ends of a bead, including faces and edges, must be treated one at a time; the sides also required a longer process when being polished. Making disc beads of turquoise could become particularly tedious and time consuming, so many turquoise beads are shaped into oval forms. Since

Beads of Turquoise and Many Colors

Turquoise multistrand *heishi* by Chris Nieto (Santo Domingo), ca. 2010. Author's collection.

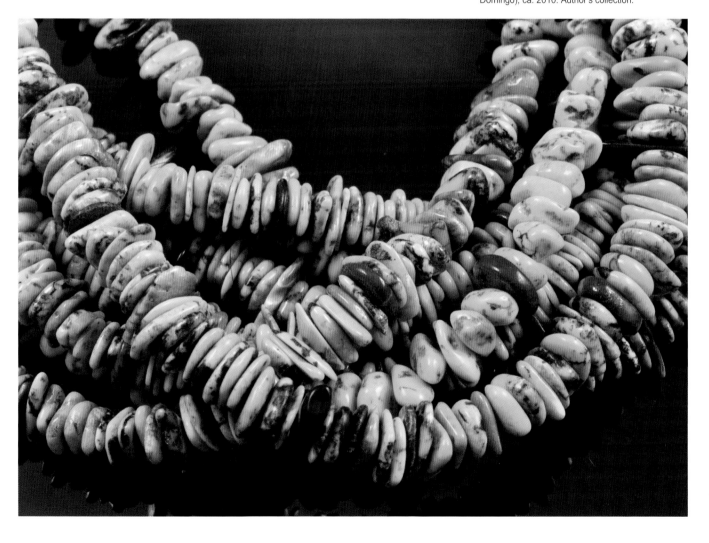

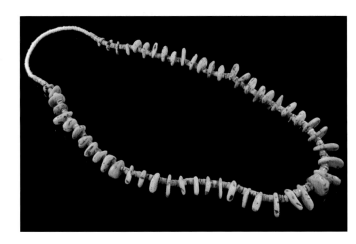

This single strand of green stone turquoise tabs on turquoise *heishi* was popular with Native wearers, 1940s. Courtesy of Suzette Jones.

turquoise breaks more easily than shell, jewelry makers save this material to use for inlay.

Nick Rosetta of Santo Domingo, interviewed in 2007, described how one of the bead-shaping processes could prove difficult: "Grinding is the toughest. I keep track of bead size and consistency by relying on feel. I do it with my eyes closed."[6]

Pueblo bead makers have been traditionally creative in choosing substitute materials from local resources, especially when regional turquoise and jet grew scarcer by the mid-twentieth century. Harking back to an Ancestral Puebloan practice, their descendants use alabaster stone and even gypsum in place of white shells.[7] In the 1930s and 1940s, Santo Domingo bead makers famously used rubber along with phonograph record plastic as substitutes for jet and onyx. We might say that Pueblo people's conservation tactics make them one of America's first recyclers!

Inevitably, the need to find new materials became a challenge Pueblo jewelers met with aplomb. They accepted stabilized and synthetic alternatives to natural turquoise. Imported coral, in round or tubular bead forms, either raw or polished, from the Mediterranean and Japan replaced red stones and shells when they became unavailable. Often, bead makers chose red glass beads to replace scarce coral. Glass beads proved useful substitutions initially and later became materials of choice. Eventually, minerals from far away, when imported for use, included lapis, opal, sugilite, and even precious gemstones.

Traditionally, when Pueblo bead makers created multiple-strand chokers, they tended to be made all in one color; this was a holdover from prehistoric times, when many-strand necklets were made from tiny jet or black seed beads.[8] Material pairing, however, also had origins in the past, as in the Mogollon culture practice of mixing turquoise and spiny oyster shell.[9]

On the other hand, Pueblo use of colors in stones did not extend to matching colors and sets until the non-Native market was well established. At that point, bead makers (and silversmiths) exercised a willful tendency to place differently colored stones in a piece of jewelry. Color requirements were based on the piece being intended to be seen from a distance (as at a dance); when shell discs and oval turquoise beads were strung together, this would usually form a pattern of intervals so the materials and colors would contrast well with each other. Shell disc beads and turquoise tabs, set at intervals, proved to be another popular pattern.

Color possessed symbolic and aesthetic meaning. The colors of the Six Directions had their corresponding materials. As early as 1822, a Mexican army report mentions that the people of San Felipe wore dark-red beads.[10] By the later nineteenth century, new choices were in place. For example, coral replaced red argillite. A deep ox-blood-red color was popular, as seen in a ca. 1936 necklace handmade by Leekya Deyuse with rich ox-blood-red coral beads, now in the Heard Museum.

While the prehistoric era had established prototype necklace forms that were handed down to Pueblo descendants—long strands of shell and stone, multiple-strand chokers, and necklaces with a central pendant feature—artisans working in the historic period began devising new styles based on the bead. In addition,

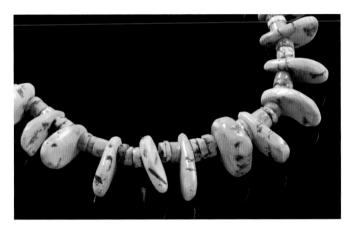

Close-up of beads and tabs.

Fred Harvey postcard of a Pueblo Indian drilling turquoise beads, ca. 1918. Private collection.

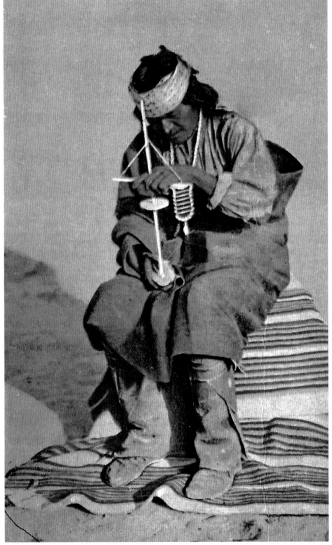

Pueblo trade expanded from intertribal consumers to new demand by non-Natives.

These changes were moderate through the early to mid-twentieth century. The early Indian traders and curio store owners were not looking for radical departures from conventional forms. In fact, Pueblo potters and weavers were under increasing pressure from non-Native patrons to keep their creations as "traditional" as possible. Yet, Pueblo design ingenuity had a way of manifesting itself. By the last quarter of the twentieth century, individual artistry emerged as a desired impulse. Those who followed the Southwestern Indian jewelry market were unsurprised that Pueblo artists often led the way.

Zuni, in particular, was noted for its expert early- to mid-twentieth-century stone fetish carvers whose creations could be strung with *heishi* or set in silver jewelry. Leekya Deyuse (1889–1966), Leo Poblano (1905–1959), and Teddy Weahkee (1890–1965) knew how to grind their carved stones or inlay into flat bases to fit a silver bezel or plate setting.[11] Leekya and Weahkee were workers employed at the archaeological excavations of Hawikuh Ruin, giving them a ringside seat to study the carved stone artifacts as they came to light.[12]

Before their innovative designs, however, Pueblo beadwork and necklaces split into three design streams. The first stream consisted of revival style (or legacy) creations based on the ancestors' works; because these were made later, however, they utilized contemporary materials and evoked a flair more suited to the present. A necklace from Santo Domingo made between 1940 and 1950 might

Pueblo ring with turquoise mosaic inlay showing lapidary skill, 1930s–1940s. Courtesy of Karen Sires.

be inlaid with shell, jet, and turquoise and modeled on a Hohokam mosaic pendant found at an archaeological site. More-unusual bead shapes, such as large "drum" beads and less common forms of Gulf shell, also fit this category of design. Even cord necklaces strung at the throat with a few distinctive beads pay tribute to their Ancestral Puebloan legacy.

The second stream offered traditional modes altered by intertribal (especially Navajo) influence and demand. Turquoise-disc bead necklaces grew popular, sometimes mingled with distinctive coral and shell beads, most often with an alternating or repeated element. The impact of the non-Native market can be seen in changes of necklace and bead scale, along with an increase in pendant focus compositions. Perhaps the most imaginative recasting of old design was the twentieth-century fetish necklace, complete with carved beads in animal shapes. Santo Domingo fetish necklaces used birds (the only permitted animal in that pueblo) based on the stylized forms produced in the prehistoric era. Zuni, however, soon outstripped the other pueblos with its renditions of single and multiple birds and other animals. Popular Zuni fetish necklaces expanded to include frogs, bears, horses, and a variety of creatures.

The third design stream has provided many challenges for Pueblo jewelers. Carving shell and stones has enriched much post–World War II invention, especially when added to metal. The activities involved in bead shaping transfer remarkably well to the metalsmithing process. Since turquoise and silver are the predominant materials of Southwestern Native American jewelry making,

their shaping owes much to Pueblo craft. Many Pueblo-made silver beads are artfully textured in homage to the organic bead form. The bead lives on in decorative silverwork touches such as raindrops, decorative doming, and skilled repoussé. Lapidary innovation is the subject of chapter 4.

Intertribal interaction with Navajo neighbors helped transform the beaded *jacla* (a transliterated Navajo term), worn in the past by men and women as earrings, into a pendant attachment. Here, Pueblo playfulness added corn kernel–shaped beads, in various colors from white to red, to the bottom of the *jacla*—adding fertility symbolism to the adornment.

Turquoise retained a special place in Southwestern Indian jewelry making, secured by the fashionable nature of the material itself. Turquoise hues flatter dark and pale skin. We will see in later chapters how the power of fashion became a prescribed treatment from the 1950s onward. In many ways, Indian-made beads needed to lose some of their tourist luster; a transfer of consumer interest from the exotic to the everyday needs of costume jewelry was necessary. Eventually this factor would pervade all three streams of design.

Nevertheless, new evolving supply resources have dictated a flexible approach to materials. In this respect, Pueblo jewelry makers also take the lead. A hallmark of Pueblo perspective on design has been their pragmatic approach to experimenting with and substituting new materials when supplies of traditional materials have dwindled. As mentioned before, their most famous conservation practice took place during the 1930s and 1940s, when

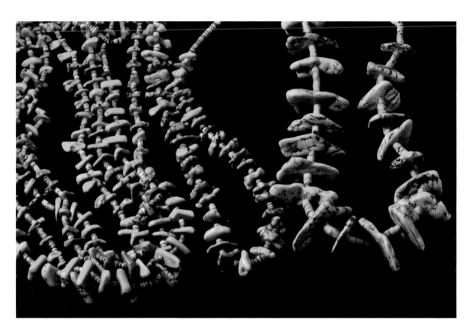

Three turquoise tab and shell necklaces showing variety in tab forms, mid-20th century. Courtesy of Steve and Mary Delzio.

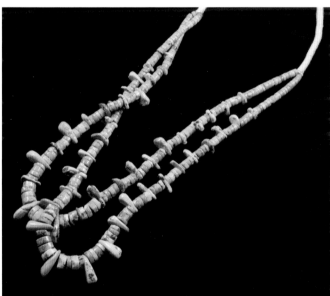

Two-strand blue-and-green turquoise necklace with hand-cut and hand-drilled disc beads, 1940s–1950s. Private collection.

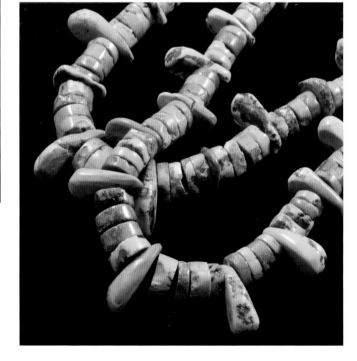

Close-up of central beads and tabs.

Single-strand green turquoise tabs on white shell *heishi*, punctuated with small spiny oyster shell tabs, 1900. Courtesy of Suzette Jones.

a host of found materials were utilized at a time when real semiprecious stone and shell were unavailable or unaffordable.

Pueblo bead makers knew to keep chipped blanks for mosaic inlay use. Older turquoise stones could be retrieved from worn or damaged jewelry and repurposed into new pieces. Puebloans possessed an ecological understanding of diminishing natural resources well before others did. By 1931, outsiders published cautions about imported Chinese turquoise replacing the materials of Southwestern mines that were playing out; similar warnings were issued about the influx of imported synthetic turquoise and enamel.[13] These breast beatings mostly originated from non-Native museum professionals. They were even uncomfortable about Pueblo and Navajo jewelers benefiting from the rise of other resources such as industrial adhesive glue, which took the place of traditionally used piñon gum.

By the 1970s, the floodgates opened to dozens of new semiprecious stones mined far from the American Southwest. In many cases, Pueblo jewelers were among the first to add Afghani lapis and Australian opal to their repertoire of materials as alternatives to traditional coral and turquoise. Jade, Siberian charoite, and sugilite joined other new materials. Pueblo jewelers beginning to occupy the high end of the market soon learned to work with diamonds and gold. A wide-ranging willingness to engage with new materials characterizes Pueblo jewelry making, and a parallel resourcefulness is shown by contemporary Zuni fetish carvers, too.

The features assigned to the term *heishi* changed with the establishment of the Southwestern ethnic arts market to outsiders.

The Pueblo Indians discovered their jewelry making made money, whether as creators of curio craft work or simply by continuing to do what they did so well. Designs changed in truth, but more as accommodation than assimilation. Pueblo jewelry makers faced fewer constraints than pottery makers and weavers, and less criticism by non-Native experts concerned about design integrity. In fact, if anything, Pueblo accomplishments were often made secondary to the larger presence of Navajo smiths and jewelers in non-Native discourse. In spite of this neglect, Pueblo artists embraced stylistic variations in stringing beads and enjoyed an emerging lapidary profile derived from the small stonework involved in bead carving.

The Indian arts marketplace was motivated, as are all markets, by profit. Terms that helped customers, especially in ethnic markets where language could be unclear, began to undergo modest changes. *Heishi*, an elegant word in itself, changed to mean a Native-made bead necklace that could be shell, shell and stone, or stone alone. Just as the materials now acquired a more elastic definition, so did the term expand to reflect a broader range of ornamental goods. When Pacific Rim mass-produced *heishi* appeared in the 1970s, with shinier synthetic materials and occasional white spots on the beads, the term widened again to define these down-market imitations as "*heishi* style" or fraudulently called them *heishi*. After all, the reasoning went, tourists often didn't understand about prices and would gladly buy something that looked like the genuine article if the price was right.

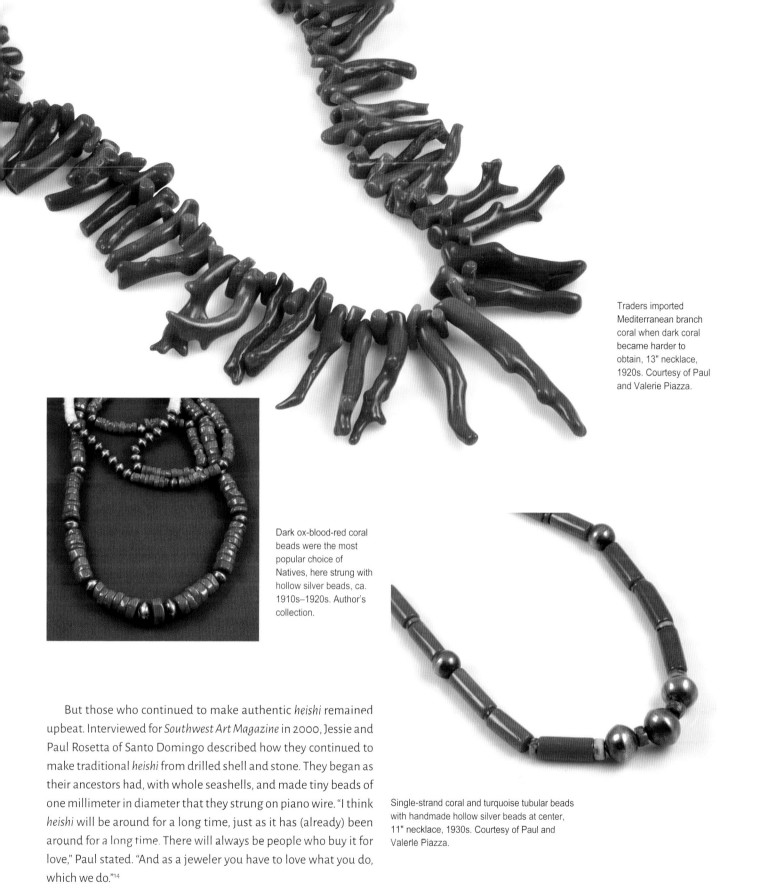

Traders imported Mediterranean branch coral when dark coral became harder to obtain, 13" necklace, 1920s. Courtesy of Paul and Valerie Piazza.

Dark ox-blood-red coral beads were the most popular choice of Natives, here strung with hollow silver beads, ca. 1910s–1920s. Author's collection.

But those who continued to make authentic *heishi* remained upbeat. Interviewed for *Southwest Art Magazine* in 2000, Jessie and Paul Rosetta of Santo Domingo described how they continued to make traditional *heishi* from drilled shell and stone. They began as their ancestors had, with whole seashells, and made tiny beads of one millimeter in diameter that they strung on piano wire. "I think *heishi* will be around for a long time, just as it has (already) been around for a long time. There will always be people who buy it for love," Paul stated. "And as a jeweler you have to love what you do, which we do."[14]

Single-strand coral and turquoise tubular beads with handmade hollow silver beads at center, 11" necklace, 1930s. Courtesy of Paul and Valerie Piazza.

Three high-quality multistrand coral *heishi* necklaces with small turquoise beads placed at intervals, mid-20th century. Courtesy of Laura Anderson.

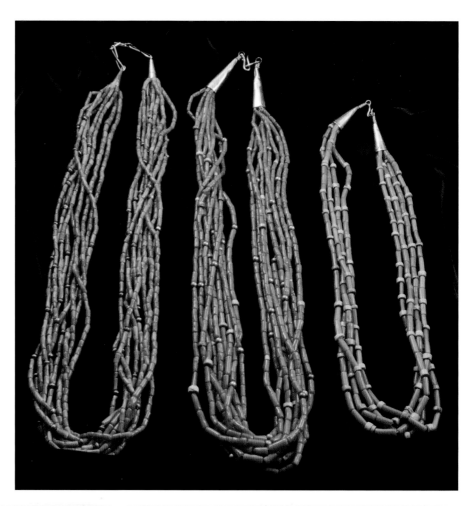

Red-glass trade beads were popular for their color and as a substitute for coral, 1910s. Courtesy of Andrew Munana Collection.

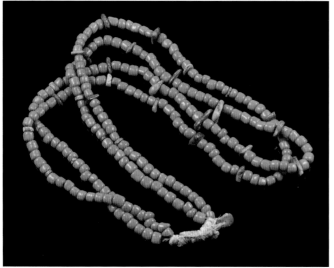

Close-up of glass beads.

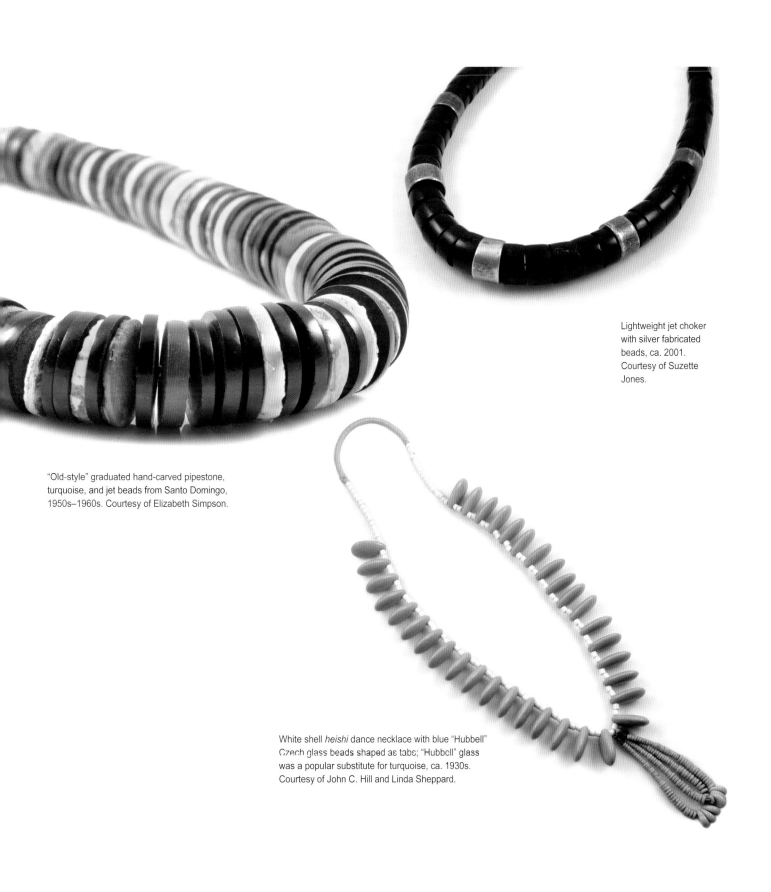

Lightweight jet choker with silver fabricated beads, ca. 2001. Courtesy of Suzette Jones.

"Old-style" graduated hand-carved pipestone, turquoise, and jet beads from Santo Domingo, 1950s–1960s. Courtesy of Elizabeth Simpson.

White shell *heishi* dance necklace with blue "Hubbell" Czech glass beads shaped as tabs; "Hubbell" glass was a popular substitute for turquoise, ca. 1930s. Courtesy of John C. Hill and Linda Sheppard.

Modern four-strand necklace of stabilized turquoise nugget beads on a plastic cord wrap, bought at an Arizona gift shop, 2016. Private collection.

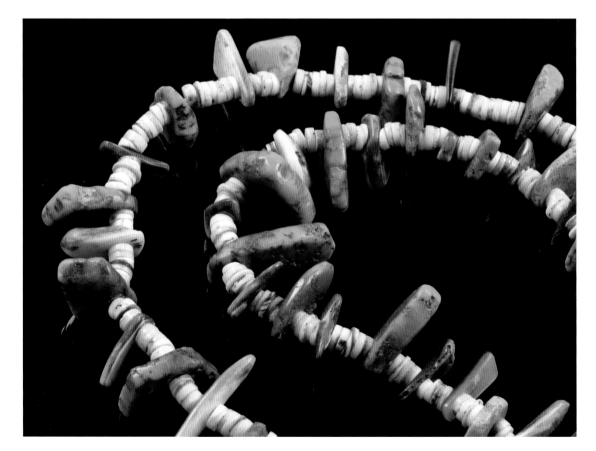

A "traditional" design of olive and pen shell *heishi* with green turquoise, spiny oyster, and jet tabs, early 20th century. Courtesy of Suzette Jones.

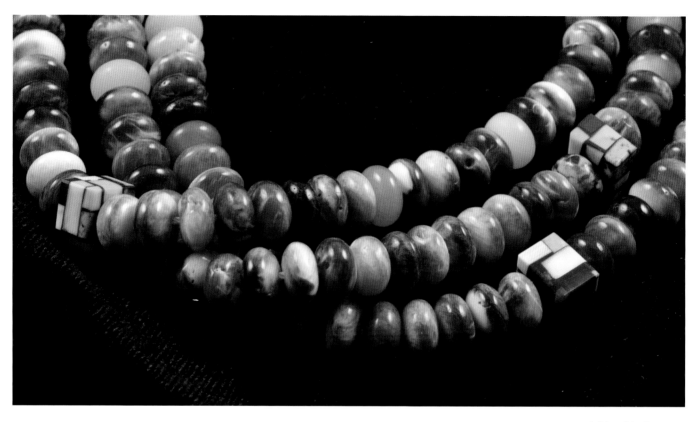

A rich variety of materials go into this three-strand creation by Charlene Reano (San Felipe), marked with her signature "chicklet" cube beads, ca. 2010. Private collection.

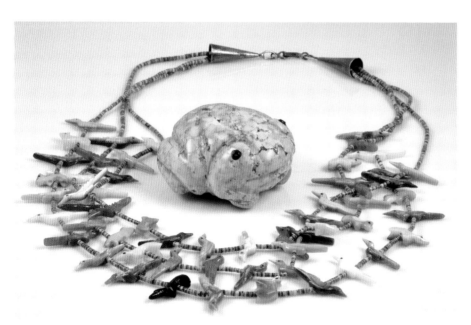

Bird fetish necklace, 12", by David Tsikewa, 1960s, posed with an older frog fetish. Courtesy of Paul and Valerie Piazza.

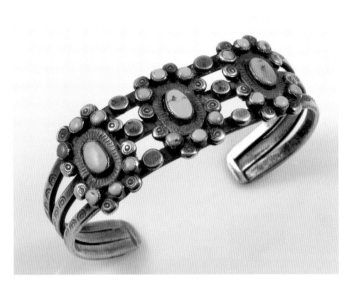

This Zuni cluster bracelet design owes much to the bead concept, 1940s. Courtesy of Bill and Minnie Malone.

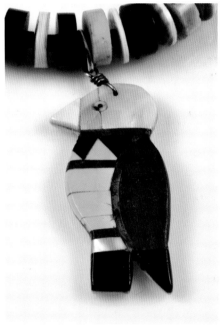

This Santo Domingo pendant bird sports a turquoise chest, ca. 1950s. Courtesy of Elizabeth Simpson.

A cluster pin with flattened silver "beads" framing the center, 1960s. Courtesy of Bill and Minnie Malone.

Child's concha belt with turquoise dot cabs that resemble beads, 1930s–1940s. Courtesy of Steve and Mary Delzio.

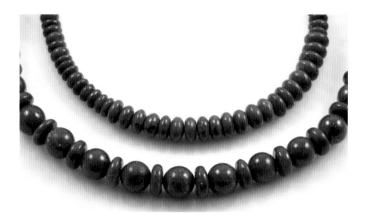

Good-quality lapis beads mark a trend toward single-stone creations other than turquoise, 1990s. Private collection.

Hues of purple from outer to inner: sugilite, purple spiny oyster, and amethyst glass beads, ca. first decade of 21st century. Private collection.

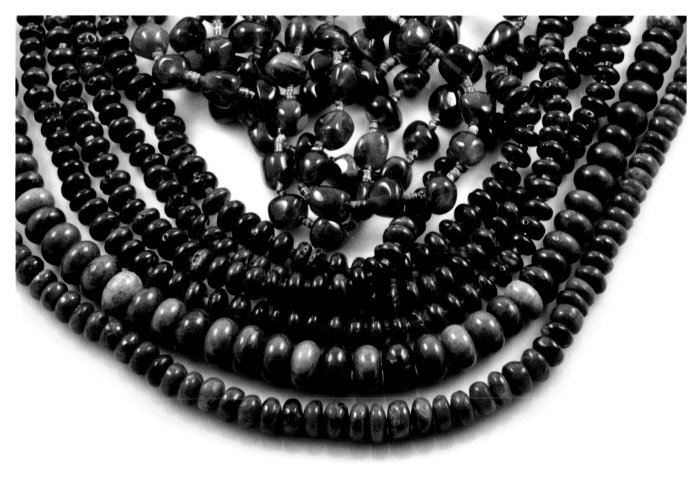

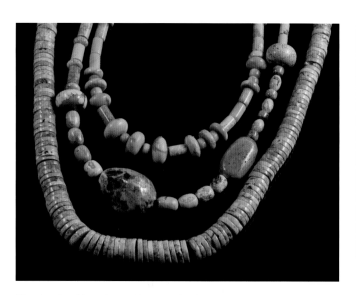

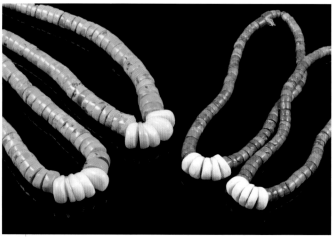

Three bead necklaces in gaspeite, a popular stone from abroad, available only in limited quantities, ca. first decade of 21st century. Private collection.

Two sets of turquoise *jaclas* with fine white corn; they were traditionally worn around the ear lobes and were often tied onto a necklace, 1970s. Courtesy of Steve and Mary Delzio.

Notes

1. M. Bahti. *Silver + Stone*. Tucson, AZ: Rio Nuevo, 2007, p. 109. Ray Lovato Sr. remains one of the most highly regarded *heishi* makers in contemporary society.

2. Parsons, Elsie Clews. *Pueblo Indian Religion*. 2 vol. Lincoln: University of Nebraska Press, 1939 (reprinted in 1966), vol. 1, p. 300.

3. Tyler, Hamilton A. *Pueblo Gods and Myths*. Norman: University of Oklahoma Press, 1964, p. 184.

4. Fox, Nancy. "Southwestern Indian Jewelry." In *I Am Here: Two Thousand Years of Southwest Indian Arts and Culture*. Santa Fe: Museum of New Mexico, 1989, pp. 64–65. Mica and selenite were two local minerals also used for decorative touches on ancient adornment.

5. Dubin, Lois. *North American Indian Jewelry and Adornment: From Prehistory to the Present*. New York: Abrams, 1999, p. 528. Experts determined that all these beads had been hand drilled with a cactus needle and sand.

6. Bahti, p. 142.

7. Lidchi, Henrietta. *Surviving Desires: Making and Selling Jewellery in the American Southwest*. Norman: University of Oklahoma Press, 2015, p. 156. The Ancestral Puebloans also made lots of beads from jet.

8. Bird, Allison. *Heart of the Dragonfly*. Albuquerque, NM: Avanyu, 1992, p. 18. It's interesting to note that during the Victorian era—which coincided with early Native historic jewelry production—mourning jewelry, including beads, were often made from jet.

9. Dubin, *North American Indian Jewelry and Adornment*, p. 472.

10. Dubin, *North American Indian Jewelry and Adornment*, p. 478. This older dark coral continues to be popular with collectors today.

11. Slaney, Deborah C. *Blue Gem, White Metal: Carvings and Jewelry from the C. G. Wallace Collection*. Phoenix, AZ: Heard Museum, 1998, p. 27.

12. *Be Dazzled! Masterworks of Jewelry and Beadwork from the Heard Museum*. Phoenix, AZ: Heard Museum, 2002, p. 65. The excavation work ended in 1923.

13. Jeançon, Jean A. *Pueblo Shell Beads and Inlay*. Denver Art Museum Leaflet 30. Denver, CO: Denver Art Museum, 1931, pp. 1–3. This pamphlet claims that imports of these materials had already started in the 1920s.

14. Hillerman, Ann. "Jewelry Design." *Southwest Art* 30.3 (August 2000), p. 146.

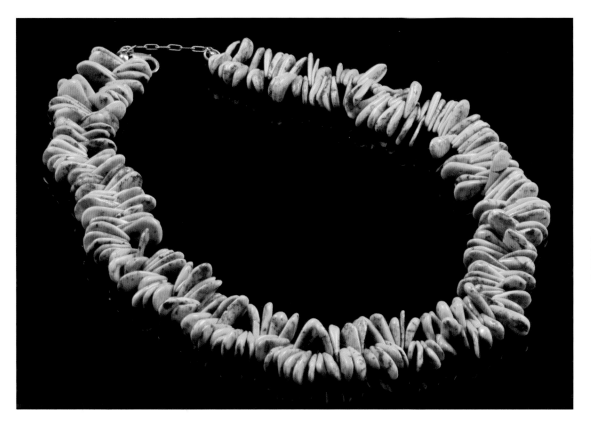

An unusual two-tier tab necklace in stabilized turquoise, 1990s–2000. Private collection.

Handmade turquoise graduated beads form a necklace with an unknown provenance (first decade of 21st century?), but possessing lovely asymmetry and style. Author's collection.

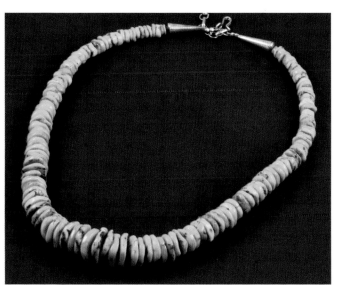

> *". . . [B]ut the idea is I didn't want to copy directly from our own sources here. So instead, I understood then that the impact of your emotional responses comes out in no matter what you do—interprets your background as well."*
>
> —**Charles Loloma** (1978)[1]

■ **THE ANCESTRAL PUEBLOAN SKILL FOR WORKING** shell and stone lies in the archaeological record for all to see; this heritage was passed on to their modern descendants. By historic times, the Pueblos already possessed an identity as fine lapidaries. While that heritage has been acknowledged in the literature of Native jewelry making, it has also become a label that obscures the extent of their creativity.

Even when silverwork became the predominant jewelry form of the late nineteenth and twentieth centuries, the shell and stone bead deeply influenced metal decoration and design elements. Cabochons set in bezels, along with shell and stone carved into flat pieces for inlay, drew their inspiration from the bead shape—whether round, ovoid, tubular, or a varied form. Early silversmiths, Pueblo and Navajo, set drilled beads in silver settings, a great example of repurposing natural materials.

The same three ingredients compose a high-quality piece of lapidary *or* silverwork: materials, construction, and design integrity. Over the years, some Pueblo jewelry makers elected to use materials of lesser quality for economic reasons but retained good construction and original design. A famous example of this occurred with the creation of Santo Domingo Depression-era jewelry, described in chapter 3. When many Pueblo jewelers found it increasingly difficult to find and afford high-quality materials in the last decades of the twentieth century, they reverted to making purely costume jewelry. Those artists who chose to be high end realized that they required a more secure partnership with middlemen, from mine owners to gallery dealers, in order to ensure their access to high-quality stones.

A good parallel to this situation is that of Pueblo fetish carvers, especially those from Zuni. Over the past thirty years they have been industrious in locating attractive local stones in place of turquoise, and repurposing glass and jet to create bold new figures. Those fetish carvers who create necklaces are particularly remarkable in their lapidary skill.

There has been a long-standing misperception that Puebloans in general made less silver than Navajos because they focused on lapidary work. Various vocal traders claimed to use silverwork from a Navajo to set inlay made by a Zuni; such collaborations have had more to do with the traders' economic needs than everyday reality. Henrietta Burton's quote of a government survey of money made by tribes in craft work shows that the Zunis made $30,000 for silverwork in 1933; this figure vastly outweighs the $12,582 total made by Northern, Southern, and Western Navajo groups.[2] However, the Navajo total figure is much larger than the $2,850 figure reported for the northern and southern Rio Grande Pueblos. In this respect the larger size of the then Navajo Nation does count toward the assumption.

The 1910s through 1930s were the decades that shaped "classical" ideas about Southwestern Indian jewelry. Non-Native artists visited or settled in Taos and Santa Fe, sketching and painting the northern pueblos and their ceremonies, and created intriguing pictures of Hopi snake dancers. The Fred Harvey Company handed out booklets of romanticized Southwestern Natives and featured Hopi dancers and potters at Hopi House in Grand Canyon Village. The Harvey Detours began ferrying tourists to pueblo ceremonial dances and beauty spots in 1926. The female hostesses wore striking Navajo

Skilled Lapidaries

Fine lapidary work: Bisbee turquoise and coral necklace by Lambert Homer Sr. (Zuni), 1965. Courtesy of Yasutomo Kodera.

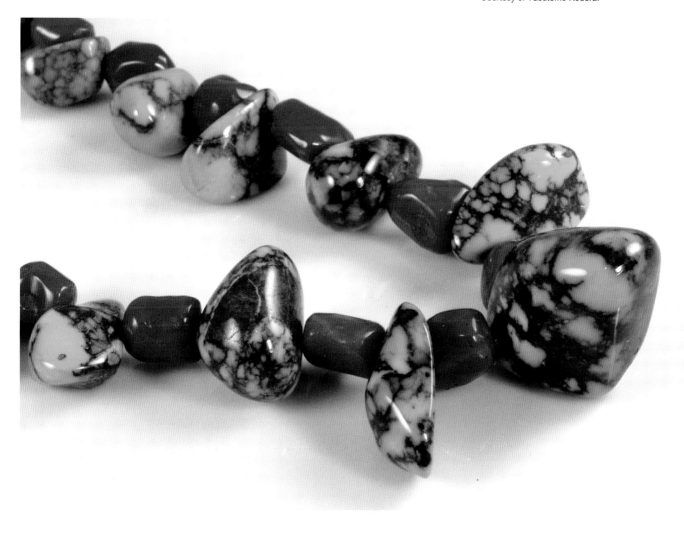

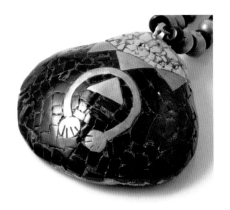

Unusual clamshell inlay on mosaic with silver beads, possibly by Reano family, mid-20th century. Courtesy of Andrew Munana Collection.

Squash blossom necklace with channel work turquoise inlay and bead-like pendants, 1950s? Courtesy of Suzette Jones.

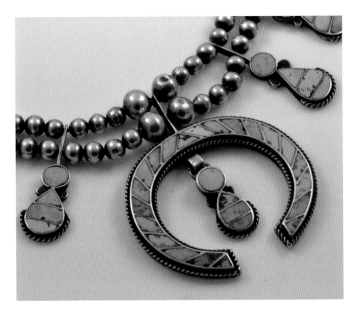

silverwork in the form of concha belts and squash blossom necklaces; they also wore masses of Pueblo beads.

The perception of Navajo silver supremacy versus Pueblo lapidary genius was accepted into popular culture by tourists and was fed by the tourism industry. Non-Native museum experts and Indian traders pointed out that adornment was divided between strongly marked Navajo silver and Pueblo-made wearable sets of multiple-cluster turquoise. By the time Route 66 was constructed across New Mexico, this split in jewelry styles was reinforced in roadside curio shops through the stereotyped products they sold.

The very first lapidary work was the rich mosaic inlay made by the Ancestral Puebloans. The common denominator between bead creation and inlay is the ability to carve from natural materials. Therefore, central to creating the bead are the very activities that compose lapidary skill. The practice of drilling is ancient itself and is utilized around the globe. Today's lapidary is mostly known for working minerals and semiprecious or precious stones into round cabochons (known as cabs), and cut or faceted gems. These activities arise from the primary techniques of carving or cutting, grinding, and polishing.

Lapidary tools found at prehistoric sites in the American Southwest reveal how ancient lapidaries learned to wield tools created from the very same materials they were able to work with great skill, precision, and knowledge.[3] An example of such inlay might involve using a large cardium shell as a base, and then setting materials such as chalcedony, obsidian, and turquoise into carved niches. The shell could be coated with tree gum as a fixative; care was taken back then to bevel and shape the edges so that no gum, or filler, could be seen.[4] Geometric motifs have also appeared on Ancestral Puebloan beads.[5]

Modern lapidary work usually falls into three categories: cabochon cutting, faceting, and tumbling. Pueblo lapidaries still follow the older method of applying grinding and polishing powders to a grinding or buffing wheel. A diamond-tipped saw is needed for harder stones. While pump drills are sometimes still used for natural turquoise, motorized equipment came to Santo Domingo (and other pueblos) by the early to mid-1960s.[6] Modern lapidaries also now polish with silicon carbide, emery, and resin.

Pueblo lapidaries, most famously the Zunis, initiated stylistic changes in stone setting by the 1890s, placing tiny bead-like stones in individual bezels; most experts agree that the Zunis developed fine row work by the 1930s.[7] A byproduct of Pueblo conservation of scrap materials became the creation of "snake eyes," or minute cabs—more like dots, and placed in multiple rows.

While nugget beads and "chunk" stone necklaces were strung throughout the historic era, modern equipment made tumbled turquoise beads easier to polish by the 1960s and 1970s.[8] Motors made many stone-bead-making steps easier. This, in turn, resulted in cheaper imitations of lesser quality entering the marketplace.

The introduction of silver "rules" and sections came early in the twentieth century, but early efforts at channel work design remained

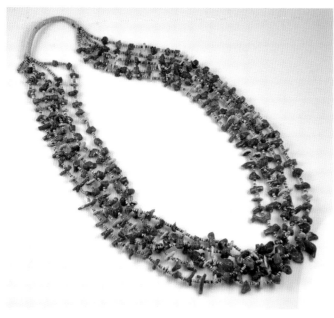

Multistrand turquoise
nugget and branch
coral on olivella shell,
1970s–1980s. Private
collection.

Close-up of beads.

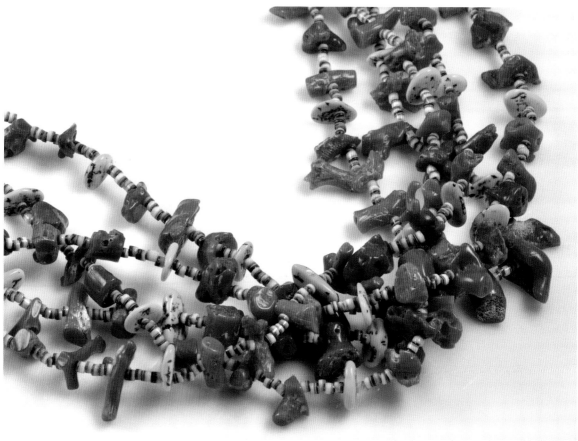

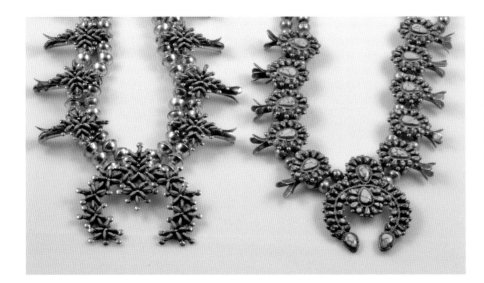

Two Zuni squash blossom necklaces: (l.) needlepoint with Sleeping Beauty turquoise by Brenda Simplicio, 1970s; (r.) petit point in No. 8 turquoise, 1940s. Courtesy of Bill and Minnie Malone.

rather inexpert until the start of the 1930s. Published accounts often claim that Navajos made the silver frames for Zuni and Pueblo lapidaries, yet some elderly Natives remember forming their own silver rules.[9] Nevertheless, the 1930s mark a period when fine inlay, including mosaic style, channel work, and cluster work, were produced. Experts have noted an intriguing design resemblance between rectangular Zuni "waffle gardens" and Hopi terrace farming and the channel work of that time.[10]

Mosaic-style inlay was not divided by silver sections. The Zunis were singled out for great facility in all aspects of inlay; Teddy Weahkee (ca. 1890–1965) was named as one of the first to make artistic inlay as early as the late 1920s.[11] Fine-quality inlay required careful fitting, smooth surfaces that lay flush together with no sign of filler. Pueblo artists achieved a high level of fine execution in inlay designs, and a preservationist approach to using materials lost during earlier construction processes.

Santo Domingo and Zuni emerged as the obvious originators of innovative inlay design, simply because they had the most lapidaries. The chief source for decorative embellishment came from observing the twisted wirework used by Spanish colonial and Mexican metalsmiths. Zuni artists became known for figurative inlay, carved from stone or flat, including birds, animals, and human figures. The carved stone creatures of Leekya Deyuse became popular during the 1930s and remain prized by collectors. The commercial possibilities of such attractive adornment were quickly noted by traders and curio store owners alike.

While Pueblo jewelry makers devised designs pleasing to their non-Native market, it fell to those very same Anglo traders and store owners to promote lapidary work that varied from so-called "traditional" *heishi* and silverwork. For this reason, Zuni prospered because of its proximity to Gallup, while Santo Domingo was located less conveniently halfway between Albuquerque and Santa Fe. When Pueblo men sought and were hired at jobs at curio stores in these cities, they were not encouraged to make original designs, but to copy what was believed to be popular, and they were often assigned to commercial benchwork tasks.

Zuni lapidary work, modestly popular, emerged as a leading artistic mode thanks to the efforts of C. G. Wallace (1898–1993). He almost single-handedly created an ongoing market for his Zuni artists. Initially a clerk for Charles Kelsey's Ilfeld Indian Trading Company in Zuni, Wallace received a trader's license and opened his own store there in 1928, along with a second shop for shipping and retail in Gallup. In 1937 he acquired a hotel on Albuquerque's Route 66.[12] He was a tireless promoter of Zuni lapidary work. He encouraged a number of Navajo silversmiths, such as Roger Skeet Sr. (ca. 1900–1969) and Austin Wilson (1900–1976), but also regularly commissioned Navajo silverwork as (less expensive) housing for Zuni inlay compositions by popular Zuni artists.

Wallace saw great potential in Zuni stone carving and inlay work and appreciated the developing forms of casting, channel inlay, cluster work, mosaic, and nugget work his artists rendered. In addition to Leekya and Weahkee, he hired the best: Horace Iule (1901–1978), Leo Poblano (1905–1959), and Dan Simplicio Sr. (1917–1969). He

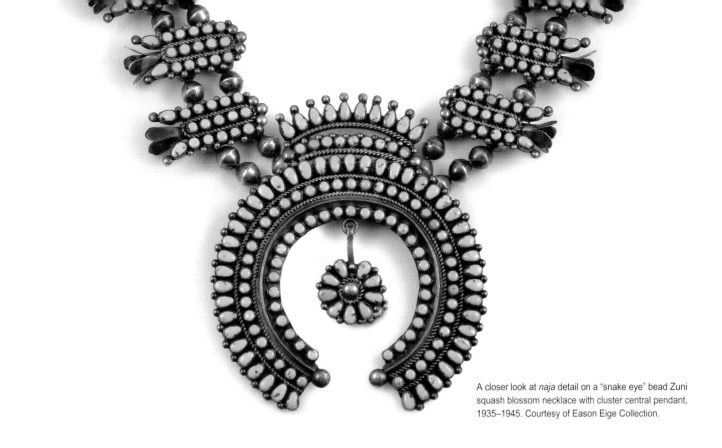

A closer look at *naja* detail on a "snake eye" bead Zuni squash blossom necklace with cluster central pendant, 1935–1945. Courtesy of Eason Eige Collection.

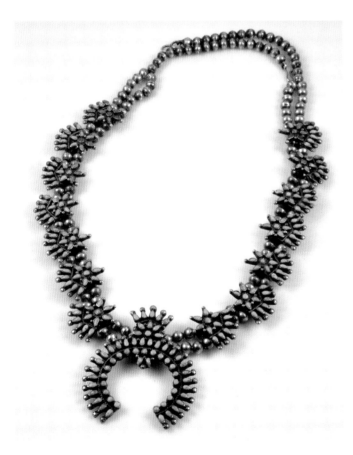

Lightweight petit point turquoise squash blossom necklaces, ca. 1950s. Courtesy of Elizabeth Simpson.

Large-scale Pueblo petit point and dots squash blossom necklace, probably meant for dancing, ca. 1950. Courtesy of Steve and Mary Delzio.

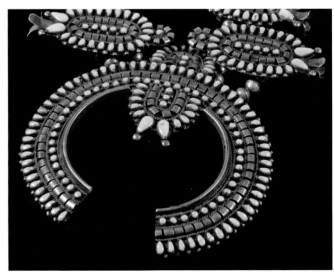

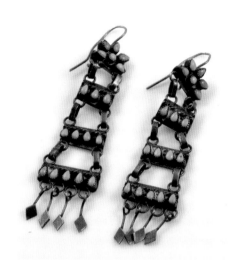

Pueblo dangle earrings have tiers of bead-like cabochons, Zuni made, 1940s. Courtesy of Bill and Minnie Malone.

fostered the unique ground flush dot (or bead form) inlay created by Frank Dishta (1902–1954) and his family; they made abstract channel inlay floral and brooch motifs, evocative of Mid-Century Modern taste, along with a signature covered-wagon design. Artists skilled in carving stone and shaping silver, Lambert Homer (1917–1972), Leonard Martza, and Annie Quam honed their lapidary skills working at Wallace's post.

From the Depression through the 1940s, Wallace focused on advocating these Zuni styles and designs, in so successful a manner that they soon superseded other Pueblo jewelry forms. A decade later, his regional fame was such that writer Dale Stuart King called Wallace "the greatest living authority on the history of Indian silver."[13] His credibility soared when he gifted 500 personal pieces of Indian artistry to the Heard Museum and provided text for a 1975 sale of part of his collection through Sotheby Parke Bernet; the catalog became a major source of provenance for works by the artists he employed.[14]

While Wallace deserves credit for helping to make Zuni jewelry popular in the marketplace, he did not always get his facts and identifications correct. He was, however, able to understand a seemingly contradictory trend developing in Pueblo jewelry making. Wallace realized that his artists did best when they adhered to traditional modes but also grew more individualistic in their designs.

From the beginning, Pueblo metalsmithing and jewelry making remained subsidiary to farming, community, and ceremonial responsibilities. The complex social organization of Pueblo individuals rendered jewelry making essential for ceremonial dancers, less so for outsider consumption. Despite the Puebloans' polite and outwardly acculturated appearance, they kept their calendrical cycle of ceremonials as a first priority, and certain types of design were withheld for private usage.

Over time, however, the increased demand for jewelry made it a feasible profession, and attitudes relaxed toward its production. Large amounts of adornment for public consumption were made after World War II, triggering the concern of academics such as J. J. Brody. Non-Native authorities on Indian arts worried about a lack of cultural relevance because consumer preferences were now noted and incorporated, but the truth was that the design impetus for Pueblo creators remained carefully controlled by their private vision of what they needed to produce—and what their customers liked.

Lapidary work opened up financial opportunities for Pueblo talent. Throughout the mid-twentieth century, "traditional" designs either froze into commercial work made to please non-Native consumers or evolved into inventive expressions of wearable art. Such expression by talented Pueblo individuals could trigger community approval or disapproval. The rise of Indian fairs in Santa Fe and Gallup, offering prize ribbons, pitted traditional Pueblo communal modesty against Anglo individualistic values. Despite this restraint, however, notable Pueblo lapidaries grew out of individuals engaged with fine arts, including Michael Kabotie (1942–2001), Charles Loloma (1921–1991), Charles Lovato (1937–1988), and Alfonso Roybal (Awa Tsireh) (1898–1955), among others.

It's also relevant at this time to see how the changing attitudes of Pueblo artists in the decades after World War II set up a climate whereby master jewelers began to emerge. A look at the greatest

Ranger set by Dishta, 1950s, with his characteristic flattened cluster bead style. Courtesy of Bill and Minnie Malone.

master jeweler of his time, an artist who influenced a large number of Native jewelry makers, is appropriate at this point. Charles Loloma, a modest Hopi man who fulfilled his traditional obligations, took lapidary and silverwork to innovative, even-startling heights. His path did not resemble those of the Zuni lapidaries, and he did not fall under the patronage of an ambitious Indian trader.

Loloma began as a talented young mural painter, went out into the world to study ceramics at Alfred University, and visualized his personal lapidary skills as a means of making adornment that reciprocally flattered the object and its wearer. He employed a more artistically sculptural approach to carving stones and shaping silver and gold. The results were highly individualistic, as in his "height bracelets," but the sense of traditional values he retained shows deep respect for his cultural roots. This less narrow focus on stylistic process allowed him to create jewelry that was both avant-garde and reassuringly Native. Loloma admitted to being stimulated by fashion, and his interest foreshadows the direction that many Southwestern Natives would take.

Later on, Loloma would work with Lloyd Kiva New and other influential educators and art specialists to shape a new institution, the Institute of American Indian Arts (IAIA). He taught at the college and, at one point, acknowledged that he and other Indian artists had not grown up with self-promotional skills. The postwar time period, full of general social change in terms of technology and communications, encouraged some Pueblo jewelers to engage in collaborations. Preston Monongye (1927–1987), for one, worked with

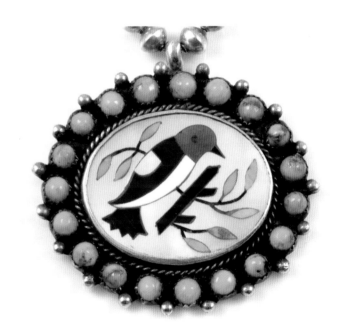

Santo Domingo inlaid bird pendant, signed "Lorenzo," ca. late 1920s–1930s. Courtesy of Elizabeth Simpson.

Spanish influence is evident in the twisted-wire design on this ring and bracelet, 1930s–1940s. Courtesy of Andrew Munana Collection.

Superbly detailed inlay of a hawk in a ring by Harlan Coonsis (Zuni), 1970s–1980s. Author's collection.

Zuni and Navajo individuals, and his collaborative effects were not always lapidary contributions.

These activities were a subtle signal that a non-Native trader such as C. G. Wallace would no longer exert a dominant control on artistic development in the future. The years of urging Natives to create tribal styles or perfect specific forms of lapidary work were ending. Nevertheless, writing on Indian silver jewelry making still manages to make strong distinctions between Navajos as superior silversmiths while Pueblos lead as natural lapidaries. This general assessment deserves to be revamped to show equal abilities in both areas. A wonderful example of the new reality can be seen in the partnership of Gail Bird (Santo Domingo) and Yazzie Johnson (Navajo), who from the 1970s onward have produced fine high-end designs rendered with virtuoso lapidary and silverwork skill.

In 1976, Hopi jeweler Lewis Lomay (1913–1996) was interviewed in *New Mexico Magazine*. He had attended the Santa Fe Indian School and learned silverwork from Navajo smith Ambrose Roanhorse (1904–1982). As a young man, Lomay had worked for Frank Patania Sr. (1917–1969) both in his Santa Fe and Tucson shops. In his interview, he spoke with enthusiasm about his combinations of silver and lapidary work. "From now on, I'm going to spend my full day on silver. I'm going to start all over again, to see what I can do, combining different metals, and doing new lapidary work with wood and shell as well as different kinds of stone. There are many new things I have in mind now. I go to bed and dream of jewelry. I can just visualize the new designs I want to try."[15]

Cluster pin with sheriff's star design, 3" diameter, 1940s–1950s. Courtesy of Suzette Jones.

Plaque choker in turquoise channel work abstract style of Quandelacy or Quam families (Zuni), 1945–1950. Courtesy of Suzette Jones.

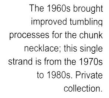

Carved bird fetish necklace from Santo Domingo, 1960s. Private collection.

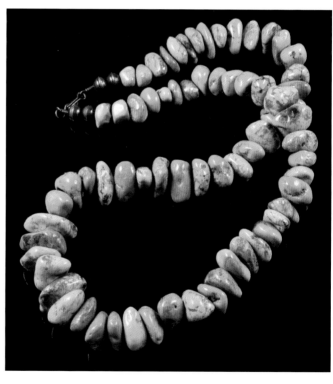

The 1960s brought improved tumbling processes for the chunk necklace; this single strand is from the 1970s to 1980s. Private collection.

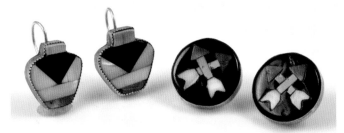

Zuni inlay earrings: (l.)
pots, maker unknown;
(r.) crossed arrows by
John Gordon Leak
(Robert Leekity), 1940s.
Courtesy of Elizabeth
Simpson.

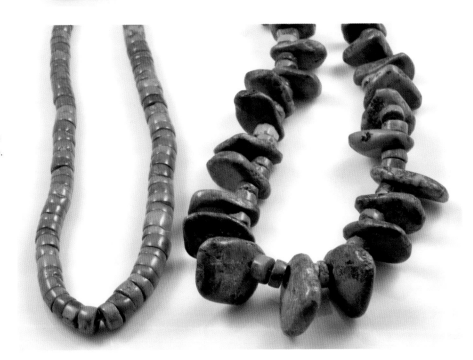

A mid-20th-century
contrast in hand-shaped
heishi. Private collection.

Experiments in color gradations on disc beads grew
from the 1970s onward. Private collection.

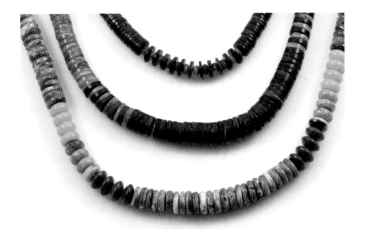

These tiny jade beads
were bought on the
West Coast by Rose
Reano (Santo
Domingo), who strung
them meticulously, ca.
2012. Private collection.

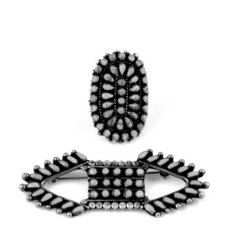

Bead shapes guide the cluster work in this ring and pin, 1930s–1940s. Courtesy of Elizabeth Simpson.

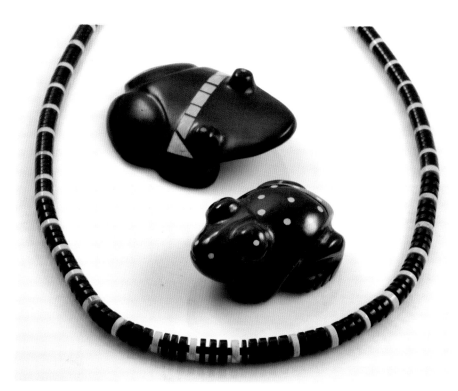

A tightly strung *heishi* strand encircles fetishes by Emery Boone and Peter and Dina Gaspar, ca. 2000. Private collection.

Close-up of beads.

Two pairs of turquoise and silver channel work Pueblo earrings flanked by older fetish carvings, 1950s. Courtesy of Paul and Valerie Piazza.

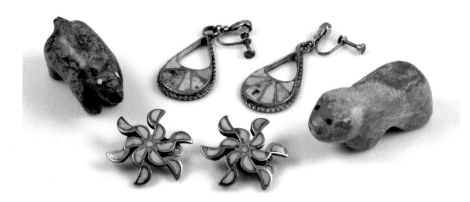

The greatest lapidary of them all—Charles Loloma; bracelet, ca. 1980–1982. Courtesy of Faust Gallery.

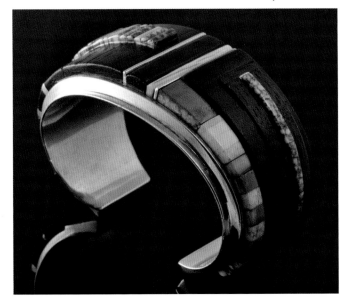

Lewis Lomay's classic designs, such as this pendant, are greatly prized for their originality, 1970s. Courtesy of Karen Sires.

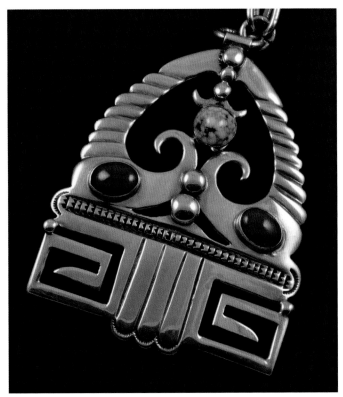

Notes

1. Interview with Heard Museum curator Erin Younger, May 26, 1978, Hotevilla, AZ. Loloma artist file. Native American Artists Resource Collection, Billie Jane Baguley Library and Archives, Heard Museum, Phoenix, AZ, p. 8. Available online: http://cdm262401.cdmhost/cdm/ref/collections/p16286coll6/id/255.

2. Burton, Henrietta. *The Re-establishment of the Indians in Their Pueblo Life through the Revival of Their Traditional Crafts: A Study in Home Extension Education.* New York: Teachers College, Columbia University, 1936 (reprinted in 1973), pp. 91–92. This table also has a section for beaded work such as small folk art animals and dolls, not adornment. Overall, the Zunis made the largest amount of money from crafts.

3. *Be Dazzled! Masterworks of Jewelry and Beadwork from the Heard Museum.* Phoenix, AZ: Heard Museum, 2002, p. 46.

4. Ezell, Paul. "Shell Work of the Prehistoric Southwest." *The Kiva.* 3.3 (December 1937), pp. 9–12.

5. Jernigan, E. W. *Jewelry of the Prehistoric Southwest.* Santa Fe, NM: School of American Research, 1978, pp. 84, 87.

6. Jernigan, p. 101. This discovery contradicts the claims made that geometric motifs are primarily a Navajo design element.

7. Fox, Nancy. "Southwestern Indian Jewelry." In *I Am Here: Two Thousand Years of Southwest Indian Arts and Culture.* Santa Fe: Museum of New Mexico, 1989, pp. 83–84. Some experts claim row work actually started in the late 1920s, but the style certainly was more produced in the 1930s. Navajo jewelers also made row work, and it can be difficult to tell the difference.

8. Rosnek, Carl, and Joseph Stacey. *Skystone and Silver: The Collector's Book of Southwest Indian Jewelry.* Englewood Cliffs, NJ: Prentice-Hall, 1976, p. 119.

9. Rosnek, pp. 60–62. The book calls this intertribal cooperation, but interviews conducted by Ernie Bulow in the 2010s found informants adamant that they could and did fashion silver themselves. Evidently, the traders the Zunis worked with would farm out silverwork that they could get cheaper from a Navajo maker; this was for economic reasons: there were more Navajo smiths working in the region, and they could knock out the silver mounts faster. The traders would then add their Zuni-made lapidary work to this Navajo-made silver.

10. Dubin, Lois. *North American Indian Jewelry and Adornment: From Prehistory to the Present.* New York: Abrams, 1999, p. 506.

11. Dubin, p. 506

12. Slaney, Deborah C. *Blue Gem, White Metal: Carvings and Jewelry from the C. G. Wallace Collection.* Phoenix, AZ: Heard Museum, 1998, pp. 12–13.

13. King, Dale Stuart. *Indian Silverwork of the Southwest.* Vol. 2. Tucson, AZ: Dale Stuart King, 1976, p. 59.

14. Slaney, p. 17.

15. Hersh, Phyllis. "Lewis Lomay Artist in Silver." *New Mexico Magazine* (July 1976), p. 21.

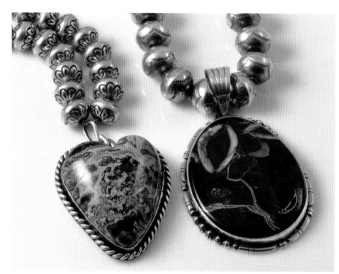

Not all Pueblo lapidary work is small scale, as these two pendants in azurite and mystery stone attest, 1990s? Courtesy of Elizabeth Simpson.

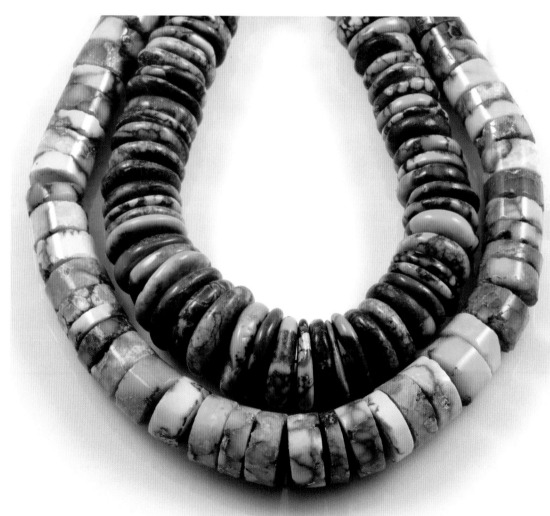

Pueblo beads could also be shaped in larger sizes, as these variscite necklaces demonstrate, early to mid-20th century. Private collection.

> *"The most dominant motif is the geometric key design. I also use the flute player, water serpents, lightning bolts and my logo, the eagle. All of them are from Pueblo legend . . . The motifs help pull me back and keep me walking that line between contemporary and traditional."*
>
> —**Ted Charveze** (1986)[1]

THERE ARE SEVERAL ISSUES TO CONSIDER before examining the most prevalent and significant design elements and motifs Pueblo jewelers offer in the marketplace. Many of these visual patterns originated from Pueblo pottery and basket and textile weaving. Jewelry making did not emerge as a viable full-time occupation until later in the twentieth century, so some imagery developed then that would not have appeared earlier. Therefore, Pueblo jewelry design must be placed in a wider context when it comes to examining what aesthetic rules it operates under. Designs in general conformed to the particular worldview of the creator's pueblo. When jewelry came into the ethnic marketplace, however, their makers were faced with powerful cultural design constraints and incentives.

Once sales of jewelry to outsiders began, many designs were prohibited by Pueblo priests and those who held key religious and community functions. In 1976, Anita Da of San Ildefonso Pueblo was interviewed for a collector publication. She stated, "In the past a lot of our Pueblo designs were not allowed out for commercial purposes; it was not until fifteen years ago that they began to draw kachinas for the [non-Indian] public to see. Some things still cannot be . . . sold—and some designs have appeared, in jewelry and other crafts, that should not have appeared."[2] Of course, there were variations to this ban in other pueblos. Zuni, which was under pressure by its traders to produce commercial work in the late 1920s and 1930s, took some interesting workarounds in designing figures that represented sacred beings.

Non-Native experts and museum professionals of the early to mid-twentieth century were most concerned with cultural relevance for Pueblo and Navajo arts. When Indian jewelry became clearly constructed for general consumption, these same professionals decried the evils of the commercial marketplace. At the same time, ironically, educators were compiling American Indian motifs for use in a new national design vocabulary of authentically genuine imagery. Some of these collations will be examined later in this chapter.

The spatial arrangement of pottery design affected the creation of adornment designs. In addition, just as Navajo jewelry makers speak of the influence of their female relatives who wove textiles, so, too, did Pueblo jewelers draw inspiration from their relatives who wove beautiful mantas and embroidered designs that were lyrical in color, repetitive in pattern, and rhythmic in motif. Pueblo dress accentuated the ornament added to it.

In reality, however, Pueblo jewelry design calls for more than a two-dimensional approach. It embraces the three-dimensional, such as with shell *heishi* creations, in which most of the five senses come into play, especially a sculptured, tactile feeling. Patterning on beads, including fetish animal carving, varies from what goes into lapidary and silverwork. The color requirements of bead, lapidary, and metalwork possess visual and stylistic clues of a different nature. More than any other type of jewelry form, pendant designs provide the most information about the development of specific types of motifs.

Key Design Elements and Motifs

When we begin to look at the critical design elements featured in Pueblo adornment, the bead and its circular function are inescapable. Certain elements also bear a close relationship to some of the design patterns used for generic Indian curio jewelry, and resemble the Indian "symbols" created for the tourist trade. What this also means is that many Indian design elements became generic in aspect, even if they originated from genuine sources. Southwestern Native cultures shared selected imagery, from star signs to feather patterns.

As the twentieth century progressed, specific popular design elements emerged. Many of these share the same self-contained qualities as the bead in terms of shape, texture, form, harmony, and balance. This also includes direction: Pueblo design elements, not unlike the patterning done on jewelry, would often have both a *centripetal* spatial orientation, that of moving inward, which marks the instinct to center in much Pueblo design, and a "sense" of *centrifugal* force that opens design outward, especially when complicated.[3] As noted by Beula Wadsworth, this means not just circles, spirals, and fluid curved or inverted lines, but dots and series of straight lines that can become zigzags, hooked, or stepped.[4]

We view these design elements as the stripped-down primal units that form a pattern. Elements range from basic lines, forms, shapes, and colors to visual values such as tone, contrast, and texture. Lines can be straight, curved, or bent; hooked lines form bows and crooks, while stepped lines represent rain. When we look at these elements on pottery, they reveal unity, harmony, balance, and emphasis on one or more design motifs.

Herringbone mosaic on a clamshell is both ancient and modern design; 2½" pendant by Percy Reano (Santo Domingo), 2012. Courtesy of Suzette Jones.

Carved animals are a long-standing adornment design motif, especially bears; necklace from M & M Fetish Co., Gallup, New Mexico, 1980s. Private collection.

Delicate turquoise mosaic work with floral design, backed on plastic, Santo Domingo, 1950s–early 1960s. Courtesy of Karen Sires.

Lines and circles can be combined to make *tablita* headdresses, curved lines represent lightning and mountains. Oval shapes become raindrops, and rectangles with curved bottoms signify feathers. Pottery borders generally present floral forms, diamond shapes (often multiples), and rolling curves that contribute to a sense of organic unity. Leaf and foliate shapes, key to pottery design, become important elements for jewelry when silver is introduced.

Color is a constant element, especially for shell and stone bead making. Here, the elements that stand out relate to direction, dominance, emphasis, gradation, repetition, and size. As early as the Ancestral Puebloan era, beads were fashioned in varying sizes for emphasis, with some shading in color, alternating bead shapes, and repetition of pattern and texture. During the 1960s and 1970s, Pueblo bead makers returned to experiment with those same elements—now motivated both by newly available image resources and modern mainstream market tastes. When bead sizes were graduated or shaded in varied color tones, emphasis was placed on the central bottom of a necklace. Lapidary stone tumbling/polishing grew more mechanically efficient in the 1960s, making texture another strong decorative element.

We have already seen the significance of the round bead shape, which can become an elongated ovoid or triangularly tab-like. Another mistake in collector literature has been to attribute tab necklaces—usually those made with small beads and strung at intervals with ovoid beads in a larger size—to Navajos, when they clearly adopted the form from Pueblo neighbors. Many of these bead necklaces are quiet masterpieces of harmony and balance in design.

Line is an interesting element in the Pueblo design aesthetic. Navajo design captured the geometric edge over the Pueblo use of lines, which are often more sinuous and flowing. This is not to say that Pueblo artists never employed geometrically angled lines—in fact they excelled in a Greek fret-like pattern—but perhaps owing to the concave and convex nature of pottery, such lines have a tendency toward the fluid, with motifs of elements representing wind and migration or movement.[5]

Color also plays a large role in Pueblo design, as mentioned earlier. We know that various Pueblo groups have specific colors for the Six Directions, and these colors do vary among the Pueblos. The white of shell, black of jet or obsidian, blue or green of turquoise, and red of coral correspond to sacred meanings. As a design element, color, depending on the material used, also lends textural and tonal contrast.

Turning now to motifs, Ruth Bunzel's observation about arrangement and color determining design on pottery holds true for some adornment design as well; she noted that numerous motifs derived from weather symbols and aspects of ceremonial regalia, such as prayer sticks and feather plumes.[6] One exception comes from Santo Domingo, which had stricter regulations and forbid motifs with religious meaning and even certain weather image combinations.[7]

Specific ancient motifs were used regularly on jewelry: Kokopelli the flute player, human hands, mazelike spirals and circles,

Santo Domingo tourist roadrunner pin backed on plastic, 1950s. Courtesy of Karen Sires.

and outlined animal figures. Many of these designs may be accompanied by border or outline elements of straight and curved lines suggesting cornstalks or vegetation. Popular historic-era pottery motifs include clouds, dragonflies, feathers, spiderwebs, and water birds (which can vary in design by pueblo). These designs appear both on stone and silver jewelry.

Wadsworth, among others, admired the presentation of Pueblo motifs in visual source material she gathered, which often appear symbolic in their placement. She considered the design elements to be functional and express harmony, along with a "fitness to purpose"; most of all, she saw motifs as "beautiful shapes" and lauded Pueblo experiments with abstract forms.[8] She felt that these designs encouraged creative translation, and that her source images would aid designers in achieving originality and *modernity* (see chapter 6).[9]

When we look at Pueblo jewelry intended for the commercial marketplace, we find that design motifs fall into certain specific categories as previously noted: natural phenomena, creatures, regalia, ancient imagery, and human figures. At this point, it's important to note that many designs have affinities with or have been outright borrowed by the Navajo and other Southwestern tribes, especially those who inherited land occupied by the ancient peoples of the region. A small amount of borrowed images from popular culture also creep in: these can range from a stylized covered-wagon motif to emblems taken from non-Native organizations, such as the Freemasons and Shriners.

Each pueblo has an origin story that speaks of emergence and journey. Pueblo origin stories mark the awareness of the natural

Inlaid roadrunner necklace, 13½", by Ed Beyuka (Zuni), 1960s–1970s. Private collection.

Anthony Lovato (Santo Domingo) tufa cast parrot pin pendant pays tribute to a popular design motif, ca. first decade of 21st century. Private collection.

world they occupied, and certain sacred landscape features that each pueblo lays claim to as a point of emergence (e.g., a local mountain or lake). Those natural phenomena essential to life—sun, moon, wind, water, rain, lightning, and clouds—have their place in these stories, and specific images used as design elements represent them. One hugely popular motif is the Zia Pueblo sun symbol converted into a sun face marked by color sections, rendered frequently by Zuni and Rio Grande artists and liberally borrowed by neighboring cultures. Over the decades, the sun face has acquired the recognition of the "smiley face" of mainstream popular culture; this design has cross-cultural appeal, and its variations in colors and facial expression have enhanced its attractiveness as adornment.

For living creatures as motifs, birds soar above all other contenders, while butterflies and dragonflies hover nearby. Birds serve as a mediator between earth and sky, bringing messages from the sacred spirits. Mera's "Rain Bird" could be known variously as Hopi Bird, Flint Bird, or Knife Wing, or simply as a thunderbird.[10] Ancient and historic-era pottery provided many prototype designs. The creature's terraced sky cap, massive wings often ending in flint knife tips, and banded mosaic-work chest are generally constant features. The Pueblo "thunderbird" shares similarities with those of other indigenous cultures. Slight variations on this supernatural bird design are found in lapidary work, where inlay colors may vary greatly. Even the later Peyote Bird design, adopted by the Native American Church, borrowed the main features seen in the Rain Bird prototype.

From this important sacred being springs one of Santo Domingo's greatest contributions to Pueblo and Native American design: the Depression-era thunderbird pendant. Mainstream America has taken this symbol to its heart, and this necklace adornment has become a colorful footnote to the history of Native jewelry in the American Southwest. The story itself is appealing.

Materials, including stone and silver, were expensive and almost impossible to obtain during the Great Depression years. The Indian Arts and Crafts Board had a governmental program that rationed silver to smiths, but most Southwestern Indians had a hard time acquiring any metal. At Santo Domingo, however, the pueblo's jewelry makers found a solution that wedded avant-garde ecological vision to folk art intention. The result created a new phrase, "Santo Domingo Depression jewelry," to signify an iconic category of Pueblo adornment that went straight to tourist and collector hearts.

The dominant design motif was the thunderbird, rendered with sharp beak and wings either uplifted or pointing down. Santo Domingo makers formed necklaces replete with rectangular or oval tabs, with a thunderbird as a pendant at the bottom center. But it

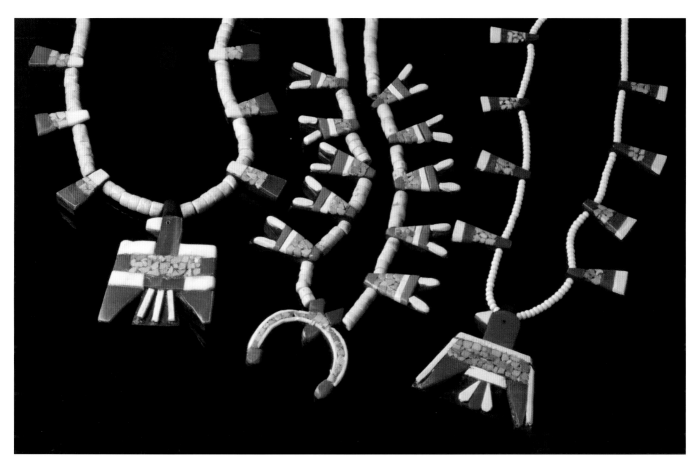

Three prime examples of Santo Domingo Depression-era jewelry, plastic and found materials, 1940s. Courtesy of Steve and Mary Delzio.

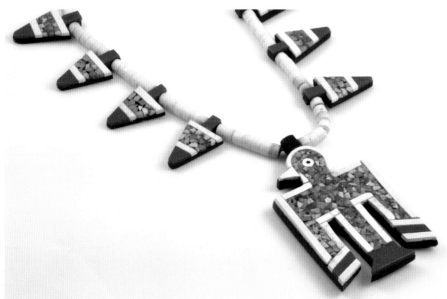

The classic streamlined tourist Pueblo thunderbird, loved by the Fred Harvey Co. and sold at Verkamp's in Grand Canyon Village; by Clara Reano, 1950s. Courtesy of Karen Sires.

Plastic inlaid bird
pendant on gypsum
beads originally bought
at Isleta Pueblo in 1936.
Courtesy of Karen
Sires.

was the ingenious found and repurposed materials that went into the shaping of these necklaces that made them so piquant. The environment was harvested for bleached animal bones, hard rubber plastic taken from car batteries and phonograph records, eating utensils (including red spoons from Dairy Queen), buttons, combs, and celluloid kitchen ware.[11]

Chips of plastic and turquoise brightened mosaic-work decoration. Vivid colors from various sources, especially red and yellow, drew eyes to the overall design. The backing for the mosaic pendant and flat tab beads could be plastic or even cardboard. Sometimes butterflies and other winged creatures were fashioned as pendants. Plain necklaces could be made up with decorative tabs, and many necklaces became sets with matching earrings.

The secret to this jewelry's success was threefold: an engaging and colorful Pueblo bird design, skillful fabrication, and souvenir appeal to tourists. The real accomplishment, however, was in the makers' resourcefulness; this adornment honored Santo Domingo creativity in the face of economic adversity. Today, young Pueblo artists make clever old-style pendants and jewelry forms rendered with plastic and turquoise chip mosaic in tribute to this historic adaptation of an ancient technique.

Lesser birds have meaningful roles, too. Some are used by certain pueblos more than others. Such is the case of the roadrunner motif, which appears more often in the Rio Grande pueblos than at Hopi or Zuni; the bird has associations with war and death.[12] There are also summer and winter season birds. Crows, owls, and ravens represent good and bad omens, sharing a duality like that of snakes,

which can cure or kill.[13] Bluebirds, jays, and swallows appear on inlay, particularly at Zuni. Eagles, which represent the Zenith of the Six Directions, are especially valued, along with parrots—a tribute to Mesoamerican trade.

Snakes were early motifs. Lois Dubin points out that frogs and lizards retained a long tradition of representing desert survival.[14] Water serpents, too, especially at Hopi, have their place. Looking at the animals that appear most frequently on Pueblo jewelry, we find bears, buffalo, antelopes, deer, mountain sheep, and rabbits. Jewelers and fetish carvers also retain the device seen on much pottery—the "life line" or heart line. This concept of the breath to animal blood or direct to the animal's heart applies to animals that are hunted; it also ties into Pueblo belief that prey animals possess supernatural power.[15]

Insects have frequently been used since ancestral times. John Adair notes that the butterfly motif was very popular in Hopi jewelry during the 1930s.[16] Allison Bird's *Heart of the Dragonfly* is an excellent recounting of the significance of this insect, especially when translated into silver crosses.[17] Dragonfly pendants and pins remain popular jewelry motifs and are much utilized in early-twenty-first-century work. Spiders appear from time to time but are more apt to materialize in Navajo design.

Certain features of ceremonial regalia have been isolated and used for design; these are objects that may be viewed by the noninitiated in public. They include prayer sticks (which the Spanish would mistake for crosses) and feathers. Masks of sacred spirits who may appear in publicly attended dances, such as the Longhorn

Popular 1930s earring designs on plastic backing. Courtesy of Paul and Valerie Piazza.

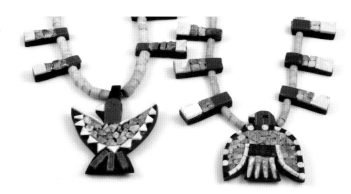

Two Santo Domingo variations on bird pendants, made with plastic and recycled materials, 1930s. Courtesy of Paul and Valerie Piazza.

Kachina, have been gingerly added, with alterations in appearance. Zuni deities Knife Wing (*Achiyalatopa*) and Rainbow Man are probably the most frequently portrayed. Sacred clowns such as the *koshari* and the *Kóyemshi* ("Mudheads") of Zuni have been depicted, but mostly only since the 1970s. Pueblo (and Navajo) jewelers opt to create a generic spirit figure, not based on what might be seen in private ceremonies, to satisfy the curiosity of outsiders.

Among ancient images, Kokopelli and the Horned Water Serpent are shown in abstract form or as outlines, the same way other beings from petroglyphs and pictographs generally are treated. The open print of a human hand, seen at ancient sites, continues to be a valid Pueblo design motif. The spiral also serves as a reference to prehistoric sources and is frequently used to symbolize a journey. The man at the entrance to a maze is a prehistoric motif, possibly Hohokam, adopted liberally by most of the Southwestern tribes for their silverwork.

Human figures based on existing petroglyphs found at Ancestral Puebloan sites also find favor as abstracted representations for jewelry design. Masks and masked dancers are popular motifs, including the Corn Maiden. Realistic human figures are less likely to be depicted but show up by the 1950s and 1960s, often as *olla* maidens. Jewelry depicting humans has become a more secular design option since the 1970s. A few modern jewelers focus on the human face or body, while employing abstraction and symbolism in their designs.

Genuine Pueblo design motifs wed traditional representation with individual preference. A Pueblo jeweler might incorporate the

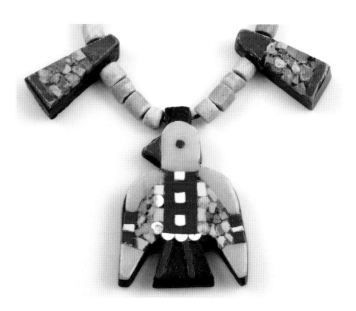

Color was an important design factor in Pueblo motifs; Santo Domingo necklace on gypsum beads, 1940s–1950s. Courtesy of Karen Sires.

Inlaid thunderbird ring
and earrings set show
the Mid-Century Modern
trend toward
abstraction, Zuni, 1950s.
Courtesy of Elizabeth
Simpson.

paw print of his personal clan animal, just as others repeat motifs commonly used in their families. Their actions denote individual choice, and undoubtedly a way around producing designs that the community might not wish to have brought forward.

Pueblo jewelry makers adopted a spirit of determination in what and how they would craft adornment for the ethnic arts marketplace. They knew what they would retain for private use and what they would put out for sale to outsiders. Non-Native pressure for certain imagery could be countered or sidestepped by an ability to make what buyers would want (or settle for). A vocabulary became established by the mid-twentieth century that satisfied consumers' desires while allowing the makers freedom to create works in the spirit of their culture.

Anthropologists investigating Pueblo pottery design generally discovered that the artists conceived of their imagery mentally or in dreams and usually did not draw out the designs they envisioned. Early writers on Pueblo jewelry also discovered that adornment designs were conceived in an identical manner. Even this author, through research and anecdotal accounts from jewelry makers, has found this approach to design conception repeated again and again. When compilations of Native American designs began to be produced by anthropologists and educators, they proved useful resources for contemporary Natives as well as others.

Unsurprisingly, Pueblo pottery was the primary source for these motifs, and various publications utilize drawings from specimens mainly in Southwestern museums. One fundamental attitude was at work at this time. Native cultures, including the Pueblos, were seen as "primitive" cultures and, as a consequence, proved to be welcome design sources for the growing concept of modernism in art and culture. Whether the fanciful outcome of European designer admiration, as in Art Nouveau or Art Deco styles, or the more theoretically measured perspective of Louis Sullivan and his students, primitive indigenous design patterns, elements, and motifs met the requirements of modernist thought.

We know the main concern in making such compilations, especially those of the early to mid-twentieth century, was to preserve designs for posterity. Pueblo design motifs in general were enthusiastically taken up by non-Native American educators as source material for modernist decorative arts application. The reasons for this will be examined in chapter 6. A look at four such design compilations, published in 1929, 1936, 1938, and 1957, shows us works that actually contributed both to Native and non-Native recognition of "typical" visual motifs.

Perhaps the best example of this idea can be found in Beula Wadsworth's 1957 work, *Design Motifs of the Pueblo Indians*. In her preface, the author calls her collection of "abstract design motifs" to be ". . . so vital, so rhythmic, so swift of tempo and free, so direct and efficient that they epitomize the newest modern theories about design."[18] She freely calls her material "Primitive," even capitalizing the word, just as her predecessors do in their earlier assemblages.

Ruth Bunzel, the distinguished anthropologist, subtitled her 1929 *The Pueblo Potter* as *A Study of Creative Imagination in Primitive Art*. Her ethnographic approach claimed individuals worked

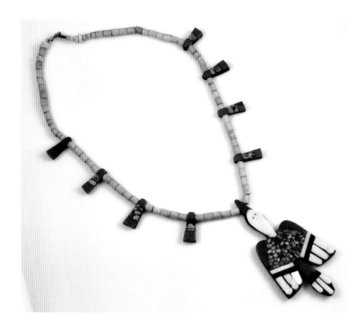

The Peyote Bird, originally a Rain Bird, was adopted by the Native American Church; Santo Domingo Depression-era necklace, 1940s–1950s. Courtesy of Karen Sires.

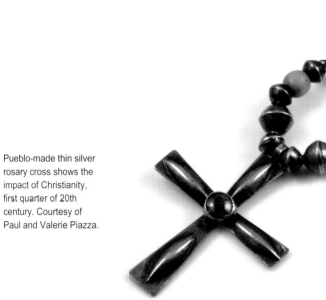

Pueblo-made thin silver rosary cross shows the impact of Christianity, first quarter of 20th century. Courtesy of Paul and Valerie Piazza.

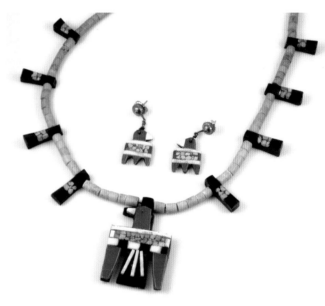

Classic Santo Domingo Depression-era red thunderbird necklace and earrings, 1930s. Courtesy of Elizabeth Simpson.

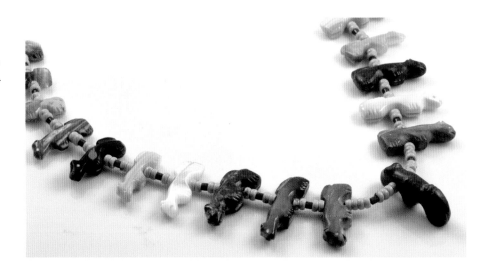

Hand-carved mountain lions, a powerful fetish animal, on necklace by Dina Gaspar (Zuni), ca. first decade of 21st century. Private collection.

within an established framework of aesthetic expression, and asked readers to observe their techniques and styles as a means of seeing into the primitive artist's psyche. Her research led her to believe that potters conceived of the whole design in their minds and created styles that were compatible with the truth of that mental visual image.[19]

Dorothy Smith Sides's 1936 Dover publication, *Decorative Art of the Southwestern Indians,* is a straightforward pictorial resource subtitled *290 Copyright-Free Design Motifs*. She examined both ancient and current cultures from the Southwest and included ceramic, textile, and basketry designs. The images reflect both geometric and naturalistic motifs. Her comments on the peoples and their designs are a mix of unaffected respect and prejudice typical of the times.[20]

H. P. Mera was a museum curator whose published works on jewelry often contained a Navajo-centric bias. Like most ethnographers, he had a deep reverence for early Pueblo pottery. His 1938 study of the region's predominant "Rain Bird" motif provided valuable material for Native artists and non-Native collectors. His focus was on pottery from ten pueblos, starting with Zuni and ending at Santo Domingo. Mera believed that the Rain Bird motif rose from an antique common source, and he endorsed its use by modern designers.[21]

Circling back to Wadsworth's later publication, it's interesting to see these experts work so hard to fit their appreciation of "primitive" art and design to the values of modernist expression. One wonders if the natural and sinuously animated design motifs of the Pueblo, possessing clear-cut elegance, should be described as "primal" design rather than primitive. When we look through Wadsworth's text and images, we see rather stylishly sophisticated patterns and elements: they include elements that capitalize on circles, spirals, dots, and straight lines, as well as curved and wavy lines, which can also be stepped, opposing, or serrated, with borders that feature scallops and points, leaves, and organic shapes. All the source books mentioned above have proved useful to Native artists looking to re-create older imagery, from hooked lines for repetitive borders to the stylized outlines of a Mimbres rabbit.

Thanks to the dissemination of pictorial archives of design motifs, Pueblo design has had great influence in general. It may be helpful, however, to realize that these pictorial compilations also allowed Pueblo design to be copied out of context, altered, and just plain adulterated in recent years. Study of genuine Pueblo object collections, such as the online archive images of the National Museum of the American Indian, should better refresh a designer's perspective.

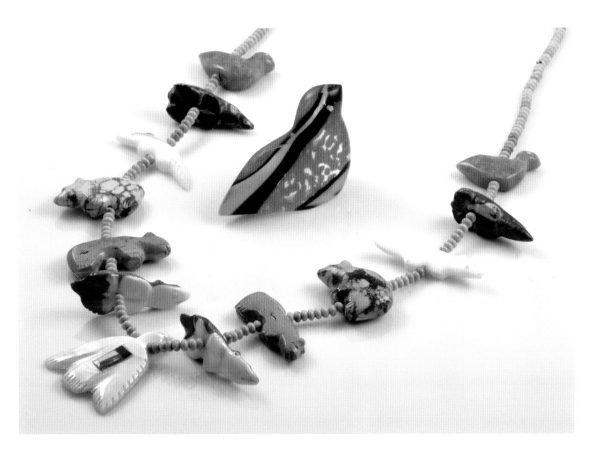

Hand-carved fetish necklace by Lena Boone (Zuni), granddaughter of Teddy Weahkee, surrounds one of her noted glass fetishes, ca. 2010. Author's collection.

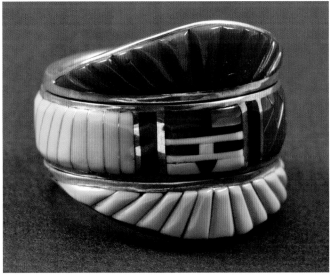

Turquoise-and-coral spinner ring with one of two sun face designs by Don Dewa (Zuni), 2016; the sun face is one of the most popular and most imitated of all Pueblo motifs. Author's collection.

Two 2½" disks with plastic backing and colorful mosaic geometrical and organic designs, 1920s–1930s. Courtesy of Andrew Munana Collection.

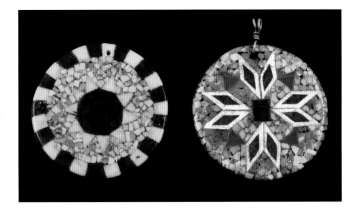

Zuni spinner pendant showing on one side a classic Rainbow Man deity, 14 kt gold, by Fred Natachu, 1990s. Courtesy of Bill and Minnie Malone.

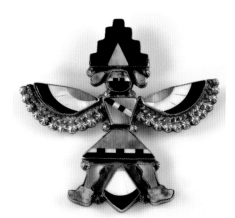

Popular motif Knifewing deity pin with terraced sky cap and flint-edged wings rendered in inlay by Bowman Paywa (Zuni), 1960. Courtesy of Territorial Indian Arts.

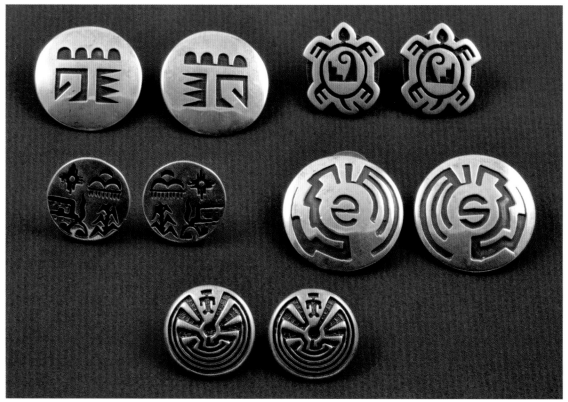

Round Hopi inlay earrings in a variety of designs, including: abstract, turtle, landscape, man in maze, late 20th century. Courtesy of Elizabeth Simpson.

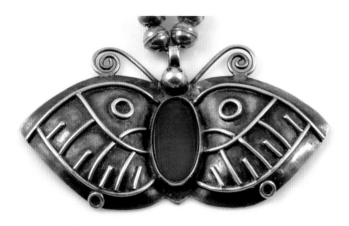

Front of 1930s butterfly pendant, green glass and silver body and beads, made at Garden of the Gods, Colorado. Courtesy of Elizabeth Simpson.

Verso of pendant showing stamp "Handmade by Indians."

Overlay silver band by Bobby Tewa (Ohkay Owingeh), showing water serpent and organic designs, ca. first decade of 21st century. Private collection.

Santo Domingo jet turtle pendant with bead-like shell decoration, mid-20th century. Courtesy of Elizabeth Simpson.

Triangular and tab earrings in bright colors and abstract designs, Santo Domingo, plastic and mosaic stone inlay: (l.) 1940s; (r.) 1950s–1960s. Courtesy of Karen Sires.

Notes

1. Pontello, Jacqueline M. "Inner Worlds, Outer Forms." *Southwest Art* (December 1986), p. 37.

2. Rosnek, Carl, and Joseph Stacey. *Skystone and Silver: The Collector's Book of Southwest Indian Jewelry.* Englewood Cliffs, NJ: Prentice-Hall, 1976, p. 109. Da was the daughter-in-law of Maria Martinez, and the wife of Martinez's son, Popovi Da; she ran the family's gallery for many years.

3. Dubin, Lois. *North American Indian Jewelry and Adornment: From Prehistory to the Present.* New York: Abrams, 1999, p. 482.

4. This can best be seen in Wadsworth's text, where the deployment of border and repetitive elements tend to throw up curves and arabesques.

5. Dutton, Bertha. *The Pueblos: Indians of the American Southwest.* Englewood Cliffs, NJ: Prentice-Hall, 1976, pp. 60–61.

6. Bunzel, Ruth L. *The Pueblo Potter: A Study of Creative Imagination in Primitive Art.* New York: Dover, 1929 (reprinted in 1972), p. 36.

7. Sides, Dorothy Smith. *Decorative Art of the Southwestern Indians.* New York: Dover, 1936 (reprinted in 1961), plate 27 text.

8. Wadsworth, Beula. *Design Motifs of the Pueblo Indians: With Applications in Modern Decorative Arts.* San Antonio, TX: Naylor, 1957, p. 94.

9. Wadsworth, p. xi.

10. Tyler, Hamilton A. *Pueblo Birds and Myths.* Flagstaff, AZ: Northland, 1979 (reprinted in 1991), p. 91.

11. Kline, Cindra. "Santo Domingo Pueblo's Depression Jewelry." *El Palacio* 120.1 (Spring 2015), p. 51. The jewelry's colorful origins have attracted new interest from those who look for Depression-era collectibles.

12. Tyler, *Pueblo Birds and Myths*, p. 223.

13. Tyler, *Pueblo Birds and Myths*, p. 173. Snakes possessed an important role in Pueblo societies. The Hopi snake dances fascinated non-Native observers, who did not always understand the important function of the gathering and dispersal of these reptiles. Snake designs are particularly effective as borders because they employ sinuous lines.

14. Dubin, *North American Indian Jewelry and Adornment*, p. 461.

15. Tyler, Hamilton A. *Pueblo Animals and Myths.* Norman: University of Oklahoma Press, 1975, p. 237.

16. Adair, John. *The Navajo and Pueblo Silversmiths.* Norman: University of Oklahoma Press, 1944, p. 177. Adair's brief statement sounds almost like an afterthought. One wonders what other popular design motifs he could have usefully described had this been a priority observation point for him.

17. Bird, Allison. *The Heart of the Dragonfly.* Albuquerque, NM: Avanyu, 1992. This book not only treats the resemblance of Pueblo-made silver cross necklaces to Spanish Christian rosary cross types but also shows how the dragonfly signifies the Pueblo sun deity and also serves as a design element sign for stars, war, and prayer sticks.

18. Wadsworth, p. xi. She also makes the interesting claim that the Spanish invasion led to the desertion of older designs.

19. Bunzel, p. 87.

20. Sides, plates 26–27.

21. Mera, H. P. *Pueblo Designs: "The Rain Bird"; A Study in Pueblo Design.* Santa Fe, NM: Laboratory of Anthropology, Museum of Indian Arts and Culture, 1938 (reprinted in 1970)

Silver design of prayer plumes on a sun face silver ring by Ronald Wadsworth (Hopi), ca. 2010. Private collection.

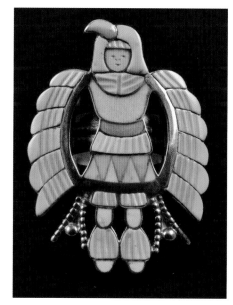

Popular Eagle Dancer ring design by Madeline Beyuka (Zuni), 1980s–1990s. Private collection.

Inlaid Mudhead clown drummer pin pendant by Virgil and Shirley Benn, 1980s. Courtesy of Abby Kent Flythe.

> *"In the beginning, . . . Indian arts were painted pictographs on rocks and decorated pottery. They used man and animal stick figures and many abstract forms. Today, we call those abstract forms 'modernistic.'"*
>
> —**Preston Monongye** (1976)[1]

WHAT IMPACT DID THE MODERNIST MOVEMENT have on

people's appreciation of Pueblo arts? In large part, at least as it originated in Europe, this was a movement calling for other ways of seeing the world, and it brought new attention to Pueblo design. The modernist mode was all about moving away from visual clutter, for returning function to form, and simplifying decoration or ornament as a means of acknowledging the impact of new technology. Abstraction and conceptual art made their debut, along with changing dynamics in building and spatial relationships. These aspects of visual consciousness suited those non-Natives who enjoyed linking modernism with "primitive" Indian expression.[2]

Modern artists had begun embracing "Primitivism" as a desired mode since the start of the twentieth century, exemplified by Pablo Picasso's use of African masks. Modernist master Max Ernst lived in the American Southwest for several years and endorsed cross-cultural design. Artists, educators, and critics believed that adopting the values of primitive art expression would make a more "universal" art for the present.[3] In America, art writers active between 1940 and 1950 encouraged the concept of art drawn from primitive consciousness.[4]

Aided by an influx of art historians exiled from Europe, American art historians resolved to praise the modes of primitive art and culture as being "simplicity and naturalness, power and originality."[5] A romanticized viewpoint? Yes, but it would take the social-consciousness raising of the 1970s and 1980s to fashion a more reasoned academic dialogue about the nature of Native American art history. Leaving theory behind, however, "Primitivism" also conveys the notion of unspoiled, spontaneous vision—imagery stripped to the primal.

To the delight of non-Native scholars and collectors, Navajo and Pueblo design, including jewelry design, possessed visual qualities that were compatible with this early Modernist stylistic quality. These indigenous creations matched the *zeitgeist* of the times. While pottery remained at the top of the list for Pueblo design achievement, non-Native museum professionals were waking up to see design affinities between Pueblo metalwork and Modernist expression.

Native decorative arts of the Southwest ranked high in displaying modernist features. Artists on either side of the Atlantic were searching for avant-garde ways of expressing an original consciousness. The definition of modern style as iconic and timeless made it a good fit with certain Native design motifs. Aspects of adornment design shared compatibility with Art Nouveau and Art Deco building design.

There was a certain cachet about Pueblo arts, from the picturesque "Anasazi" ruins to the exquisite tonality of pottery from San Ildefonso, Santa Clara, or Hopi. Non-Native social leaders, from Mabel Dodge Luhan in Taos to Edgar Hewitt in Santa Fe, encouraged Social Realist artists to view Indian arts and dancing during visits to the Southwest. Some artists maintained their social criticism, such as John Sloan, whose satirical etching *Indian Detour* (1927) showed brash Anglo tourists ignoring Indians performing their ceremonial dances.[6]

During this time, there was a great deal of romanticism expressed about Southwestern Native culture, not to mention the

Modernism Takes Cross-Cultural Root

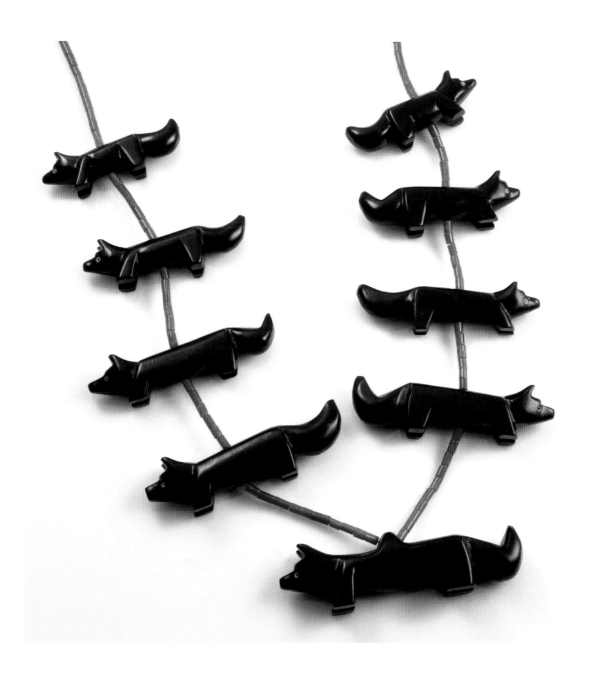

Sleek minimalist foxes by Bernard Homer Sr. (Zuni) adorn this necklace, 1940s–1950s. Private collection.

The Quandelacy family (Zuni) developed superb abstraction in turquoise-and-silver channel work, 1950s. Courtesy of Territorial Indian Arts.

patronizing condescension of non-Natives who felt sure they knew best about preserving "traditional" Indian design. In terms of jewelry, this viewpoint was shortsighted. True, *heishi* creation was an ancient craft, and old-style *heishi* could still be made, but the tide was turning in a forward direction. There would be bumps in the road as museum professionals such as Rene d'Harnoncourt and others argued for Native artistry uncontaminated by the tourist market.[7] Once again, the non-Native experts missed the point: the Indians were always in control of their design process.

The patriotic search for fine-quality American design began when access to Europe was blocked during the First World War. American educators, led by Arthur Wesley Dow, agitated for a national design ethic based on indigenous forms and motifs, free from the omnipresent hand of European fashion leadership.[8] Dow began campaigning in 1915, spurred by partisan purpose for the American fashion industry; he and others seized upon indigenous design motifs as a means of an authentic national identity that could be labeled "our own."[9] Museum collections, such as the American Museum of Natural History in New York, were promoted as a resource for textile and fashion designers.

There were some successes. In 1925 the American silk manufacturer H. R. Mallinson & Co. released a series of American Indian–themed silk prints from various cultures, including a pattern drawn from Hopi motifs.[10] In that same year, the *American Silk Journal* published illustrations by Phoebe Wilhoit that used indigenous designs, including Zuni and Hopi pottery and weaving motifs, as inspiration for then-modern garments.[11]

Anthropologists had already joined the search for Pueblo design as being useful for educational purposes, as we saw in chapter 5. Their pictorial archive collection books were helpful to fashion and industrial designers who sought examples of indigenous arts. Navajo designs tended to receive the strongest accolades. But when we look at those architectural and applied-art designs called Mid-Century Modern, we find that Pueblo design imparts similar characteristics: organic form and clean simplicity in style. Art Deco style also shared decorative elements such as stepped forms, rounded corners, and organically shaped elements.

In America, a homegrown adaptation of the Arts and Crafts movement allowed builders to offer a new look for furniture and dwellings. From this wellspring, architects engaged with the American Southwest created a variant style, soon known as Pueblo Deco. In part on the basis of Art Deco's utilization of romantic themes, from Mesoamerican temples to Scandinavian folk art, American architects such as Mary Colter and John Gaw Meem erected structures that paid tribute to the aesthetics of Pueblo communal structures, Ancestral Puebloan towers, and related edifices.

Pueblo Deco, in fact, is a remarkable example of cross-cultural design influence. It arose during the period when American designers had become intrigued with the "primitive" aesthetics of America's Native peoples. Colter, in particular, was searching for a mode of exterior architecture and interior decoration that melded indigenous and Spanish colonial "cubistic" form.[12] Stepped terraces, decorative recesses, and a powerful sense of measured scale,

A mid-20th-century teenager from Santo Domingo inlaid this deer's head on a large mosaic shell. Courtesy of Andrew Munana Collection.

proportion, and contrast marked this regional style. When we compare Pueblo Deco ornament to Pueblo jewelry, we see an affinity for balanced central pendant adornment that rides high on the structural framework.

Once the belief faded out that America's Indians would pass into assimilated oblivion, new attempts began to boost their reduced economic circumstances through various programs, including the building of an arts-and-crafts market.[13] The notion of handmade craft, bringing money directly to its makers, was also championed by non-Native educators. Ruth Underhill's publication for the Indian Arts and Crafts Board, *Pueblo Crafts*, best represents this viewpoint. She gives scant attention to silverwork in this book, first published in 1945 and then republished in 1953. While she believed that both Navajos and Pueblos first had access to and knowledge of silver around 1850, she claimed that the Pueblo were thought to be less known than Navajo for their work in silver, but admitted that Santo Domingo was currently doing a thriving trade in jewelry.[14]

The crafts label suited Indian jewelry creation for a time, particularly when acknowledging that talent lay in various generations of families, particularly those in Hopi, Santo Domingo, and Zuni. But the role of the craftsperson did not match what was really emerging: full-fledged individualistic vision creating wearable art. It would take moving into the last quarter of the twentieth century before the term "crafts" could fall by the wayside.

As long as Pueblo creations were relegated to a crafts function, jewelry makers could not break out of a market designation that

The double diamonds on this ring echo geometric weavings of the mid-20th century. Courtesy of Steve and Mary Delzio.

The crisp, clean lines on this ring by Jennifer Medina (Santo Domingo) pay tribute to modernist design, ca. 2015. Private collection.

hindered the recognition of individual creativity. By the 1960s, the long-held label of "traditional crafts" started to sound outmoded, and the IAIA established its art college programs. While a number of Pueblo families continued to work in time-honored modes, others began stretching their design vision in new ways that still showed respect for their heritage.

Let us return, however, to the realities of Mid-Century Modern as an impetus for design change. From our twenty-first-century viewpoint, how accurately can the label of "modernist" be applied to Pueblo jewelry design? The answer can best be made by looking at designs created between 1915 and 1950. With stone and silver firmly linked by then, an aesthetic arises that coincides with modernist values. Pueblo designs are clean, effective, and without undue emphasis on any specific elements. When we look for mature mid-twentieth-century designs, however, we need to move our examination to items made between 1940 and 1960.

Changes are subtle but apparent after some investigation and include Navajo designs as well. Keeping our eyes on Pueblo design elements, some characteristics appear to alter, most likely due to individual experimentation. Specific elements include that silver moves to subtler scale and proportion, along with clean lines, while beadwork shows greater variety in contrast, gradation, emphasis, and texture. Other bead changes reflect marketplace modifications. Pueblo silver often emphasizes a smaller scale, undoubtedly for market purposes (which Zuni had adopted several decades earlier), while Hopi silverwork acquires a new stylistic transformation altogether.

What was happening? Tradition and culture, always in effect, are more firmly joined now by individual determination, growing out of the need to experiment and find personal expression. Freed from the idea that his or her jewelry must conform to an ideal traditional craft mode, Pueblo jewelry makers continue to work within their cultural context, but there is now room to make what suits their creativity best.

One way to show this subtle but inevitable change is to examine a specific design motif that has been consistently popular since the nineteenth century. We can turn to an artist active at this mid-twentieth-century time period and compare that individual's work with other contemporary artists, Navajo and Pueblo. The leaf and foliate motif comes to mind, along with an artist whose stylistic approach contains subtle sparks of modernity. One of the most talented individuals at Zuni, gifted both as silversmith and lapidary, is Dan Simplicio Sr. Like other Natives, he served in the US Army during World War II, and his European tour of duty allowed him to view Old World artistic masterpieces. Simplicio was impressed by the bas-relief of Roman laurel wreaths seen on ancient monuments.[15] This inspired him to devise a flattened form of chiseled silver stem with stylized flower that is distinctive from other heavier Native midcentury leaf designs. His foliate motif has been much admired and, unfortunately, also much imitated over the years by less able smiths.

Several other Pueblo individuals reveal the impulses of Mid-Century Modernism in their work during this same time period. While their pieces became most celebrated in the 1970s,

Glenn Pacquin's (Laguna) brass cuff is marked by modernist simple repetitive patterning, showing an affinity with industrial design, 1990s? Courtesy of Steve and Mary Delzio.

This silver-and-turquoise pin mirrors Art Deco ornament, 1930s. Courtesy of Karen Sires.

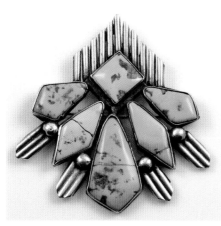

The streamlined channel inlay recalls Mid-Century Modern adornment, by Anselm "Lefty" Wallace (Zuni), ca. 2014. Courtesy of Territorial Indian Arts.

A mid-20th-century belt buckle balances organic silver design with abstract inlay to achieve an Art Nouveau–like aesthetic effect. Courtesy of Steve and Mary Delzio.

these works also compare to those of the White Hogan and Frank Patania Sr. studio Navajo smiths. In fact, Julian Lovato of Santo Domingo worked for Patania both in his Santa Fe and Tucson shops. His clean, incisive silverwork reveals a new aesthetic for Pueblo expression. Joe H. Quintana (1915–1991) of Cochiti also brought innovation to the field. Their contributions will be further discussed in chapter 7.

Just in time to keep the crafts label from reviving, two individuals talented in fine art (which was often not approved by pueblo governance) emerged who drew dealer and collector attention to their skilled jewelry making. These individual artists stand at an apex of sorts in terms of museum-quality work. Charles Loloma began painting murals as a teenager, studied ceramics at Alfred University, and devised silver and gold wearable art that revolutionized all Southwestern Native jewelry design and fabrication. Michael Kabotie, one of the founders of Artist Hopid, created modernist artworks that reveal true cross-cultural appreciation of design, including jewelry that resonated with non-Native connoisseurs. They, too, will be discussed in chapter 7.

Turning to the essential Pueblo bead, design elements also begin to change in the midcentury decades, most notably in the 1950s through 1970s. Key individuals from Santo Domingo were already experimenting with making silver beads for use as *heishi*. Color, form, and shape retain traditional elements, although changes in materials will affect colors. Size and emphasis allow variations to be tried out; most often, these alterations can be seen in cluster work dance sets or beads at the bottom center of a strand.

Rarely are Pueblo colors garish or necklace shapes absurd. Marketplace demands are being considered, while conservatism still drives the making of adornment required for dances and ceremonials.

Two Santo Domingo *heishi* makers have had their bead innovation treated in published articles, an unusual event. Charles Lovato, the pueblo's sole active fine artist, was profiled in an Arizona magazine upon the occasion of an exhibition of his works in Scottsdale in 1976. Lovato's modernist usage of symbols and abstraction in his artworks clearly informs his jewelry making, which in turn influenced other Native *heishi* makers. Lovato's gift was to recharge the traditional *heishi* style into high-end compositions through a skillful process of integrating metal beads into the stonework, which was shaded into beautiful tones that move from dark to light.[16] He worked other colors, from turquoise and melon shell, into artful color combinations and made his beads intricate and gradated. Lovato also created liquid gold necklaces (see chapter 7) from 14-karat gold, adding gold nugget beads as design touches.

A 1998 article in the *Indian Trader* paid tribute to the long career of Augustine Lovato, who learned to make beads from his parents in the 1930s. After service in World War II, he worked for the Sun Bell Company until 1971 then set up his own business.[17] Augustine was traditional in his approach to jewelry making, which brought him many local customers seeking ceremonial *heishi* necklaces. His pieces were large scale and made with high-grade turquoise, stabilized Bisbee and Morenci being his favorites. His *jaclas* with corn elements at the bottom were outstanding, but the boldness of his

Exterior decorative detail from the KiMo Theatre (1927) in Albuquerque, New Mexico, built in the Pueblo Deco architectural style—a Route 66 landmark.

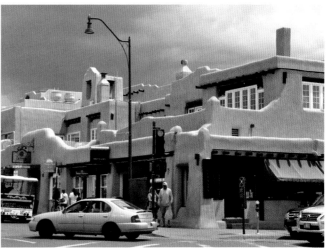

The Pueblo Revival hotel, La Fonda, in Santa Fe, New Mexico, had close associations with the Santa Fe Railroad and the Fred Harvey Company from the 1920s through 1960s.

designs showed younger bead makers a standard to measure their work against.

Navajo and Pueblo silverwork created prior to the mid-twentieth century was often difficult to tell apart. Starting in the 1960s and blooming more fully in the 1970s, distinctions begin to grow that allow jewelers' origins to stand out more clearly. We see this most markedly in the example of Hopi overlay, which originated as a tribal style in the 1940s and 1950s and shows a decidedly modernist approach to the play of dark and light tonal qualities and clear, direct design motifs. This new style initially emerged as a collaboration between non-Native museum professionals and Hopi smiths, but, as always, the design conception reflects the artists' aesthetic vision, one that would grow in the decades ahead.[18]

The sharp visual patterning of the former Indian Hospital on Lomas Blvd., Albuquerque, New Mexico, built in 1932–1934, reflects Pueblo Deco design.

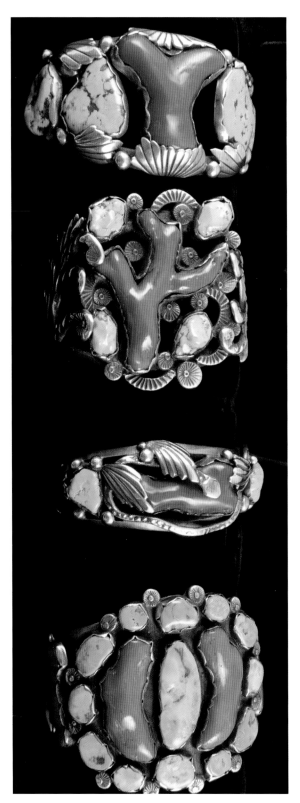

Dan Simplicio Sr. made stunning turquoise and branch coral pairings, framed by modernist foliage in silver, 1940–1960. Courtesy of Karen Sires.

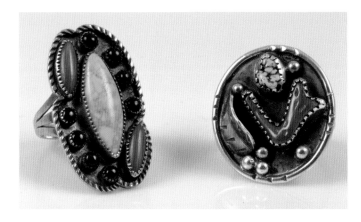

These two mid-20th-century rings have a leaf and foliate style that Dan Simplicio Sr. would flatten and transform. Courtesy of Elizabeth Simpson.

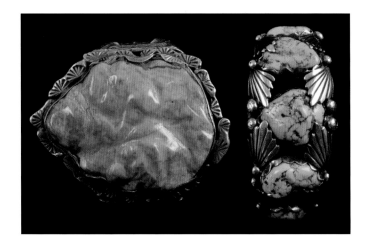

Simplicio's carved and nugget turquoise cuffs are enhanced by his personal decorative style, 1940–1960, and are now widely imitated. Courtesy of Karen Sires.

This lively silver, ironwood, and turquoise pin by Preston Monongye, 1980s, pays an indirect tribute to bead forms. Courtesy of Abby Kent Flythe.

Two generations of modernist aesthetics: (l.) organic silver "squash" blossom necklace by Joe H. Quintana (Cochiti), ca. 1950s; and (r.) dragonfly pendant by his son Cippy Crazyhorse, 1990s. Private collection.

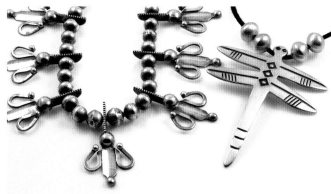

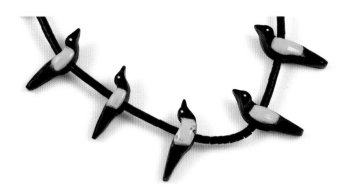

Jet blackbirds with turquoise wings fetish necklace (Santo Domingo?) retains an unadorned mid-century appeal, 1970s. Courtesy of Steve and Mary Delzio.

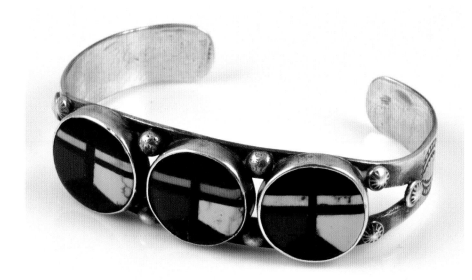

An unusual inlaid bracelet from the 1920s with abstract color circular designs. Courtesy of Elizabeth Simpson.

Pueblo bead makers indulge in a modernist legacy of bold hues and new materials that shake up traditional practices, 1980s–1990s. Private collection.

Veronica Poblano (Zuni) creates a retro period playfulness with this necklace in marcasite and black onyx, 2014. Author's collection.

Notes

1. Rosnek, Carl, and Joseph Stacey. *Skystone and Silver: The Collector's Book of Southwest Indian Jewelry.* Englewood Cliffs, NJ: Prentice-Hall, 1976, pp. 113–114.

2. Rushing, W. Jackson. *Native American Art and the New York Avant-Garde.* Austin: University of Texas Press, 1995, pp. 4, 7. The year 1915, the start of the Panama-California Exposition in San Diego, marks the beginning of an intellectual interest in cultural primitivism, inspired by the exposition's featured design of the Maya, Aztec, and Southwestern US Native cultures. A fascination with the "Other" already existed. Connections were now made between pre-historic-era designs and modern early-twentieth-century American Indian aesthetics.

3. Rushing, p. 126. These ideas were explored by Wolfgang Paalen, author of "Totemic Art," Max Ernst, and Barnett Newman, among others. Newman was an active ". . . critic and curator of primitive and primitivist art from 1944 to 1947."

4. Rushing, p. 123. These critics' ideas, in turn, were shaped by C. G. Jung's theories about the primitive consciousness; in turn, they became embedded in John Graham's influential compilation *System and Dialectics of Art* (1937).

5. Minor, Vernon Hyde. *Art History's History.* Upper Saddle River, NJ: Prentice-Hall, 2001, p. 209.

6. Rushing, p. 68.

7. McLerran, Jennifer. *A New Deal for Native Art: Indian Arts and Federal Policy 1933–1943.* Tucson: University of Arizona Press, 2009, p. 26. This appears to be a bias against tourist arts as "low art" versus fine arts as "high art," which experts felt should be championed.

8. Tartsinis, Ann Marguerite. *An American Style: Global Sources for New York Textile and Fashion Design, 1915–1928.* New York: Bard Graduate Center, distributed by Yale University Press, 2013, p. 13. Dow wanted a "distinctly American design" that would become "a new period style for our own needs." National designs were not a new idea. In the nineteenth century, Napoleon had commanded the Empire Style into existence, while England's Prince Albert and art critic Henry Cole had advocated a National Design curriculum to curb industrial manufacturing excesses.

9. Tartsinis, p. 30.

10. Tartsinis, p. 115. Leon Bakst had created the Hopi designs in 1924.

11. Tartsinis, p. 91.

12. Breeze, Carla. *Pueblo Deco.* New York: Rizzoli International Publications, 1990, p. 8.

13. Burton, Henrietta. *The Re-establishment of the Indians in Their Pueblo Life through the Revival of Their Traditional Crafts: A Study in Home Extension Education.* New York: Teachers College, Columbia University, 1936 (reprinted in 1973), p. 83. Her study offered logical steps toward boosting sales through roadside markets, established markets, recreational activities tied to crafts sales, and—quite interestingly—using more Indian designs in interior decorating.

14. Underhill, Ruth. *Pueblo Crafts.* Lawrence, KS: Haskell Institute; Bureau of Indian Affairs, 1953, p. 123.

15. Bulow, Ernie. "West by Southwest: Zuni Silversmith Dan Simplicio Sr.; Challenging Tradition." *Gallup Journey* (September 2011), p. 2. Simplicio mentions Roman laurel leaf wreaths as inspiration. In an earlier career, I worked extensively with Roman art; Simplicio was taken by the Hellenistic-era stylized foliate forms in stonework that the Romans preferred, which are flatter than Classical Greek–era vegetation carvings.

16. Magee, Anne. "Charles Lovato at Main Trail: 'What the Mind Sees.'" *Arizona Living* (April 29, 1976) (3 pp.). Lovato is remarkable for having a career as an easel painter, which was not an approved venue in Santo Domingo, along with making pottery and jewelry, while maintaining a good balance of traditional pueblo and modern lifestyle.

17. Yokoi, Rita. "The Artistry of Augustine Lovato." *Indian Trader* (April 1998), p. 10.

18. Harold and Mary-Russell Colton of the Museum of Northern Arizona worked with Hopi smiths on the development of the Hopi overlay style and provided a venue for this work at the museum. The overlay technique itself—with its strong sense of depth and contrast, clean geometric lines, and distinct motifs—was both modernistic and yet very much in line with Hopi design vision.

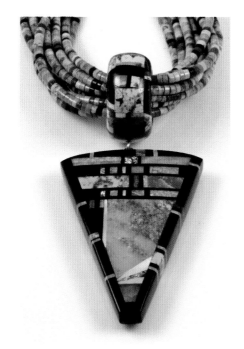

Chris Nieto's ceramic pendant on multistrand *heishi* has an Art Deco–era feel. Private collection.

More than twenty strands of delicate monochrome tortoiseshell *heishi* maintain the fluidity of modernist design, mid-20th century. Courtesy of Territorial Indian Arts.

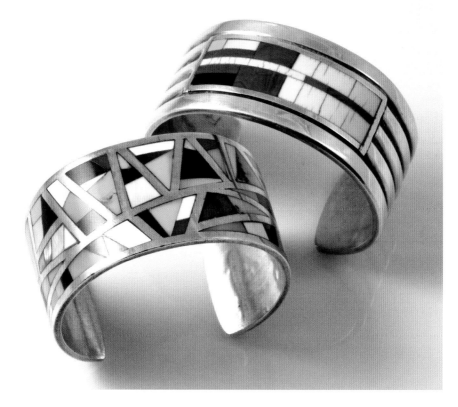

Two channel inlay cuffs with abstract geometric and angular patterns, mid-20th century. Courtesy of Elizabeth Simpson.

CHAPTER 7

" I let my jewelry speak to those who wear it. All the good things I think, I say through my jewelry. When I am finishing something, I am happy, and I sing. "

—Joe H. Quintana (1983)[1]

COMPARED TO SHELL AND TURQUOISE, which possessed sacred associations, the Puebloans viewed silver as a secular material. They had been exposed both to gold and silver ornaments and were familiar with silver table services and bridle gear brought by the Spanish colonists. Living in relative proximity to the settlers, and often forced to work for them, it's reasonable to assume that Pueblo Indians understood the value of this metal. Certainly they took note of Spanish silver filigree work and twisted-wire decoration. In the 1820s through 1840s, when Mexico ruled New Mexico, numerous itinerant *plateros* (metalworkers) came north; Natives of northern New Mexico could observe many examples of drawn silver wire for filigree work made in this period.[2]

Several accounts claim that the Zunis were working brass and copper in the 1840s and had a forge in the pueblo by 1850.[3] Navajo and Pueblo individuals likely learned iron mongering from Mexican, and later American, army smiths. Therefore, by the mid-nineteenth century, a general interest in metalworking would have been fairly common. No smoking-gun evidence exists, however, to refute John Adair's claim that Pueblo peoples learned silver craft from Navajos. Whatever the circumstances, the Navajo were quickly established as the transmitters of silver craft.

Even Edward Curtis, who photographed the Navajo, Hopi, and Zuni in the first years of the twentieth century, wrote that the Navajo had been the first silversmiths. After Adair's landmark fieldwork of the 1930s, named Navajo individuals were firmly established as the means of transmission to other tribes. In terms of the Puebloans, former enemies and now friendly neighbors, the process was likely one of reciprocal obligations between individuals of the two peoples.

There were never as many Pueblo silversmiths as Navajo. This was because the Navajo were more numerous and far flung. Many Pueblo individuals were involved in farming, and some of those who lived near cities went to work for curio shop owners. Nor were there as many traders for most of the Pueblos. The exception to this was Zuni, which was closer to the Navajo reservation than the eastern Pueblos, along with proximity to Gallup and the railroad. Hopi, the most remote location of all, did not develop a strong silverwork tradition until the 1940s; given the cultivation of other Hopi crafts, pottery, basketry, weaving, and *katsina* carving, this occurrence is understandable.

Adair's *Navajo and Pueblo Silversmiths* has been a longtime guidebook for scholars and collectors. Nevertheless, even the finest researchers can be guilty of exaggeration on occasion. Adair's claim that the best Pueblo silversmiths were practicing in the nineteenth century and were absent between 1900 and the 1940s (p. 172) smacks of hyperbole. The first forty years of Pueblo silverwork in the early twentieth century is actually a period when distinguished individuals were learning or practicing. Zuni was home to a number of smiths, including Juan de Dios and Horace Iule, who taught Indian students during this time. Margaret Wright's groundbreaking research on Hopi silverwork offers us a number of established individuals: Grant Jenkins, Pierce Kewanwytema, Frank Nutaima, Morris Robinson, Washington Talayumptewa, and Ralph Tawangyaouma operated within that time frame. Master smith Paul

Solid to Liquid Silver Beads

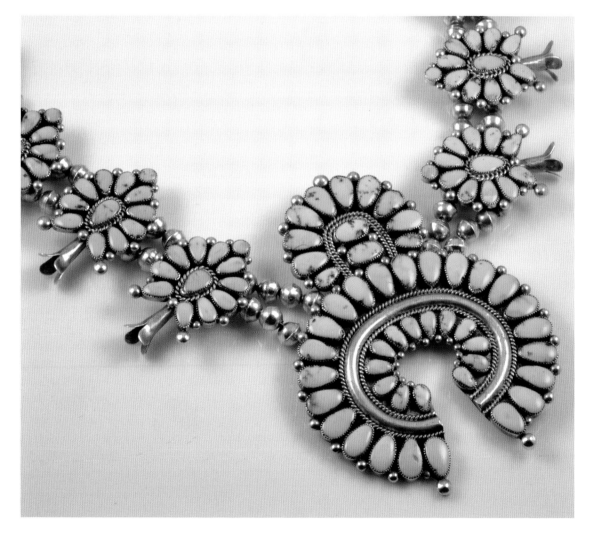

Zuni cluster work unites silver and stone at its best: a piece by Alice Quam, 1970s. Courtesy of Bill and Minnie Malone.

Pueblo silver was influenced by Spanish-inspired filigree work, 1930s–1940s. Courtesy of Andrew Munana Collection.

"Snake eyes" row bracelet evokes beads in design, 1950s. Courtesy of Elizabeth Simpson.

Saufkie learned to work silver in the 1920s and would go on to help take Hopi silversmiths in a new direction with the overlay technique.[4] Lewis Lomay (Lomayesva) of Oraibi was taught the craft in 1930, working tirelessly to create what would become award-winning pieces in following decades.[5]

To be fair, there were documentation problems with sorting out Rio Grande smiths of the early to mid-twentieth century. Many smiths moved about between pueblos, pursued multiple arts in multiple locations (such as San Ildefonso's Alfonso Roybal, a.k.a. Awa Tsireh), went to work for curio shops in Albuquerque, or studied jewelry making in general at the Santa Fe Indian School. Some individuals traveled as far as Phoenix or California to work in shops managed by non-Natives. A few, such as Alvin Concho Lewis of Acoma, just fell through the wide cracks in research during this time. Adair later went on to study jewelers at Zuni Pueblo and soon found difficulties in sorting out its myriad families of lapidaries and smiths.[6]

Many Pueblo smiths proved to be very facile silver workers. A number were already adept lapidaries, and particularly good at fashioning silver beads. Looking at early Pueblo-made silverwork (when it can be identified as such), it isn't difficult to extrapolate that the rounded or bead-like shape, initially created for shell and stone adornment, served as a basis for metal decorative design. The "raindrops" or "dots" (or "shots" as some contemporary Pueblo smiths call them) do figure prominently on silver creations. Even the proliferation of small cabochon stones resemble beads; the fondness for these circles or ovals runs steadily through Pueblo design elements and motifs.

Some Pueblo silverwork exhibits the influence of embellished Spanish metalwork and leather decoration. Punches and dies favored "organic" elements (such as cornstalks) and the active use of silver wire in rich scrollwork. Zuni's many silversmiths swiftly received recognition of their own; writers on jewelry credited the post-1890 trend toward incorporating small stonework on silver as a Zuni innovation. Yet, when the new century progressed, Zuni and other Pueblo silver pieces often did not match the size and heavy-gauge proportions that Navajo work achieved. By the mid-twentieth century, the Zunis had cleverly created a dual pin/pendant backing for these jewelry forms, and even a delightfully two-sided "spinner" shape for pendants.

A distinctive category of Pueblo-made adornment was the silver cross necklace, made principally in the Rio Grande area. Isleta became known as a center for such work. The story of how Pueblo silversmiths created fine necklaces that pleased Hispanic Catholic priests as supposed rosaries, all the while incorporating symbols of their now-underground religion, has been aptly told in Allison Bird's *Heart of the Dragonfly*.[7] These necklaces joined silver squash blossom necklaces in popularity. The silver petals of the "squash" beads were more likely viewed as blossoms, possibly sunflowers, by Puebloans, rather than the Moorish pomegranate bead shape adapted by Navajo smiths.[8]

The Puebloans first crafted large, round silver beads since they were the easiest to make; they were domed hemispheres that later became soldered together to shape a globular hollow bead.[9] Reports claim that only the pueblos of Acoma, Isleta, Laguna, and

Zuni were making silver beads in the 1870s; these were the same sources that maintained the Zunis were the first to add more stones in settings.[10] Ruth Underhill rather obscurely reports that delicate openwork and multiple turquoise stones characterize the "old pueblo manner."[11] Bird's research found that the shapes of the silver beads used on cross necklaces varied, depending on what kind of dap the smith utilized to dome each half of the bead before soldering; most of these cross necklaces were made in the period between 1880 and 1910.[12]

This, of course, did not mean that the form died out, and occasionally even lightweight tourist versions of the Pueblo cross necklace were made up to and through the 1960s. Red coral glass beads were utilized to make the finials for some cross necklaces, and these beads became so popular that they were utilized for necklaces with an attached silver double-barred cross or dragonfly form. An interesting "old-fashioned" touch was the addition of small items such as pieces of seashell to these cross necklaces [13] After 1980, spirited revivals of the cross necklace were created as a tribute to Pueblo old-style design.

Pueblo silver workers started out with classic designs with clean lines in the 1910s through 1930s and became more decorative over the next decades by adding wire openwork and organic stamping. Individuals such as Lewis Lomay and Julian Lovato matched Navajo counterparts in meeting the demand for sweeping unity and harmony of design; their bracelets, necklaces, and pins retained Mid-Century Modern design elements. The silverwork of Morris Robinson (1901–1984) is especially indicative of the trend toward

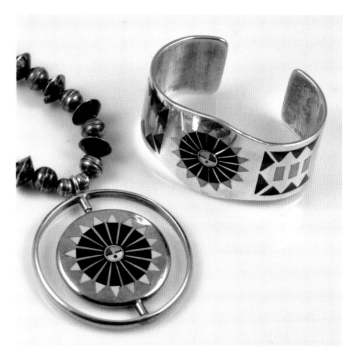

Spinner pendant by Fred Natachu (Zuni) with matching bracelet, 1960s–1970s. Courtesy of Elizabeth Simpson.

Early hollow-formed silver beads strung with "padre" glass beads on a rosary (cross shown in chapter 5), early 20th century. Courtesy of Paul and Valerie Piazza.

making shape expressive on its own, and he inspired other Pueblo smiths, including his nephew Charles Loloma. In the late 1950s into the 1970s, a second wave of interpretation arose from the works of Loloma and Preston Monongye: their interest in building innovative jewelry forms presaged the high-end market direction that many new jewelers would take by the end of the 1970s.

Once the Pueblos were producing silver beads, several other necklace types emerged. Zuni and scattered artists from other Pueblos made squash blossom–type necklaces combined with their lapidary proficiency in channel work, cluster turquoise settings, and needlepoint and petit point stonework. One of the most talented mid-twentieth-century Pueblo artists in creating squash blossom necklaces with a potent plant design element was Joe H. Quintana of Cochiti. By this time, various Pueblo artists began exploring making what outsiders saw as a quintessentially "Navajo" jewelry form: silver beads that resembled non-Native pearl necklaces.

Santo Domingo and Zuni were the sources for fine fetish necklaces, strung with and without beads. The early-twentieth-century Zuni-made necklaces were usually created with tiny birds; Santo Domingo necklaces feature birds only, since other animal forms were frowned upon. Expert early- to mid-twentieth-century Zuni carvers whose creations were strung with *heishi* or set in silver jewelry were Leekya Deyuse (1889–1966), Leo Poblano (1905–1959), and Teddy Weahkee (1890–1965). Leekya and Weahkee were employed at the archaeological excavation of Hawikuh Pueblo, and their study of the carved stone artifacts would influence future Zuni

design.[14] By the 1950s, Zuni and Navajo artists were carving multiple small animal figures for adornment. Starting around the 1980s, some artists—including Eddie Beyuka, Porfilio Sheyka, Shirley and Virgil Benn, and Dale Edaakie—created necklaces with inlay animals instead of miniature fetish animal carvings.

One of the best-documented collections of Native jewelry is that of C. G. Wallace. His collection, now in the Heard Museum, clearly demonstrates the powerful contributions of Zuni jewelers, revealed in Deborah Slaney's 1998 exhibition and catalog, *Blue Gem, White Metal: Carvings and Jewelry from the C. G. Wallace Collection*. She focused on the twinned lapidary and silver achievements of influential Pueblo jewelry makers, with particular emphasis on master carvers, mosaic overlay and inlay, casting, the nugget style, channel inlay, cluster and row work, and petit point and needlepoint. In the section on casting, works by Horace Iule (ca. 1900–late 1970s) and Juan Dedios (active 1910s–1940s) are shown. Both men trained many young Zuni students in silversmithing during the early to mid-twentieth century.[15] This fact again rebuts Adair's claim that Pueblo smiths produced less and received less training in silverwork during the first four decades of the century.

Pueblo smiths were experienced in handling copper, brass, and silver. What proficiency did they have with working gold into fine jewelry? In fact, Pueblo efforts may have outstripped Navajo endeavors. Lois Dubin claims that Morris Robinson, a Hopi, constructed a gold bracelet in 1929.[16] Charles Loloma reportedly first worked with gold in 1953.[17] Given the wide range of experimentation going on—especially when Native artists later studied with

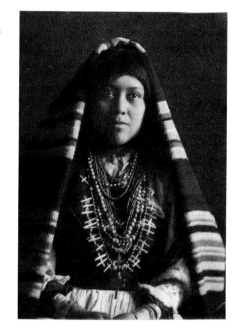

Postcard created from a 1906 photograph of an Isleta woman by Karl Moon; he had a studio at the Grand Canyon in the early 20th century. Private collection.

high-caliber non-Native jewelers who set up workshops in Santa Fe, Scottsdale, and Tucson—the late 1960s and early 1970s confirm an active launch period for investigation of gold fabrication. Julian Lovato learned from the senior Frank Patania. Master jeweler Pierre Touraine taught high-end Pueblo jewelers, including Ted Charveze (1936–1990) and Phillip Honanie, how to be comfortable using non-traditional materials such as gold and diamonds.

Gold was a problematic material on several levels. Its high cost and relative scarcity, compared to silver, was a major factor. As a metal, gold was softer to work, and smiths were careful to hoard any particulate dust while working; nor could gold be hammered as effectively as silver. Unlike in Mesoamerica, where gold worked by Natives was a tradition, there was no established taste for the material. Those Southwestern Native artists who took up gold-smithing inevitably became high-end jewelers whose gold fabrications appealed to non-Native consumer tastes. Hopis Preston Monongye, Emory Sekaquaptewa, Victor Coochwytewa, and Duane Maktima worked with gold, along with Loloma's niece Verma Nequatewa (known as Sonwai). At Zuni, Dennis Edaakie, Alice Quam, Lee and Mary Webothee, and Edith Tsabetsaye made gold adornment. Other Pueblo smiths utilizing gold include Richard and Jared Chavez and Harvey Chavarria.

By the mid- to late twentieth century, many Pueblo artists experimented with adding gold touches to silver adornment, and round decorative elements sometimes were fashioned using gold wire.[18] The most interesting pairing with another material came with the creation of bracelets, rings, and pendants of high-grade

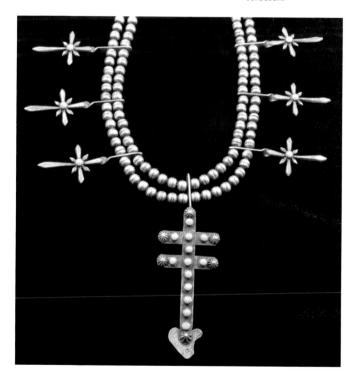

Lightweight cross necklace with bead-like cabs, probably for tourist trade, 1950s. Private collection.

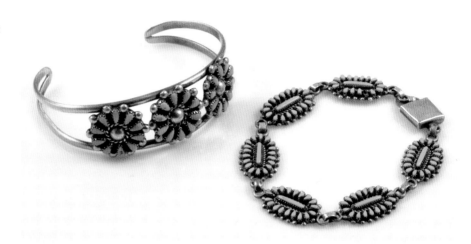

Zuni children's bracelets: (l.) cluster cuff, 1960s; (r.) petit point links, 1980s. Courtesy of Bill and Minnie Malone.

turquoise set in gold. The yellow luster of gold made a strong framework for the robust beauty of stones from acclaimed Southwestern mines, along with imported Persian turquoise, both catering to a booming collector demand. Pueblo bead makers also sought high-quality turquoise when they could afford it, and even made gold findings for some pieces. After 1980, artists added gold as a material of choice, and more frequently mixed gold and silver elements on single pieces, such as bolos.

A landmark creation took place in the 1950s, representing the ultimate development in bead making. Ray and Mary Rosetta of Santo Domingo fashioned silver *heishi* with fine beads one-sixteenth of an inch in diameter. They created hand-drawn silver and cut the tiny, fine tubes into a lustrous cascade of minute beads. The name for this new metallic version of an ancient adornment came in 1957 from Lillian Young, an Albuquerque resident, who stated that the necklace she was handling felt like "Liquid Silver."[19] The Rosettas' son Johnny and his Hopi wife, Marlene, joined the family design enterprise. They worked with hand-drawn 23-gauge sheet silver, which was cut, half rounded, with tubing made from points pulled through a drawplate; this material was then cut, strung on fine wire or nylon cord, and carefully polished.[20] They followed this success with Liquid Gold, which was advertised in various California galleries through the 1960s and 1970s.

Liquid Silver—and Liquid Gold—were ingenious reaches, making *heishi* by hand from fine silver tubing. Nevertheless, the costly materials and laborious process were quickly threatened by manufactured imitations that undercut the price and exclusivity of

the genuine article. Mass-produced liquid silver–style necklaces could be found by the dozens in Indian arts shops by the 1980s, ensuring that less discerning buyers flocked to the cheaper and easier-to-obtain product. The Rosettas deserve critical acclaim for their creative artistic achievement, and their metal *heishi* possesses a proud hallmark.

Experimentation with variations on pre-1940 classic design marks the 1950s through 1970s. Pueblo bead makers and smiths altered texture, tone, and contrast when combining carved stone and silver. *Heishi* necklaces could now be punctuated with small silver beads, often as interval spacers or decorative contrast. The rolled bead color could be blended after 1968, when Clara and Charles Lovato—accidentally—created a technique that shaded the colors in a necklace while stringing the beads.[21] Carved turquoise organic forms, animal and vegetal, mounted in silver settings drew collector interest. Tumbled turquoise nugget beads, accentuated by metal spacers, began to develop in the 1960s.

This time period coincided with the new growth and development of fetish carving at Zuni and a few other pueblos. Previously, carvers traditionally chose animals used in hunting or representative of the Six Directions. Young artists now made a wider variety of figures, including even dinosaurs and exotic wildlife, and began using new materials. This change paralleled the declining availability of coral and turquoise, so carvers sought out new local and interesting natural minerals. Birds, mammals, and reptiles not previously considered appropriate attracted more collector enthusiasm. By the 1970s, some carvers chose to make silver

Traditional *heishi* styles continue to flourish; a classic tab turquoise necklace with coral *jaclas* by Ike Lovato (Santo Domingo), ca. 1965. Courtesy of Eason Eige Collection.

Silver-and-jet old-style Pueblo cross necklace by Mike Bird-Romero (Ohkay Owingeh), ca. 2010. Private collection.

Spiny oyster shell double-strand dance necklace wlth *Jaclas*, attributed to Augustine Lovato (Santo Domingo), 1970s. Private collection.

pendant mounts for their fetishes, although the animals they chose tended to be market-driven selections such as bears and horses.

During the 1950s influential individuals such as Lloyd Kiva New and certain Indian traders began pushing the concepts of fashion and costume jewelry to Native jewelry makers. Some *heishi* makers, especially in Santo Domingo, began to create small changes in design elements. Bead shapes, ranging from drum to barrel to fluted ovals, appeared on stone and shell necklaces as interval spacers or decorative contrast. The idea of adjustable balance through gradation and repetitive forms was being reestablished.

Mainstream Non-Native jewelry styles, such as pearl chokers and strands, influenced Native jewelry making at this time. Graduated silver bead necklaces, with the largest bead centered at the bottom, had been made as early as the 1930s, but now beads became embossed, fluted, or even inlaid on the central bead. Some bead makers chose to place differing beads at the bottom of a long necklace. The next step was to change bead shape: a melon seed bead is an elongated bead made from 28-gauge silver strips, molded into boat-shaped cavities with a punch and die set, and sealed with wire solder.[22] Some melon bead necklaces are strung with small conical beads spaced between the longer beads.

Turning to another popular jewelry form, earrings, we see just how significant the bead was in determining design choices, including those made of silver. Pueblo earring design conformed to Spanish decorative modes. This point was often lost by early writers on Native adornment. Robert Bauver's *Navajo and Pueblo Earrings* (2007) restores and documents this early connection. The book is based on the collection of noted New Mexico art dealer Robert Gallegos. Bauver chronicles the key designs: mosaic tabs, bead *jaclas*, and silver dangles. The most-popular earrings derived from Spanish dress ornaments. These styles generally were dangles, ranging from narrow pomegranate shapes to filigree drops and oval, tiered drops of silver and stone. These, along with delicate openwork *coquettas* possessing fan or shell motifs, were the most popular late-nineteenth-century designs. Gallegos was able to collect fine filigree work from Acoma, Isleta, Laguna, and Zuni.[23] Beads appear in many earring styles, but the most common one is a silver hoop threaded with one (or more) bead-like balls.

When we again review J. J. Brody's 1979 comment, quoted in the introduction, where he claims that Pueblo jewelry made for consumer/outsiders "has artistic validity that appears to be irrelevant to its artists," we now can better understand what prompted that remark. Non-Native arts experts and specialists, rooted in an anthropological background, were most interested in Indian arts that expressed cultural relevance. The marketplace success of Pueblo (and Navajo) arts by the 1970s displeased these experts because it meant that Native artists were very much in control of their design and where they wanted it to go for economic success. Instead of conforming to spiritual or academic expectations, Southwestern Native artists were discovering their own means of handling tradition, culture, and personal expression. Not to mention making a living.

Something really did happen in the 1970s to make Pueblo (and other Southwestern Native) jewelry a more thoroughly established

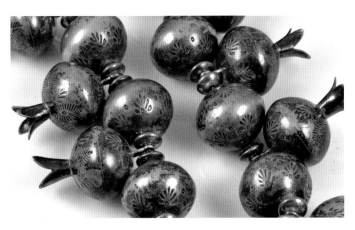

Squash blossom necklace with large stamped silver beads and inlay *naja*, mid-20th century. Courtesy of Steve and Mary Delzio.

Close-up of beads.

Tubular silver bead necklace on cotton wrap, 1960s–1970s. Private collection.

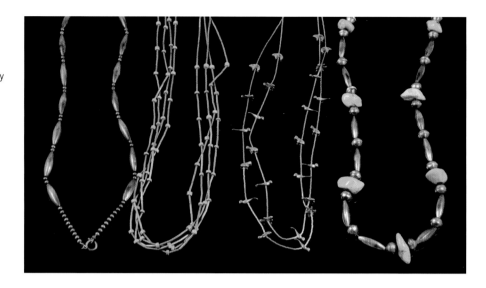

Four tourist necklaces showing changes in tubular silver beads, 1950s–1970s. Courtesy of Steve and Mary Delzio.

and viable industry. There were, of course, a number of social factors coming together: better tools were more accessible and more affordable; good-quality turquoise, local and imported, was actively available; many young men were coming home from Vietnam seeking independent employment; and somehow the word of a "boom" in Native jewelry had piqued general interest.

Being more attuned to the marketplace accelerated jewelry design development. Native artists could view mainstream jewelry designs in regional department stores, as well as specialty shops in arts centers such as Scottsdale and Santa Fe. Soon, earrings shaped like buttons sported sun face designs, and *jaclas* were scaled down to meet the proportions of feminine business dress. New's comments on fashion were absorbed by more than just his students at IAIA, and many of them went home to spread the word. As Native jewelers became exposed to a wider variety of mainstream jewelry fashions, Pueblo bead shaping and stringing grew more expansive, although original designs remained the point of departure.

An unexpected and welcome picture of the times emerges from a 1976 article in *New Mexico Magazine*. "The Jewelry Heritage of Santo Domingo" opens with a description by author Florence Hawley Ellis of the first Arts and Crafts Fair at Santo Domingo in July 1975. There had been much internal argument in the pueblo's council before agreement, and Ellis was there to witness the fair's success. She noted the great collaborative effort, as well as the policing of booths to ensure that original items were sold, and even mentions how a "thousand necklaces" were on offer along with

many other jewelry forms. What is most fascinating is her description of how these pieces "varied from the old conservative to ultra-modern designs that could have been at home in a city studio."[24] She went on to note the social changes since World War II that led up to this event, including the changeover to a cash economy, and the fact that making jewelry would prove a lucrative way to stay home in the pueblo. Much of the rest of the article recounts facts known, and an outdated claim that Santo Domingo artisans did not invent *heishi*. The author repeats the notion that early-twentieth-century Santo Domingos were noted traders, and claims that the jewelry makers used lesser-quality turquoise since "in that period good turquoise was largely commercial and went into shops."[25]

Such articles, however, are the exception rather than the rule for the decade. Only when the 1980s came and Native artists emerged with firmly established identities as artists did documentation pick up pace. Anthropological "fluorescence" could finally fade away, as Native self-determination in the arts became matter of fact.

While the 1970s served as a turning point toward true artistry in Southwestern Native jewelry creation, the decade also ushered in a dark cloud of annoying fakes and reproductions that would characterize much of the low-end market for years to come. It seems extremely unfair that Native artistry should be vandalized in this manner, but when antique, vintage, and stylish contemporary Indian jewelry developed a strong market identity, the same type of black market that haunts most categories of arts and antiques snapped into place, including imitation Pueblo adornment.

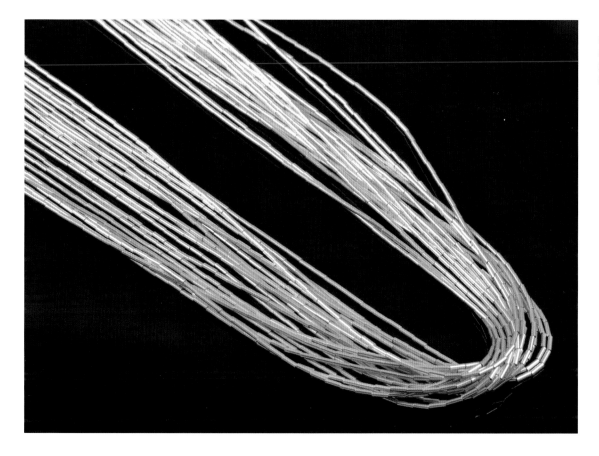

Close-up of "Liquid Silver" *heishi* beads, 24", 1990s. Courtesy of Steve and Mary Delzio.

Charles and Clara Lovato *heishi* necklace in graduated colors, 1970s–1980s. Courtesy of Abby Kent Flythe.

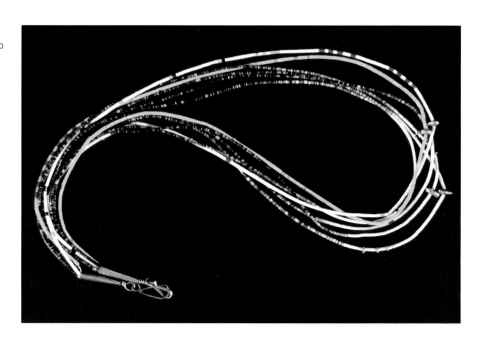

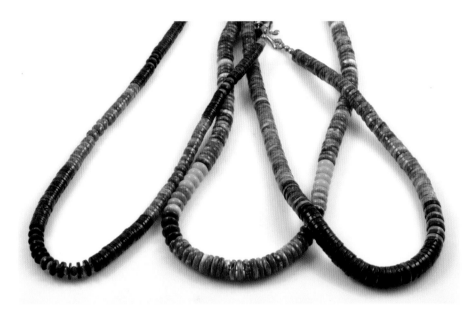

Three single strands of spiny oyster shell beads showing variations in color bands, 1980s–1990s. Private collection.

Silver bolo set with Nevada turquoise by master smith Julian Lovato (Santo Domingo), late 1990s. Courtesy of Yasutomo Kodera.

Close-up of large 15" chunk turquoise necklace with four brass beads, 1950s. Courtesy of Steve and Mary Delzio.

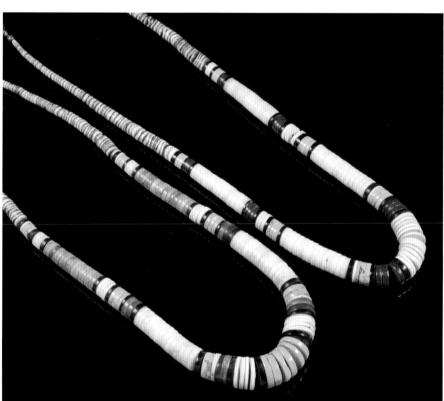

Two *heishi* necklaces showing imaginative color combinations. Courtesy of Steve and Mary Delzio.

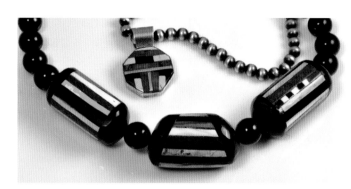

Drum beads with inlay by Delbert Crespin (Santo Domingo), ca. 2000, and inlay pendant with silver beads by Orlando Crespin, 1980s. Courtesy of Elizabeth Simpson.

Notes

1. Gumert, Shirley. "Joe Quintana's Singing Silver." *Artists of the Sun*, August 17, 1983, p. 29.

2. Rosnek, Carl, and Joseph Stacey. *Skystone and Silver: The Collector's Book of Southwest Indian Jewelry.* Englewood Cliffs, NJ: Prentice-Hall, 1976. There are errors aplenty in this book, but its overview of pre-1868 metalwork activity is generally concise and correct.

3. Rosnek, pp. 16–32. Brings together several sources, but Bauver's *Navajo and Pueblo Earrings* gives a more succinct picture of nineteenth-century Zuni metalwork activity.

4. Wright, Margaret Nickelson. *Hopi Silver: The History and Hallmarks of Hopi Silversmithing.* Albuquerque: University of New Mexico Press, 1998 (reprinted in 2003), p. 44.

5. Hersh, Phyllis. "Lewis Lomay, Artist in Silver." *New Mexico Magazine* (July 1976), p. 20.

6. Bulow, Ernie. "Mysteries of Zuni Silver: Decoding Adair's List," *ATADA News* 25.1 (Winter 2015), pp. 26–33. This article shows how extremely difficult it was to obtain research from reticent individuals and confused recollections, plus sorting through ownership of designs.

7. Bird, Allison. *Heart of the Dragonfly.* Albuquerque, NM: Avanyu, 1992. This book sets a context for Pueblo adoption and adaptation of cross necklaces, and how various pueblos developed their choice of beads and crosses, borrowing liberally from Spanish European Catholic forms as cover for their real design intentions.

8. Bedinger, Margery. *Indian Silver: Navajo and Pueblo Jewelers.* Albuquerque: University of New Mexico Press, 1973, pp. 80–82. The Pueblos were less horse oriented than the Navajo, so Spanish silver bridle gear, while certainly known, might possess less relevance than squash seeds. This design connection could use more study.

9. Fox, Nancy. "Southwestern Indian Jewelry." In *I Am Here: Two Thousand Years of Southwest Indian Arts and Culture.* Santa Fe: Museum of New Mexico, 1989, p. 80.

10. Fox, p. 81. Her sources come from a variety of the early writers on Southwestern Native jewelry; these statements became codified as facts by the 1970s.

11. Underhill, Ruth. *Pueblo Crafts.* Lawrence, KS: Haskell Institute; Bureau of Indian Affairs, 1953, p. 123. She provides no explanation for this statement.

12. Bird, p. 21.

13. Ibid.

14. Slaney, Deborah C. *Blue Gem, White Metal: Carvings and Jewelry from the C. G. Wallace Collection.* Phoenix, AZ: Heard Museum, 1998, pp. 26–29. These artists have become big names in the antique and vintage Indian art markets. Collectors tend to hold on to their works, so old and new enthusiasts will pay top dollar for anything genuine that becomes available. Hopi and Zuni artists were early users of non-Native visual compilations of older designs.

15. Slaney, pp. 33–34.

16. Dubin, Lois. *North American Indian Jewelry and Adornment: From Prehistory to the Present.* New York: Abrams, 1999, p. 534.

17. Tanner, Clara Lee. "Southwestern Indian Gold Jewelry." *The Kiva* 50.4 (1985), p. 202. Many experts have incorrectly claimed that Natives did not make gold jewelry until the 1970s; the truth is that the 1970s were when Native jewelers determined that there was enough of a high-end market for this product, and began learning to work gold in earnest.

18. Tanner, p. 204. The implication has always been that gold was developed to please non-Native tastes, but Native pride in working gold became a feature in converting individuals to high-end jewelry designers.

19. Rosnek, pp. 118–120.

20. Rosnek, pp. 120. This was a time-consuming process requiring real finesse.

21. Dubin, *North American Indian Jewelry and Adornment,* p. 529.

22. Branson, Oscar T. *Indian Jewelry Making.* Vol. 1. Tucson, AZ: Treasure Chest, 1977, p. 39. The melon seed shape is rooted in antiquity.

23. Bauver, Robert. *Navajo and Pueblo Earrings 1850–1945: Collected by Robert V. Gallegos.* Los Ranchos de Albuquerque, NM: Rio Grande Books, 2007, pp. 8 and 63+.

24. Ellis, Dorothy Hawley. "The Jewelry Heritage of Santo Domingo." *New Mexico Magazine* 54.4 (April 1976), pp. 10–18, 44–45.

25. Ellis, p. 14. One interesting thing about this article is an air of remoteness, reporting without engaging in active interviews with artists; this may have to do with the time when it was written and the predominance then of anthropological observation.

Comic bird pin from local New Mexico advertising shows the impact of popular culture, by Porfilio Sheyka (Zuni), 1950s. Courtesy of Abby Kent Flythe.

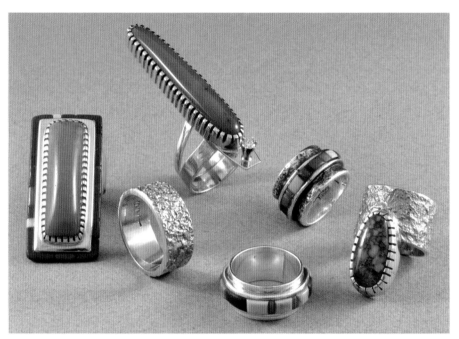

Versatile ring designs in gold, silver, and semiprecious stones by Charles Loloma, 1960s–1980s. Courtesy of Faust Gallery.

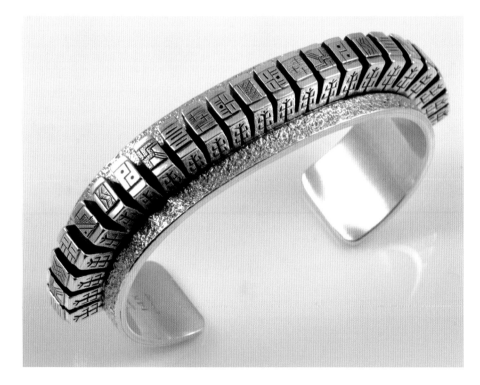

Silver square row bracelet stamped with cornstalks and 14 kt gold plate designs on top, by Roderick and Marllyn Tenorlo (Santo Domingo), ca. first decade of 21st century. Courtesy of Steve and Mary Delzio.

> *" I would suggest the need for all of us to strike a balance, in the name of cultural continuity, between the best of the past, the present, and the future. "*

—**Lloyd Kiva New** (1998)[1]

LLOYD KIVA NEW (1916–2002) WAS AN IMPORTANT figure in the arts of the American Southwest. Of Cherokee heritage, New's career as artist, designer, educator, and arts administrator deeply influenced the direction of Southwestern Indian art; he worked closely with Pueblo artists, too, including Charles and Otelie Loloma.[2] In 2016, four Santa Fe museums paid tribute to New. Their exhibitions featuring New's life and work confirm the fact that he was able to envision and predict a direction for Native artists, including Pueblo jewelers.

First of all, New understood that the power of fashion could aid widespread appreciation of Native adornment, especially wearable art, and contribute to an ongoing Native style. While director of the Institute of American Indian Arts (IAIA), New encouraged intertribalism as a means of fostering Native student cooperative aesthetics. Just as important, however, he saw that while a Native artist's tribal legacy was vital, so too was the need for the individual to experiment and develop a creative aesthetic that was unique to that person.[3]

He also understood the outsider scholarly worry about cultural continuity and knew that while Native art was changing, its viewers needed to be brought along to understand why and what such change entailed. This reality came about, however, precisely because the rules changed after 1980. The 1970s were the incubator for social change in the United States and design shifts in Pueblo jewelry. Having moved past the craft stage to that of wearable art, jewelers from the 1980s onward cemented their identities as Native *artists*. This allowed freedom for those who wished to continue making jewelry in "traditional" ways, those who wanted to attempt their own form of "Pueblo old-style," and those who, like Loloma, desired to go where their individuality and background led them.

The cycle of Pueblo life and belief has grounded today's jewelry makers, many of them coming from families with multiple generations of artistic talent. Their quiet pride in their background, anchored by unwavering tradition and shared values, helps them invigorate their artwork with personal nuance. Design choice can be understood best when we regard Native artistry in terms of tradition, craft, and popular culture influencing personal identity.[4]

New and Loloma, while working together at the IAIA, recognized that a genuine Native (and certainly Pueblo) reticence prevented their students from effectively marketing and promoting their artwork. Loloma was well aware of this cultural diffidence and took Dale Carnegie courses to compensate for his personal shyness. He went on to promote marketing when on the faculty of IAIA. Students at the college were exposed to the marketplace issues of selling their work, as at any art school. This had to create some discomfort for Native artists brought up in a hierarchical society that did not award personal self-aggrandizement.

The story of how today's Pueblo artists overcame this conflict will be told someday. What has emerged since 1980 is a growing lack of self-consciousness about being Native and an artist, undoubtedly assisted by popular global culture, more widespread education of Native youth (including college experience), and acceptance in the marketplace. The age of the individual had arrived and we can examine their contributions to a growing

Design Today: Past Meets Future

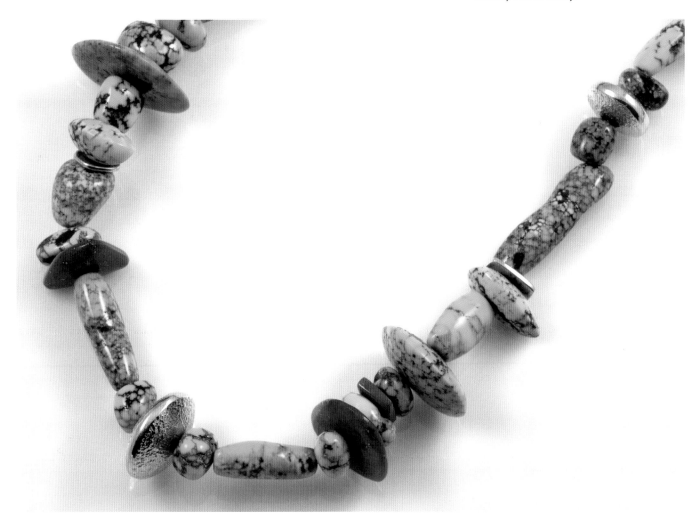

Loloma's heir, niece Verma Nequatewa (Sonwai), uses the finest materials—Lone Mountain turquoise, gold, coral, and spiny oyster—in this necklace, 2015. Courtesy of Faust Gallery.

attitude called "Native Style," perhaps an indirect tribute to Lloyd Kiva New's aspirations for his students.

The Pueblo design aesthetic possesses great powers of renewal and innovation. From traditional bead making to avant-garde flair, Pueblo jewelers today employ a fluidity that resonates with the history of their bead and stone creations. Building on such powerful artistry, it is no surprise that many of these artists are considered cutting edge. While some jewelers, bead makers, and silversmiths continue producing stone and silver *heishi*, others have moved beyond traditional means to employ new materials, techniques, and outlooks, or even make old-style tributes that take advantage of ancient creative modes that remain relevant today.

Every construction technique, from small stonework to overlay, was open to any Native artist's use. Tribal styles were experiments of the past, as intertribalism opened up new ideas for collaboration between artists of various heritages. Nevertheless, a stubborn streak of tribal pride prevailed in old-style tribute jewelry and attention to nuances in *heishi* creation. In many ways, the need to shine in the marketplace put younger artists on the defensive. Marketing, ever a worry for many Pueblo artists, now gained a boost from new technological tools that allowed past practices to be reevaluated. The turbulence of SWAIA Indian Market politics has left a number of young (and mature) artists looking for new means of displaying "Native Style."

Much of twentieth- and early-twenty-first-century popular culture, from fashion to wearable art, relies on the axiom "everything old is new again." Contemporary Pueblo artistic imagination possesses a fondness for cultural conceptualism that even Marcel Duchamp would approve of. But the foundation for such ease in design was established long ago in the makers' genes. The legacy of ancient design, the adaptations in modern-era creation, and the heritage of families working together over generations has placed today's Pueblo jewelers in a rich context.

Is this development a form of full-bodied cultural assimilation? Not really. Native jewelers turn popular culture on its head to fit their own evolving sensibilities. They do not—cannot—abandon their aesthetic heritage but instead use intertribal expression to help create a Native style that will be their story to tell in the decades ahead. Over one hundred years of technological change has transformed every American environment but has not vanquished indigenous respect and observation. And we know by now that the Pueblo worldview has proved among the richest of design motherlodes.

The evidence of this can be seen at any of the established shows, such as the Heard Museum Guild Fair and Indian Market or the SWAIA Indian Market. The artists' booths there will reveal both long-established and supermodern jewelry designs. While issues related to quality of materials and their availability affect all Native artists in the Southwest, the Pueblos in particular have proven to be historically adaptable in their use of stabilized turquoise and other low-grade stones. They've been grounded in providing affordable goods for years and understand what truly makes their works appealing.

Veronica Poblano has won awards for her unique designs such as this pendant of fine stones that are offset by silver bead forms, late 1990s. Private collection.

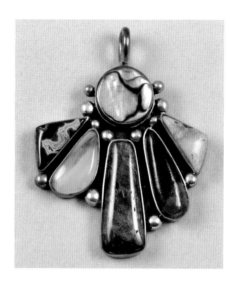

Joe Caté (Santo Domingo) fashioned this six-strand *heishi* from Tonapah turquoise, and his wife, Rosey, created the mosaic earrings on balsa wood, 1989. Courtesy of Abby Kent Flythe.

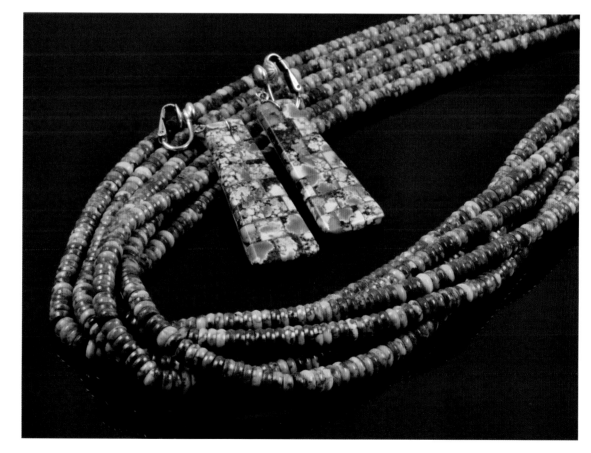

Heavy triple-strand turquoise *heishi* beads by Lester Abeyta (Santo Domingo), 2015. Private collection.

The 1980s and 1990s created a period where the market focus switched to named individual artists. Now it became possible to make a living from one's artistry, and there were collectors ready to buy attractive designs. Pueblo individuals aimed for and reached the high-end market, and there was plenty of room for good work to attract willing buyers. The author still remembers the excitement of predawn Saturday mornings at the SWAIA Market in the late 1980s, where eager consumers lined up at still-empty booths, waiting for the artists to arrive and a chance to grab a new creation. That mood can swell up in recent years, but the 1980s and 1990s were particularly marked by such collector fervor.

Like all Native artists today, Pueblo jewelry makers have a strong sense of their worth in the marketplace. Some young artists may aim too high in their prices, but the Indian art market has a way of shaking out and recalibrating artist expectations. The bead, too, remains a staple of the new artistry. The major challenges in this particular ethnic marketplace remain the ability to acquire top-quality materials, for new artists to meld technology with design integrity, and to nurture genuinely original creations that grow from a Native-based aesthetic and reflect both ancient and contemporary values. Lloyd New's fashion motive may well be the glue that binds these works.

Let's examine some of the most active artists today. Since one purpose of this book has been to ask readers to be wary of marketplace labels, we will use four carefully constructed post-1980 artist categories: **High-End**, **Bead Virtuosos**, **Fine Design**, and **Cutting Edge**. The artists considered in this chapter do *not* fall readily into just one of these categories but often straddle two or more. The reason for this may be found in the quote at the start of this chapter. Every artist in this book has been able to build her or his individual creativity on the bedrock of traditional Pueblo design.

The artists mentioned here do not represent all modern jewelry makers. Santo Domingo and Zuni deserve a volume each (or more) to do justice to all their artists. Hopi, which currently has only a few bead makers, will seem underrepresented. The analysis provided here, however, skims the surface to acknowledge names that have become well known at Indian art markets and are active at the present time.[5] I apologize in advance for the many omissions I have been forced to make.

High-End jewelers can be largely defined by their use of the finest materials and techniques, by their comfort in handling gold and gemstones, and as winners of numerous show awards. They have confidence in their design savvy, and their collectors expect top-of-the-line quality in their creations. Interestingly, many of these artists come from several generations of talented families. Two artists who fulfill these criteria are Verma Nequatewa and Veronica Poblano.

Verma is the niece of Charles Loloma; she spent more than twenty years training under his watchful eye. Her jewelry is sold under the trade name *Sonwai*, which means "beautiful" in Hopi. She is considered one of the best in the business, noted for her expert stone cutting, inlay, and designs that come from the heart. Like her famous uncle did, she uses a small airplane to traverse the rugged Hopi landscape, searching out natural rock formations that will

A green-tone mosaic tab–style plaque choker by Jolene Bird, 2013. Private collection.

Reverse side of choker with abalone tabs.

Ten-strand melon and jet shell *heishi* by Mary Coriz (Santo Domingo), 2016. Private collection.

inspire her stone cutting and shaping.[6] That same affinity for materials marks Veronica Poblano's work; the daughter of famed Zuni inlay artist Leo Poblano, she has passed on her talent to her children as well. She makes beads with exquisite care, but much of her jewelry is sculptural and delicate. Veronica has created many one-of-a-kind designs, working fearlessly both with traditional and newer materials such as druzy, fire agate, and gold, fashioning pieces that enhance the wearer.

Another deeply influential high-end artist is Laguna/Hopi master jeweler Duane Maktima, who has trained many individuals who now represent active talent at Indian arts shows. A graduate of Northern Arizona University (NAU), he taught at IAIA in the 1990s and conducted a number of prestigious workshops. His techniques include overlay, reticulation, and hollow form, and he's known to embrace unusual stones such as calkacydirite, faustite, and rosarita. His design vocabulary is impressive, from Art Deco to Scandinavian sources, and his unique abstract imagery uses motifs based on beads, shell mosaic, and Hopi pottery.

Hopi high-end jeweler Charles Supplee was a leader in guiding Indian adornment to wearable art status in the 1970s. He pulled away from traditional designs earlier than others, aided by his studies under Pierre Touraine in Scottsdale, Arizona. Supplee was one of the first to work with diamonds, lapis, charoite, and lavulite, creating well-balanced pieces with a sense of movement. His aesthetic sense is echoed by San Felipe father and son artists Richard and Jared Chavez. Richard trained as an architect before moving to making complex inlay jewelry designs,

incorporating gold and fine stones. Jared studied at Georgetown University before returning home to join his father in the fabrication of very fine art abstract designs with a modernist appeal. Jared's interest in printmaking has influenced his approach to silverwork and tufa casting.[7]

Bead Virtuosos largely come from Santo Domingo and Zuni. A leader in this category was the late Joe Caté (1944–2007), who often collaborated with his wife, Rosey. Their classic *heishi* is so greatly prized in the collector market that it's hard to find these days. They preferred to work with very high-grade turquoise from mines now closed, which adds to their collector demand. Bead virtuosos have two things in common: it's difficult to mention artists without extending back to parents and grandparents; at Santo Domingo, a handful of last names represent a large core of local talent. And all these artists learned "the right way" of making beads from their families, including the more painstaking processes.

For example, fine contemporary bead makers are Lester and Sharon Abeyta, the children of Richard and Delia Abeyta. Richard studied under Charles Loloma at the IAIA and taught his son and daughter traditional tools and techniques and how to appreciate fine design. Lester makes fine tab earrings and is known for beautifully tapered, graduated bead necklaces. Sharon is equally skilled. The author purchased a white clamshell multistrand necklace from her that honors ancient creations. Kenneth Aguilar studied at the IAIA from 1967 to 1971 but learned bead making from his mother, Ventura. Kenneth and his wife, Angie Crispin, share labor in making *heishi* with rich colors.

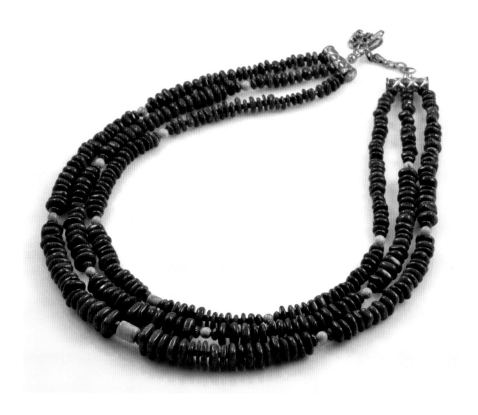

Kenneth Aguilar (Santo Domingo) makes attractive *heishi*: a triple-strand choker of lapis with incidental turquoise beads, ca. 2010. Private collection.

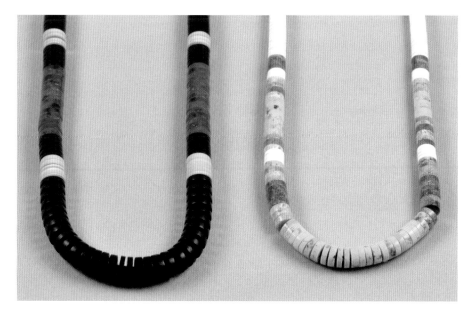

Two single-strand *heishi* necklaces by Calvin and Pilar Lovato (Santo Domingo), ca. 2015. Private collection.

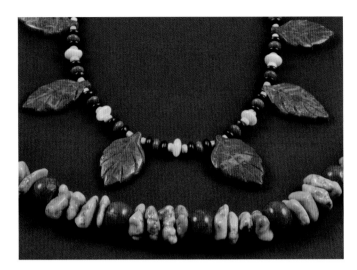

(Bottom) Tumbled green turquoise choker set with Applewood beads at intervals by Eileen Coriz (Santo Domingo), 2014; (top) multicolored bead choker with Applewood leaves by Chris Nieto, ca. 2012. Private collection.

Jolene Bird is an inventive designer of "traditional" jewelry forms, from mosaic arm bands to necklaces derived from ancient Hohokam designs. She works with natural materials and hand-cuts and grinds all her beads. She even borrows more-recent traditions and inlays mosaic on top of vinyl record material. Mary Coriz, from the noted Coriz family (her father was Santiago Coriz), produces fine stamp work, inlaid shell earrings and pendants, and flawless multistrand *heishi* on cotton wrap or cord. Delbert Crispin works with his wife, Torevia, and their Santo Domingo traditional pieces are marked by rich colors and bold accents and often have large inlaid pieces or big distinctive beads.

The Lovato name belongs to a number of families in the pueblo. Ray Lovato Sr. is one of the most distinguished *heishi* artists in the marketplace. His parents, Ike Lovato and Tonita Reano, taught him to drill turquoise for beads in the 1950s. He prefers natural turquoise while acknowledging it's a harder material to work. Lovato is known for his meticulous single-strand necklaces, and collectors value the quality of the stone he uses. Calvin and Pilar Lovato are a husband and wife team, known for their traditional designs. Their single-strand, multicolor bead necklaces are their most popular work, along with a fine assortment of earring styles: tab, dangles, and short *jaclas*. They also make shell and red-clay multistrands with small turquoise and white highlight stones.

Chris Nieto is self-taught, although his grandfather made Depression-era jewelry. He taught himself to cut beads at six years old and was ready for inlay work on spiny oyster shell or deer antler by age ten. Nieto entered the Indian art shows later. His multistrand *heishi* is luxurious and he has become noted for his ceramic pendants, which exhibit a Mid-Century Modern retro feeling. (*Author disclosure*: I was introduced to his work by a Scottsdale dealer well before he began exhibiting at shows; I was convinced he'd be a success and my predictions seem to have come true.) Another Santo Domingo star is Mary Tafoya. She learned from her parents, Frank and Anita Coriz, and her inspiration comes from the Depression-era jewelry that sustained many Pueblo artists through the 1920s and 1930s. Tafoya works with found materials to make cheerful designs that pay tribute to the jewelry of that past era; many of her creative images are one-of-a-kind free-form inlay motifs from nature.

From Zuni, Jovanna Poblano, daughter of Veronica Poblano, has made bead creations her particular specialty. Her creations are distinctive and richly colorful; Jovanna works in a spiritual and modern eclectic mode, and her use of abstraction is pronounced in works that are not *heishi* but designed pieces with pendant and beads. She doesn't limit herself to traditional materials, choosing Austrian crystals, antique glass, hand-cut beads, and strong stones such as lapis, malachite, or Sleeping Beauty turquoise. Her pieces are symmetrical "statements" and are unique.

Piki Wadsworth is the daughter of noted jeweler Cheryl Yestewa. She is one of the few Hopi artists making beads these days; she uses the traditional methods of hand shaping, cutting, drilling, and polishing. She likes working with high-grade turquoise and learned to make beads at an early age, turning to silverwork later on. Her single-strand turquoise necklaces are especially prized by collectors.

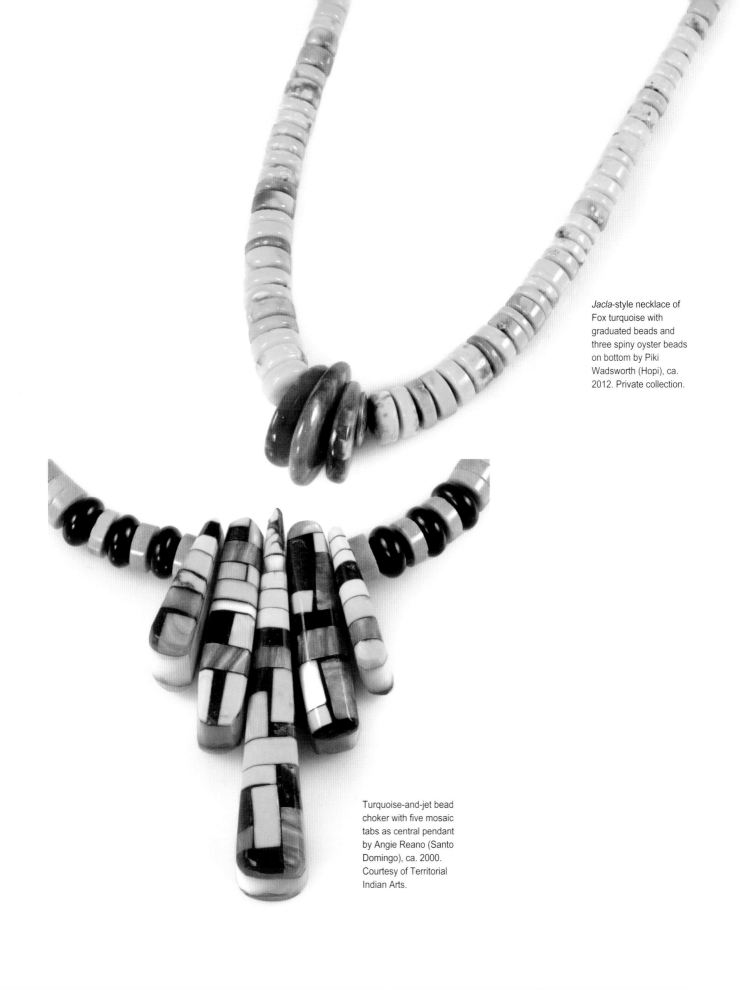

Jacla-style necklace of Fox turquoise with graduated beads and three spiny oyster beads on bottom by Piki Wadsworth (Hopi), ca. 2012. Private collection.

Turquoise-and-jet bead choker with five mosaic tabs as central pendant by Angie Reano (Santo Domingo), ca. 2000. Courtesy of Territorial Indian Arts.

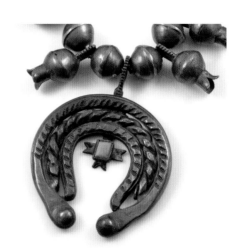

Copper squash blossom necklace, 15", in old-style Pueblo style by Dyaami Lewis (Laguna), ca. 2006. Courtesy of Andrew Munana Collection.

The category of **Fine Design** fits many Pueblo artists. The jewelers mentioned in this section fulfill two qualifications: they create clearly wearable art using unique designs that strike a happy balance between tradition and innovation, and they have a devoted following at Indian art shows and markets. A winning example of a fine designer is Mike Bird-Romero from Ohkay Owingeh. Largely self-taught, his aesthetic senses were deeply influenced by his mother, Lorencita Bird, a distinguished weaver and educator. He is particularly noted for his old-style Pueblo designs and motifs; he devoted many years of research and investigation into older jewelry fabrication, aided by his writer wife, Allison. Bird-Romero pieces are known for clean, expert silverwork and unusual stones; his works sell out quickly at Indian Market, especially his finely tuned cuffs and superb silver beads, which often grace a cross necklace. Also from Ohkay Owingeh with Hopi blood, Bobby Tewa practices crisp, elegant overlay and mosaic inlay that differs from traditional Hopi overlay styles. Active since the 1970s, he is a favorite at Indian Market.

The son of master artist Joe H. Quintana, Cippy Crazyhorse (Cochiti) maintains a highly personal unique approach, choosing heavy-gauge silver over other materials, and employs chisel and strong stamp design. His style is classic and beads often give way for precisely fashioned dragonfly and cross pendants. San Felipe artist Charlene Reano works with her Santo Domingo husband, Frank, making award-winning mosaic inlay. Their contribution to contemporary beadwork is the distinctive "chicklet" cube bead fashioned from mosaic scraps; this bead makes a stunning interval pattern on long bead strands. In recent years, Charlene's superlative "Cleopatra" reversible mosaic neck collars have attracted collector and critical attention.

Santo Domingo's foremost mosaic artist since the 1970s has been Angie Reano Owen, daughter of Joe Reano and Clara Lovato Reano. An inspiration for many young people at the pueblo, Owen's herringbone mosaic style has translated well to bracelet cuffs and rings. Her study of ancient mosaic jewelry forms revitalized her contemporary modes, including the square mosaic earrings she is particularly noted for creating. Also at Santo Domingo, Anthony Lovato learned tufa casting and beadwork from his grandfather Santiago Coriz and father, Sedelio F. Lovato. His unique designs draw from Pueblo motifs, from corn to figural "spirit" pendants. His tufa carving is augmented by strong stones such as amber, chorolite, and spiny oyster.[8] Lovato delights in reversible necklaces and makes coral beads, and his creations "feel" very artistic.

Santo Domingo jewelers Jennifer and Stephanie Medina are younger artists who work with one-of-a-kind designs that are innovative in shape and silhouette. They, too, have been trained in making *heishi* and have a healthy respect for the power of the bead. Their original outlook leads them to create novel colorful combinations while utilizing gemstones or crafting unique mosaic inlay. Stephanie makes truly new-wave versions of the Santo Domingo thunderbird.

At Laguna, Acoma-born father Greg Lewis and his son Dyaami are silversmiths who choose to work in traditional modes. They have made copper jewelry popular again with many collectors.

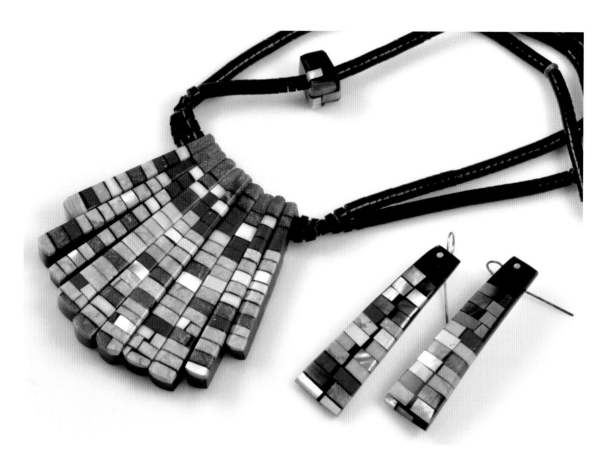

Reversible "Day 'n' Night" mosaic finger tabs on jet *heishi* with matching earrings by Charlene Reano, 2012. Courtesy of Suzette Jones.

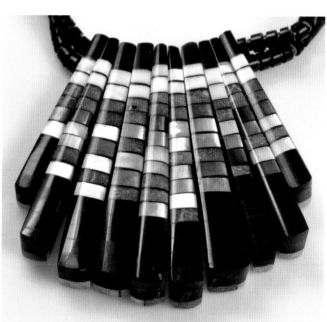

"Night" with lapis tips.

Sleeping Beauty turquoise mosaic disc necklace with abalone verso by Stephanie Medina (Santo Domingo), 2016. Author's collection.

They use old hand tools to fashion stamps and remarkable relief decoration. Greg's care for preserving old-style jewelry techniques pays off in fine details—such as small, delicately executed insect pins.

Moving to Zuni Pueblo, the multitudes of talent in place since the 1970s are staggering. One couple, Fred and Lolita Natachu, are emblematic of fine design and careful technical execution. They prefer more-traditional designs, such as thunderbirds, Knifewing, and Rainbow Man, rendering these images into delicate mosaic and channel inlay, often using jet, Mediterranean coral, and Sleeping Beauty turquoise. Myron Panteah (1966–2016) was gifted in taking ancient petroglyph or pictograph imagery and rendering them with a modernist twist; he was a Pueblo silversmith par excellence.

The fourth category, **Cutting Edge**, applies to most of the artists previously mentioned. We see a combination of high end, fine design, and virtuoso finishing in these artists' works. Perhaps the most important ingredient is that these jewelers see themselves as part of a new "Native Style," and their creations are clearly fine art. Previous and existing mainstream labels hold no appeal for them, yet at the same time they acknowledge the enormous debt they owe to traditional jewelry making. Cutting edge has become the mantra of many Indian art show judges and dealers. Amid worries about the continuation of Indian jewelry as a viable luxury collectible, these artists are determined to keep experimenting and offering objects of sensual delight, and the bead shows up as a recurrent decorative motif or detail.

Pat Pruitt of Laguna Pueblo was one of the first individuals to mix industrial and fine design for adornment. Collectors who visit his studio speak with awe of its "space age" equipment. Pruitt's aim is to make technologically savvy fabrication, utilizing computer software if required, but still crafting pieces with "traditional undertones." He works with steel piercing and other more exotic materials, most of which will not be found in most Native jewelers' workshops. Pruitt studied under Greg Lewis, so he has been suitably trained in long-established formats, but his swing into industrial design has opened new avenues for construction and innovation.

Husband and wife team Steve LaRance (Hopi) and Marian Denipah (Navajo/Tewa) benefit from training in sculpture, sandcasting, and fine bead making. Steve still makes stone sculpture. Their power as unique designers comes from simple yet dramatic pieces that emphasize the materials being used. David and Wayne Nez Gaussoin, of Picuris/Navajo descent, appear to be the standard bearers for "Native Style," and they know how to use fashion as an element in their clearly avant-garde designs. They specialize in new takes on jewelry forms. Both artists have worked on their education, taught jewelry making, and opened themselves to new experiences.

Ben Eustace (Zuni) learned to devise traditional and contemporary jewelry during the 1950s. Three of Ben and Felicita's (Cochiti) thirteen children have learned much from them. Ben passed on his inventiveness to his daughters. Bernadette makes strong channel inlay, shadow box with set stones, and a distinctive leaf motif with twisted-wire detailing. Christine studied at the University of New

Myron Panteah (Zuni) called this design his "Dog Man," but it feels more like "Walk Like an Egyptian," ca. 2005.

Mexico and has become known for abstract and detailed pieces related to ancestral ruins and petroglyphs. Jolene Eustace has won many awards, learned from her parents and her study at IAIA under Duane Maktima; her silver and 14-karat gold creations are richly abstract and sculptural in shape, and she employs material such as sugilite to great effect.

Another member of the large Eustace family, Robert Mac Eustace Jones, demonstrates corresponding talent, in which some pieces show real "think outside the box" ingenuity, such as a bracelet with movable parts. He explores jewelry shapes and form and comes up with series of adornment ideas that are not alike but share a common theme. Jones is also pursuing graduate work in Native art history, so his interest in revisionism is strong and inborn. An expert smith, he is shown at work shaping and creating a silver bead (see photographs on pages 140–141).

Zuni, with its many families of multigenerational talent, has a large number of artists who fulfill the "cutting edge" categorization. Gomeo Bobelu is deeply spiritual in nature; he specializes in abstract and realistic human figures, an interest not particularly favored by the Zunis. He admits to being inspired by Rene Lalique, and there is a delicacy in Bobelu's execution of his subjects that is unique. Colin Coonsis, the son of major artists Harlan Coonsis and Rolanda Haloo, has distinguished himself over the past decade by innovative work with flat and raised mosaic inlay. Most recently, he has begun making cuffs and rings with eye dazzling and nontraditional colors that possess a desirable "pop."

Two-strand hand-shaped coral bead choker by Steve LaRance (Hopi), ca. 2009. Private collection.

Robert Mac Eustace Jones demonstrates selected steps in the process for constructing hollow silver beads.

1. The dapping block for different sizes of beads.

4. Hammering the slug into a domed half.

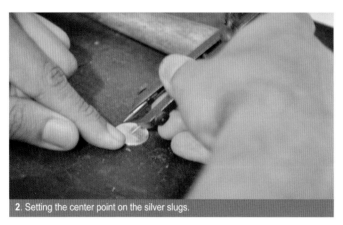
2. Setting the center point on the silver slugs.

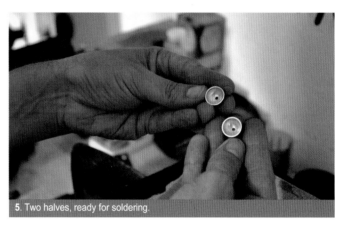
5. Two halves, ready for soldering.

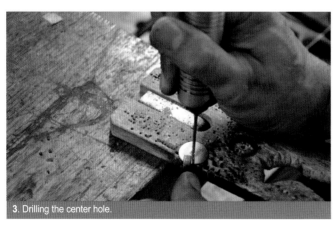
3. Drilling the center hole.

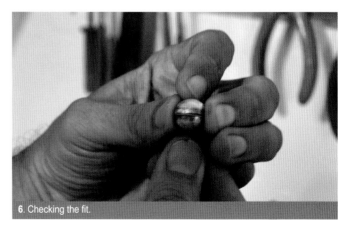
6. Checking the fit.

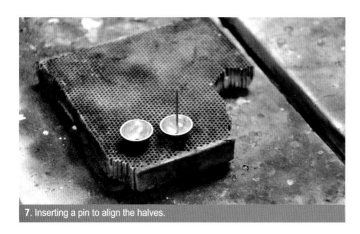

7. Inserting a pin to align the halves.

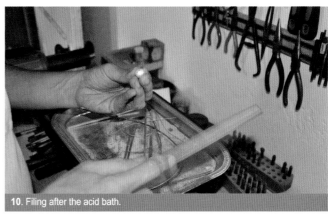

10. Filing after the acid bath.

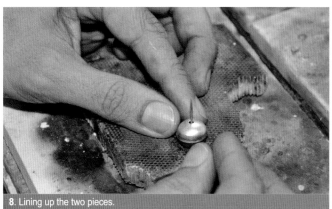

8. Lining up the two pieces.

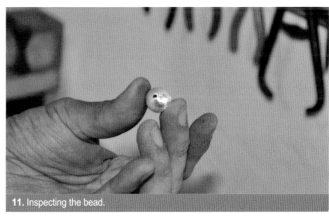

11. Inspecting the bead.

9. Soldering the halves together.

12. The bead on a chain.

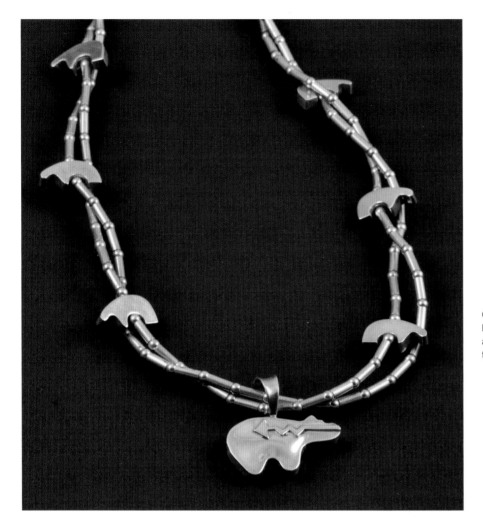

Carlton Jamon (Zuni) created a trademark "Silver Bear" hollow silver bead around 1989 that is admired and often imitated; this necklace with bears dates to the 1990s. Private collection.

Shaun Sheyka, grandson of Porfilio Sheyka, has an interest in industrial and technological design, seen in the mesh around this gaspeite stone ring, 2016. Private collection.

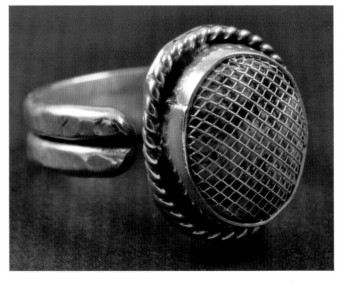

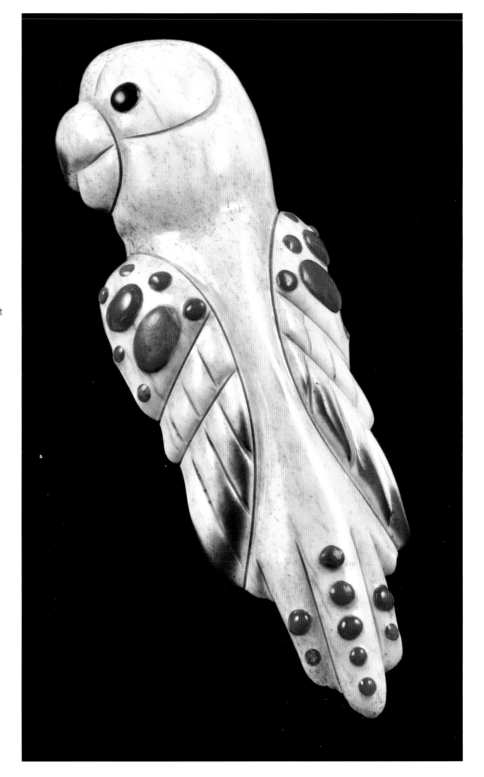

Carved from bone by
Troy Sice (Zuni), this
saucy parrot proudly
wears bead adornment
on his feathers, 2015.
Private collection.

Carlton Jamon has been active since the 1980s and learned jewelry making from his grandmother. In the late 1980s he created a hollow-form silver bear pendant and smaller beads in the same shape. The silver bear became his trademark, but Jamon has also experimented with a wealth of technical innovations since then. That same artistic restlessness informs the work of Dylan Poblano, son of Vernonica Poblano. He studied jewelry at the Fashion Institute of Technology in New York City as a youth and creates both abstract and representational silverwork, sleek beads, and adornment that shows sly references to popular culture. Poblano also takes on unusual materials, a Zuni talent, and renders them beautifully.[9]

The grandson of talented inlay artists Porfilio and Ann Sheyka, Shaun Sheyka probes a more technological angle. His works include items such as a phonograph ring with a spinning turntable, and fine stones wrapped in silver mesh for effect. A fetish carver whose forays into jewelry making have been highly successful is Troy Sice. His preferred carving material is antler, and he's known for his whimsical standing and sitting bears; one notable feature of his work has been a great willingness to use the bead itself as a decorative motif.

It's not surprising that a Native cultural group that has been adept at practicing survivance should succeed so well at melding past, present, and future jewelry design. The Pueblo people have a strong track record of coping with shortfalls and nudges from mainstream culture. The historical factors that make them a compelling presence in the ethnic marketplace are their history of inventiveness, ability to recycle found materials, steady trading under the portals in Albuquerque's and Santa Fe's plazas, and a powerful worldview that shapes their designs.

Henrietta Lidchi's dynamic study of the Indian jewelry industry, which came out in 2015, speaks of the concerns that collectors may be fading away with age, a trend toward one-time tourist consumption, and a lack of collecting interest in younger people.[10] These are troublesome issues for a luxury ethnic-goods market. It explains worries by Indian arts show organizers about "same old same old" designs that will drive away buyers; as a consequence, there has developed a hunger for avant-garde adornment and opportunities for young artists who may be able to deliver a refreshingly innovative product.

Pueblo jewelry artists have much to offer. The bead, whether it is traditionally hand ground and cut or fashioned in another mode, remains a basic adornment choice. The future of Native American jewelry—as collectible, costume jewelry, wearable art, or fine art—depends on the vision of makers and buyers. Since Native jewelry makers have adopted the aphorism "everything old is new again," Lloyd Kiva New's prediction for Native art looks to be a durable lifeline.

Notes

1. New, Lloyd Kiva. *The Sound of Drums: A Memoir of Lloyd Kiva New.* Edited by Ryan S. Flahive. Santa Fe, NM: Sunstone, 2016, p. 211. This quote comes from a speech by New to the ATLATL Conference in San Francisco on October 9, 1998. The speech was titled "The Artist as Visionary."

2. New started an innovative fashion gallery in Scottsdale, Arizona, during the 1950s. He even collaborated with Charles Loloma on a popular handbag; Loloma designed and created the decorative brass metal hardware.

3. The exhibitions in Santa Fe during 2016 all paid tribute to New's vision of the artist as someone who recognized tribal legacy while pursuing the education of any mainstream artist—the need to experiment, share, and learn new techniques and processes—in order to better establish a personal artistic identity.

4. This definition has been the foundation for my choice of design history methodology over other academic approaches. Native peoples have been traditionally suspicious of anthropological investigation and its tropes. By the time we reach the post–World War II era of Native artistic production, we cannot just label ensuing developments as cultural assimilation. The movement to individual choice—aided by popular culture, wartime experience and angst (Vietnam, Desert Storm, Iraq), better opportunities for college and specialized education, and increased travel and social interactions—calls for specific types of discernment. Native pride in heritage, location, and close-knit families offers today's artists a sense of identity that those from other cultures may lack. Native writers will take over later in the twenty-first century, and their revisionism of what has come before will help replace outdated viewpoints.

5. Biographical information that is reliable remains difficult to find on many contemporary Pueblo artists. Some receive scattered mentions in books. The following paragraphs contain data derived from the Heard Museum's Billy Jane Baguley Library's Artist Files, selected Internet sources from museums and noncommercial institutions, and personal interviews conducted between 2012 and early 2017. Information collected from commercial Internet sources is full of errors, especially when dealing with dates.

6. Osburn, Annie. "Jeweler Verma Nequatewa (Sonwai)." *Indian Artist* (Spring 1998), pp. 36–41. This informative article has interesting information about Nequatewa's training under Loloma and reveals the hard work that goes into producing high-end fabrications.

7. Pardue, Diana. "A New Era in Jewelry: Forging a Future." *Ornament* 31.2 (2007), p. 49. This article evaluates many "cutting edge" artists and notes Jared Chavez's unique educational experience.

8. Van Cleve, Emily. "One-of-a-Kind Tufa Casting Provides Endless Possibilities [Anthony Lovato]." *Santa Fe New Mexican* (August 15, 1996), pp. 46–47.

9. Pardue, 2007, p. 48. Dylan Poblano's New York City art school training and versatility are described here.

10. Lidchi, Henrietta. *Surviving Desires: Making and Selling Jewellery in the American Southwest.* Norman: University of Oklahoma Press, 2015, pp. 221–223. This is the very best of recent works that examine Southwestern Indian jewelry, and the author approaches the subject through multiple perspectives. Her observations on the future of the commodity in general are thought provoking. Lidchi began collecting and observing the market in the 1990s, and by the first decade of the twenty-first century she was able to discern substantial changes in professional presentation and outlook. She also records part of an instructive interview with a well-known Santa Fe dealer who notes that artists can reach customers more directly thanks to changes in technology and online market and sales sites, along with the worrisome rise of "one time" consumer sales.

PRICES FOR ANTIQUE, VINTAGE, AND CONTEMPORARY

Pueblo beads and jewelry are well established in the marketplace, as they are for Navajo adornment and works by other Natives of the American Southwest. I am tempted to make an anecdotal rather than factual comment, however, when I state that Pueblo-made jewelry may be slightly less pricey in general. Yet, this applies really only to contemporary Pueblo jewelry. Of course, we can exempt high-end artists right away; their materials and designs will always fetch greater prices. At this point, it must also be said that certain tribal styles noted for specific artistic techniques, such as Hopi overlay and Zuni inlay, are very popular in the market. Prices for both types of adornment are competitive, especially on auction sales sites such as eBay™.

When we turn to beads, prices vary strongly between hand-made bead creations using good materials and those that have commercially made beads, using glass, plastic, seed, or stabilized stone materials. Beginning collectors will often struggle when faced with deceptive marketing labels. At the lower end of the market, necklaces sell for below $100, while those that are genuinely made in traditional, time-consuming manners can start close to $1,000 and move upward from there. Collectors need to be particularly careful in buying silver bead strands, generally known as "Liquid Silver," because the real thing is deservedly pricey; however, the majority of such items in the marketplace are commercial knockoffs of a handmade process.

It pays to know the three key factors in buying high-quality jewelry: good construction, good materials, and design with integrity.

When purchasing anything lacking even just one of these factors, the buyer will be shortchanging himself or herself. Looking closely before purchasing goes without saying. I have witnessed pieces made by artists with big names in the field who have finished their objects poorly, with inferior findings or lesser-quality stone substitutions near the terminal cones. These can also appear at the major Indian arts shows, which have supposedly been vetted by experts. In no way is this a practice limited to specific cultural groups, but more often it is simply a matter of the individual rushing to complete a piece (and many artists are guilty of such poor time management).

In fact, much Pueblo jewelry is created as costume jewelry, and its makers offer reasonable prices, especially compared to those who follow the Loloma-esque path of designing "wearable art." Rings may be had for $200 or less, although an individual who is popular at the Indian arts shows is more likely to seek a price above $200 or $300. Bracelets can range from $140 to $40,000+ if one seeks out a genuine cuff by a high-end artist. I generally find that Pueblo-made earrings are reasonably priced and good investments. When we turn to *heishi* or *heishi*-like adornment, prices are wildly variable. Bead necklaces bought at I-40 roadside shops will likely price well under $100. Some beads made within the last twenty years sell for less than $400. Fine necklaces should fetch prices starting at $1,000 and climbing. Pieces by high-end and big-name fine designers can and do reach five figures.

Genuine vintage and antique pieces will be pricey, although I've discovered that dealers may be more flexible in their prices for pieces where the piece's maker is not known. On the other hand,

Valuation and Marketplace

since Loloma pieces are still in circulation in the market, so too are clever forgeries; it's absolutely essential to get confirmation of authenticity from experts. Facebook sites exist just to uncover fakes! Be careful of eBay™ market prices. I do not advocate buying an older piece strictly by photograph; there are deficiencies in stonework and beads that cannot be seen easily except by physical inspection. Vintage necklaces may also require restringing if the buyer wants to wear the item; be careful what vendor you choose for such a job. As always, poor physical condition of a piece will lower its sales price; however, collectors need to know that if they want to purchase items requiring restoration work, those costs can be considerable.

Buying directly from artists is the most satisfactory means of contact. The big Indian arts shows, in Phoenix (Heard Museum), Santa Fe (SWAIA Indian Market), and Indianapolis (Eiteljorg Museum), are good places to begin, but be aware that prices could be at their highest in those venues. Investigate newer offshoot markets and pop-up markets in scattered geographic locations. Since Native artists today are creating what they call fine art, do not insult them with "best price?" and bargaining. Put deposit money down for any work you commission, and establish a good-faith timetable for completion. High-end artists can and will prefer that such transactions be arranged with their dealer/gallery representatives. For older art, it pays to use dealers who are members of the Antique Tribal Arts Dealers Association (ATADA). Retail stores that are members of the Indian Arts & Crafts Association (IACA) are also bound by ethics pledges.

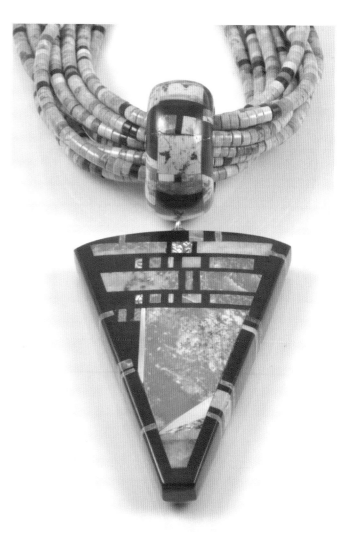

THERE ARE ESTABLISHED PUBLICATIONS devoted to the Pueblo Indians and their culture listed in the bibliography. Many are technically anthropological in nature and provide valuable information about the various language-based groups. What's important to know is that there are cultural variations between the groups, and particularly between the Rio Grande Pueblos and the western Pueblos. For the most authoritative reading on Pueblo beads, one can turn to Lois Dubin's *History of Beads* (2009) and her section on the Southwestern peoples in *North American Indian Jewelry and Adornment* (1999). Few other research publications on Indian jewelry provide the same level of information about Pueblo bead making.

Traveling to Pueblo Country is one of the best means of learning about their art and culture. These peoples are integrally bound to their landscape, and the geographical wonders of the Rio Grande valley run all the way from Isleta in the south to northernmost Taos Pueblo. Travel west on I-40, once the old Route 66, and you will see Laguna's old mission church perched high on its hill off the interstate, or find the turnoff south to the dramatic profile of Acoma, Sky City. Forty miles southwest of Gallup, New Mexico, one can encounter the peaceful beauty of Zuni, guarded by its Corn Mountain. Driving north of Flagstaff, over distant Arizona roads and remote canyons, will lead to the three mesas of Hopi, where their isolation is a matter of pride.

The Pueblos themselves offer very limited opportunities for exploration; it's important to remember that they are conservative private communities. Some pueblos, such as Jemez, are closed to outsiders, but they do offer a fine visitor center with an excellent illustrated timeline mounted on its walls, and a few local artisans selling good wares outside in front. Other pueblos such as Acoma, Taos, and Zuni have an established place for tourists to gather and go on guided tours. The best time to visit a pueblo is when outsiders are invited; these opportunities come on feast days or when a pueblo arts show is arranged and advertised. Santo Domingo has become well known for its annual Arts and Crafts Show on Labor Day weekends. Hopi's Cultural Center is located on Second Mesa, and their museum demonstrates how their distinctive arts developed.

The best places to begin really looking at Pueblo arts, especially jewelry, are in the cities of Albuquerque and Santa Fe. They are working cities with educational tourist attractions plus galleries and shops selling Indian arts. A number of Pueblo Indians are licensed vendors who show their jewelry in the main plazas. Albuquerque's Old Town Plaza's east portal is a place for seeing such works, and artists show their wares under the portal of the Palace of the Governors in Santa Fe. There is a variety of goods in a wide range of prices, and an opportunity to talk with the artists.

I have visited Albuquerque's Indian Pueblo Cultural Center since the late 1980s, but I have never seen the place look as good as it has since a recent makeover in 2016. A visit to the IPCC permits the viewer to see educational exhibitions, read cultural resources, and attend dances and lectures; the restaurant there is noted for its Pueblo delicacies. Old Town has numerous shops,

Pueblo Arts Research Resources

The Santo Domingo Trading Post in Old Town Albuquerque, New Mexico.

including the eclectic, well-preserved curio shop, the Covered Wagon, and Maisel's is still in business in the nearby downtown area. The Indian-owned Santo Domingo Trading Post offers authentic pieces, while Wright's Indian Arts, located farther uptown, shows innovative new works both by established and young Pueblo jewelers.

Santa Fe boasts numerous museums. On Museum Hill, the Museum of Indian Arts and Culture and Wheelwright Museum offer pertinent permanent collections and exhibitions; the Wheelwright recently unveiled a jewelry gallery that serves as a veritable "who's who" of Navajo and Pueblo artists. Closer to the downtown plaza, the Institute of American Indian Arts Museum organizes intertribal exhibitions. While Santa Fe is known for its art galleries, one shop, Keshi, specializes in recent fetishes and jewelry from Zuni and other pueblos. In Pojoaque, just north of the city, the Poeh Art Museum often features exhibitions on cutting-edge Pueblo arts, and the permanent collection of jewelry exhibited at the Millicent Rogers Museum in Taos contains some of the finest historical Pueblo-made beadwork and silverwork in the region.

Many times in the course of writing this book I have despaired of communicating through words the sheer beauty of Pueblo beads and adornment. Fortunately, I work with a photographer whose unerring eye has captured just the right details, play of light, and symmetry wrought by hand. Sometimes a handmade necklace possesses asymmetry due to its fragility during the creation process. This irregularity becomes beautiful, too. As always,

it's especially pleasing to know that the range of prices for this Native-made jewelry offers something for everyone.

There is a place where this adornment comes together in purpose. At ceremonial dances throughout the pueblos every year, the beat of drums and tread of feet, punctuated by flashes of white shell, blue and green turquoise, warm-hued coral, and glittering silver, ensure that the rituals of old maintain our world in balance. The Pueblos dance for all of us, and they command *our* respect and observation. We honor their prayers when we wear the materials they have fashioned.

Adair, John. *The Navajo and Pueblo Silversmiths.* Norman: University of Oklahoma Press, 1944.

Bahti, Mark. *Southwest Indian Designs: With Some Explanations.* Tucson, AZ: Treasure Chest, 1994.

———. *Silver + Stone: Profiles of American Indian Jewelers.* Tucson, AZ: Rio Nuevo, 2007.

Bailey, Irma. *Joe H. Quintana, Master in Metal: Selections from the Irma Bailey Collection.* Santa Fe, NM: Museum of Indian Arts & Culture, 2004.

Batkin, Jonathan. *The Native American Curio Trade in New Mexico.* Santa Fe, NM: Wheelwright Museum of the American Indian, 2008.

Bauver, Robert. *Navajo and Pueblo Earrings 1850–1945: Collected by Robert V. Gallegos.* Los Ranchos de Albuquerque, NM: Rio Grande Books, 2007.

Baxter, Paula A. "Cross-Cultural Controversies in the Design of American Indian Jewellery." *Journal of Design History* 7.4 (Winter 1994), pp. 233–245.

———. "Native North American Arts: Tourist Art." In *The Dictionary of Art.* Vol. 22. Edited by Jane Turner. London: Grove, 1996, pp. 667–670.

———. "Navajo and Pueblo Jewelry, 1940–1970: Three Decades of Innovative Design Revisited." *American Indian Art Magazine* 21.4 (Autumn 1996), pp. 34–43.

———. "Nineteenth Century Navajo and Pueblo Silver Jewelry." *The Magazine Antiques* 153.1 (January 1998), pp. 206–215.

———. *The Encyclopedia of Native American Jewelry.* Phoenix, AZ: Oryx, 2000.

———. *Southwest Silver Jewelry.* Atglen, PA: Schiffer, 2001.

———. *Southwestern Indian Rings.* Atglen, PA: Schiffer, 2011.

———. *Southwestern Indian Bracelets: The Essential Cuff.* Atglen, PA: Schiffer, 2015.

Be Dazzled! Masterworks of Jewelry and Beadwork from the Heard Museum. Phoenix: Heard Museum, 2002.

Bedinger, Margery. *Indian Silver: Navajo and Pueblo Jewelers.* Albuquerque: University of New Mexico Press, 1973.

Bell, Barbara, and Ed Bell. *Zuni: The Art and the People.* 3 vols. Grants, NM: Squaw Bell Traders, 1975–77.

Bird, Allison. *Heart of the Dragonfly.* Albuquerque, NM: Avanyu, 1992.

Branson, Oscar T. *Indian Jewelry Making.* 2 vols. Tucson, AZ: Treasure Chest, 1977.

Breeze, Carla. *Pueblo Deco.* New York: Rizzoli International, 1990.

Bulow, Ernie. "Mysteries of Zuni Silver: Decoding Adair's List." *ATADA News* 25.1 (Winter 2015), pp. 26–33.

Bunzel, Ruth L. *The Pueblo Potter: A Study of Creative Imagination in Primitive Art.* New York: Dover, 1929 (reprinted in 1972).

Burton, Henrietta. *The Re-establishment of the Indians in Their Pueblo Life through the Revival of Their Traditional Crafts: A Study in Home Extension Education.* New York: Teachers College, Columbia University, 1936 (reprinted in 1973).

The C. G. Wallace Collection of American Indian Art, November 14, 15, and 16, 1975. Auction sales catalog. New York: Sotheby Parke-Bernet, 1975.

Chapman, Kenneth. *Pueblo Pottery Designs.* New York: Dover, 1995.

Cirillo, Dexter. *Southwestern Indian Jewelry.* New York: Abbeville, 1992.

———. *Southwestern Indian Jewelry: Crafting New Traditions.* New York: Rizzoli International Publications, 2008.

———. "Design Motifs in Southwestern Indian Jewelry." *American Indian Art Magazine* 34.4 (Autumn 2009), pp. 58–69.

Colton, Mary-Russell F. "Hopi Silversmithing—Its Background and Future." *Plateau* 12 (July 1939), pp. 1–7.

Douglas, Frederic, and Rene d'Harnoncourt. *Indian Art of the United States.* Exhibition catalog. New York: Museum of Modern Art, 1941.

Dubin, Lois Sherr. *North American Indian Jewelry and Adornment: From Prehistory to the Present.* New York: Abrams, 1999.

———. *The History of Beads: From 30,000 B.C. to the Present.* Rev. and expanded ed. New York: Abrams, 2009.

Dutton, Bertha. *The Pueblos: Indians of the American Southwest.* Englewood Cliffs, NJ: Prentice-Hall, 1976.

Ellis, Dorothy Hawley. "The Jewelry Heritage of Santo Domingo." *New Mexico Magazine* 54.4 (April 1976), pp. 10–18, 44–45.

Bibliography

Ezell, Paul. "Shell Work of the Prehistoric Southwest." *The Kiva* 3.3 (December 1937), pp. 9–12.

Farnham, Emily. "Decorative Design in Indian Jewelry." *Design* 35 (March 1934), pp. 13–15, 23–24.

Fewkes, Jesse Walter. "Designs on Prehistoric Hopi Pottery." *Annual Report of the Bureau of American Ethnology* (1919), pp. 207–284.

Fox, Nancy. "Southwestern Indian Jewelry." In *I Am Here: Two Thousand Years of Southwest Indian Arts and Culture*. Santa Fe: Museum of New Mexico, 1989.

Frank, Larry, with Millard Holbrook II. *Indian Silver Jewelry of the Southwest 1868–1930*. West Chester, PA: Schiffer, 1990.

Garmhausen, Winona. *History of Indian Arts Education in Santa Fe*. Santa Fe, MN: Sunstone, 1988.

Gibson, Daniel. *Pueblos of the Rio Grande: A Visitor's Guide*. Tucson, AZ: Rio Nuevo, 2001.

Gritton, Joy L. *The Institute of American Indian Arts: Modernism and U.S. Indian Policy*. Albuquerque: University of New Mexico Press, 2000.

Grugel, Andrea. "Culture, Religion and Economy in the American Southwest: Zuni Pueblo and Laguna Pueblo." *GeoJournal* 77 (2012), pp. 791–803.

Gumert, Shirley. "Joe Quintano's Singing Silver." *Artists of the Sun* (August 17, 1983), pp. 29–30.

Haury, Emil W. "Minute Beads from Prehistoric Pueblos." *American Anthropologist* 33 (1931), pp. 80–87.

Heard Museum. Billie Jane Baguley Library. Native American Artists Resource Collection.

Heard Museum. Billie Jane Baguley Library. Pamphlet Files and Vertical Files.

Hersh, Phyllis. "Lewis Lomay, Artist in Silver." *New Mexico Magazine* (July 1976), pp. 18–21.

Hillerman, Ann. "Jewelry Design." *Southwest Art* 30.3 (August 2000), p. 146.

Hoerig, Karl A. *Under the Palace Portal: Native American Artists in Santa Fe*. Albuquerque: University of New Mexico, 2003.

Hoffman, Wendy, and Patrice Locke. "An Historical Look at Old and New *Heishi*." *Indian Trader* (November 1981), pp. 5–7, 10.

"Introduction to Heishi." Brochure. Albuquerque, NM: Indian Arts & Crafts Association, 1988.

Jeançon, Jean A. *Pueblo Shell Beads and Inlay*. Denver Art Museum Leaflet 30. Denver, CO: Denver Art Museum, 1931.

Jernigan, E. W. *Jewelry of the Prehistoric Southwest*. Santa Fe, NM: School of American Research, 1978.

Kenagy, Suzanne G. "Made in the Zuni Style." *Masterkey* 61.4 (Winter 1988), pp. 11–20.

King, Dale Stuart. *Indian Silverwork of the Southwest*. Vol. 2. Tucson, AZ: Dale Stuart King, 1976.

Kirk, Ruth Falkenburg. *Southwestern Indian Jewelry*. [Reprinted from *El Palacio*.] School of American Research Papers 38. Santa Fe, NM: School of American Research, 1945.

Kline, Cindra. "Turquoise Tenacity: Saving Every Last Bit for Santo Domingo's Mosaic Jewelry," *El Palacio* 120.2 (Summer 2015), pp. 37–41.

Lidchi, Henrietta. *Surviving Desires: Making and Selling Jewellery in the American Southwest*. Norman: University of Oklahoma Press, 2015.

Lowry, Joe Dan, and Joe P. Lowry. *Turquoise: The World Story of a Fascinating Gemstone*. Layton, UT: Gibbs Smith, 2010.

Magee, Anne. "Charles Lovato at Main Trail: 'What the Mind Sees.'" *Arizona Living* (April 29, 1976), (3 pp.).

Mangum, Richard, and Sherry Mangum. "The Hopi Silver Project of the Museum of Northern Arizona." *Plateau*, n.s. 1 (1995), complete issue.

Mathien, Frances Joan. "Pueblo Jewelry Making in Chaco Canyon, New Mexico," *El Palacio* 119.2 (Summer 2014), pp. 52–59.

McBrinn, Maxine E., and Ross E. Altshuler. *Turquoise, Water, Sky: Meaning and Beauty in Southwest Native Arts*. Santa Fe: Museum of New Mexico Press, 2015.

McGreevy, S. B. "Indian Jewelry of the Southwest: Finished in Beauty." *Art and Antiques* 3 (May–June 1980), pp. 110–117.

McLerran, Jennifer. *A New Deal for Native Art: Indian Arts and Federal Policy 1933–1943*. Tucson: University of Arizona Press, 2009.

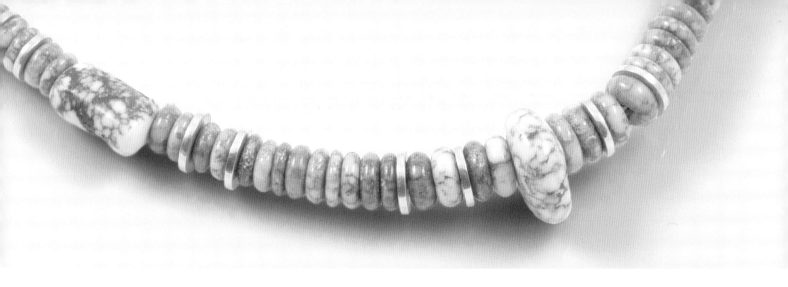

Mera, H. P. *Pueblo Designs: "The Rain Bird"; A Study in Pueblo Design*. Santa Fe, NM: Laboratory of Anthropology, Museum of Indian Arts and Culture, 1938 (reprinted in 1970).

———. *Indian Silverwork of the Southwest*. Vol. 1. Tucson, AZ: Dale Stuart King, 1960.

Minor, Vernon Hyde. *Art History's History*. Upper Saddle River, NJ: Prentice-Hall, 2001.

Monongye, Preston. "The New Indian Jewelry Art of the Southwest." *Arizona Highways* 47 (June 1972), pp. 6–11, 46–47.

Neumann, David. "Modern Development in Indian Jewelry" *El Palacio* 57 (June 1950), pp. 173–181.

New, Lloyd Kiva. *The Sound of Drums: A Memoir of Lloyd Kiva New*. Edited by Joe Flahive. Santa Fe, NM: Sunstone, 2016.

Orchard, William C. *Beads and Beadwork of the American Indians*. New York: Museum of the American Indian, Heye Foundation, 1975.

Ortiz, Alfonso. *The Tewa World: Space, Time, Being and Becoming in a Pueblo Society*. Chicago: University of Chicago Press, 1969.

Ortiz, Alfonso, ed. *Handbook of North American Indians*. Vol. 9. Washington, DC: Smithsonian Institution Press, 1979.

Osburn, Annie. "Jeweler Verma Nequatewa (Sonwai)." *Indian Artist* (Spring 1998), pp. 36–41.

Ostler, James, Marian Rodee, and Milford Nahohai. *Zuni: A Village of Silversmiths*. Zuni, NM: A:Shiwi, 1996.

Pardue, Diana. *The Cutting Edge: Contemporary Native American Jewelry and Metalwork*. Phoenix, AZ: Heard Museum, 1997.

———. *Contemporary Southwestern Jewelry*. Layton, UT: Gibbs Smith, 2007.

———. "A New Era in Jewelry: Forging a Future." *Ornament* 31.2 (2007), pp. 48–51.

———. "Everything Is Golden." *Native Peoples* 25.1 (January–February 2012), pp. 36–40.

Parsons, Elsie Clews. *Pueblo Indian Religion*. 2 vols. Lincoln: University of Nebraska Press, 1939 (reprinted in 1966).

Pontello, Jacqueline M. "Inner Worlds, Outer Forms [Ted Charveze]." *Southwest Art* (December 1986), pp. 33–37.

Ringlero, Aleta M. "Man of Steel: Innovative Pueblo Jeweler Pat Pruitt." *American Indian Magazine (NMAI)* (Summer 2008), pp. 18–21.

Rosnek, Carl, and Joseph Stacey. *Skystone and Silver: The Collector's Book of Southwest Indian Jewelry*. Englewood Cliffs, NJ: Prentice-Hall, 1976.

Rushing, W. Jackson. *Native American Art and the New York Avant-Garde*. Austin: University of Texas Press, 1995.

Sando, Joe S. *The Pueblo Indians*. San Francisco: Indian Historian Press, 1976.

Schaafsma, Polly, ed. *Kachinas in the Pueblo World*. Salt Lake City: University of Utah Press, 1994 (reprinted in 2000).

Schiffer, Nancy. *Jewelry by Southwest American Indians: Evolving Designs*. West Chester, PA: Schiffer, 1990.

———. *Masters of Contemporary Indian Jewelry*. Atglen, PA: Schiffer, 2009.

Sei, Toshio. *Knifewing and Rainbow Man in Zuni Jewelry*. Atglen, PA: Schiffer, 2010.

Sides, Dorothy Smith. *Decorative Art of the Southwestern Indians*. New York: Dover, 1936 (reprinted in 1961).

Slaney, Deborah C. *Blue Gem, White Metal: Carvings and Jewelry from the C. G. Wallace Collection*. Phoenix, AZ: Heard Museum, 1998.

Struever, Martha Hopkins. *Loloma: Beauty Is His Name*. Exhibition catalog. Santa Fe, NM: Wheelwright Museum of the American Indian, 2005.

Tanner, Clara Lee. *Southwest Indian Craft Arts*. Tucson: University of Arizona Press, 1968.

———. "Southwestern Indian Gold Jewelry." *The Kiva* 50.4 (1985), pp. 201–218.

Tartsinis, Ann Marguerite. *An American Style: Global Sources for New York Textile and Fashion Design, 1915–1928*. New York: Bard Graduate Center, dist. by Yale University Press, 2013.

Tisdale, Shelby J. *Fine Indian Jewelry of the Southwest: The Millicent Rogers Museum Collection*. Santa Fe: Museum of New Mexico Press, in assoc. with the Millicent Rogers Museum, 2006.

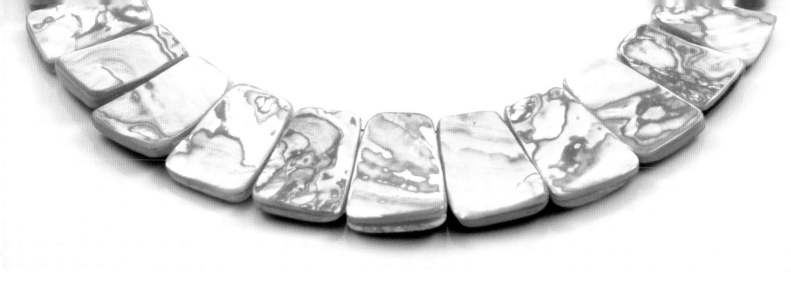

Tyler, Hamilton A. *Pueblo Gods and Myths*. Norman: University of Oklahoma Press, 1964.

———. *Pueblo Animals and Myths*. Norman: University of Oklahoma Press, 1975.

———. *Pueblo Birds and Myths*. Flagstaff, AZ: Northland, 1979 (reprinted in 1991).

Underhill, Ruth. *Pueblo Crafts*. Lawrence, KS: Haskell Institute; Bureau of Indian Affairs, 1953.

Van Cleve, Emily. "One-of-a-Kind Tufa Casting Provides Endless Possibilities [Anthony Lovato]." *Santa Fe New Mexican* (August 15, 1996), pp. 46–47.

Vizenor, Gerald, ed. *Survivance: Narratives of Native Presence*. Lincoln: University of Nebraska Press, 2008.

Wadsworth, Beula. *Design Motifs of the Pueblo Indians: With Applications in Modern Decorative Arts*. San Antonio, TX: Naylor, 1957.

Wengerd, Stephanie K. "The Role and Use of Color in the Zuni Culture." *Plateau* 44.3 (Winter 1972), pp. 113–124.

White, John Howell. "Imaging (Native) America: Pedro deLemos and the Expansion of Art Education." *Studies in Art Education* 42.4 (Summer 2001), pp. 298–317.

Wright, Margaret Nickelson. *Hopi Silver: The History and Hallmarks of Hopi Silversmithing*. Albuquerque: University of New Mexico Press, 1998 (reprinted in 2003).

Yokoi, Rita. "Heishi Techniques, Styles and Authenticity." Brochure. Albuquerque, NM: Indian Arts & Crafts Association, 1996.

———. "The Artistry of Augustine Lovato." *Indian Trader* (April 1998), p. 10.

———. "The Steps Involved in Making Traditional *Heishi* Beads." *Indian Trader* (July 1998), p. 15.

Index